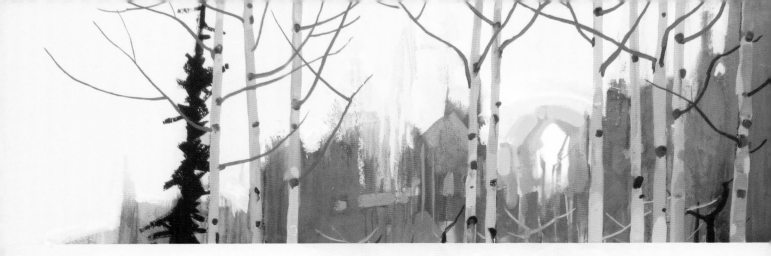

Watercolor
Masters AND Legends

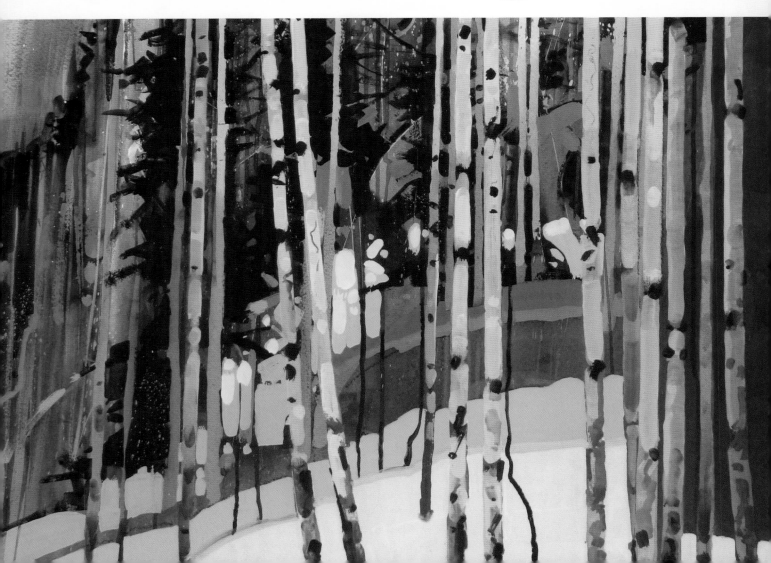

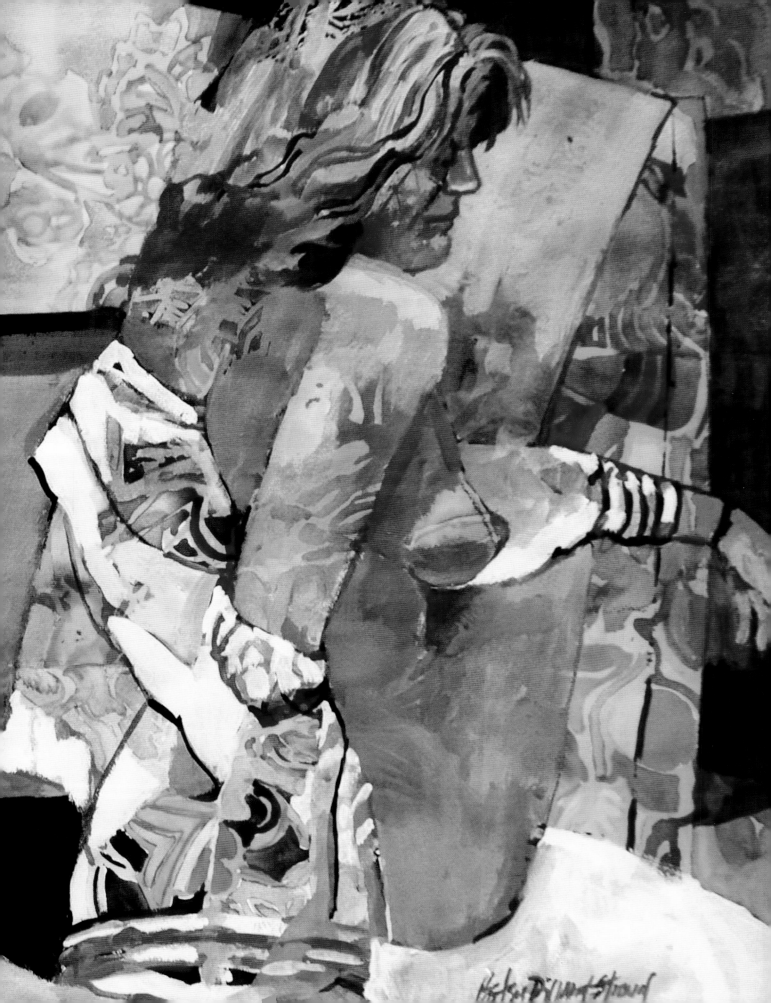

Watercolor
Masters AND Legends

Secrets, Stories AND Techniques FROM 34 Visionary Artists

Betsy Dillard Stroud

NORTH LIGHT BOOKS
CINCINNATI, OHIO
www.artistsnetwork.com

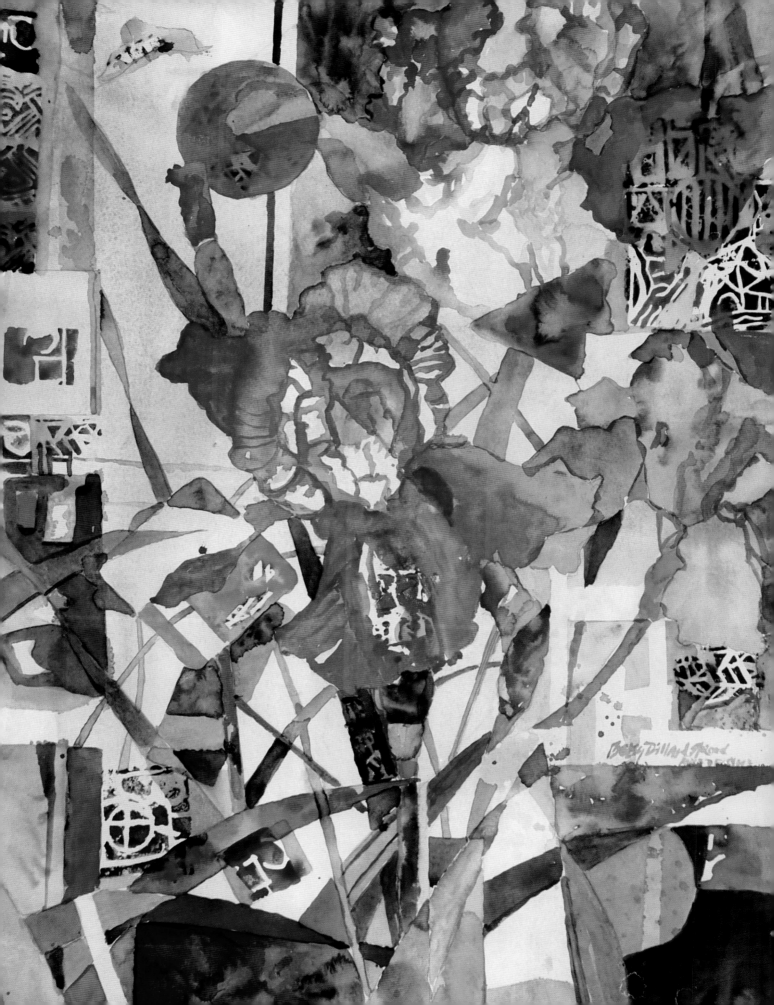

CONTENTS

[10] Masters

[120] Legends

◀ **Shehrezade's Secret Garden #39**
Betsy Dillard Stroud
30" × 22" (76cm × 56cm)

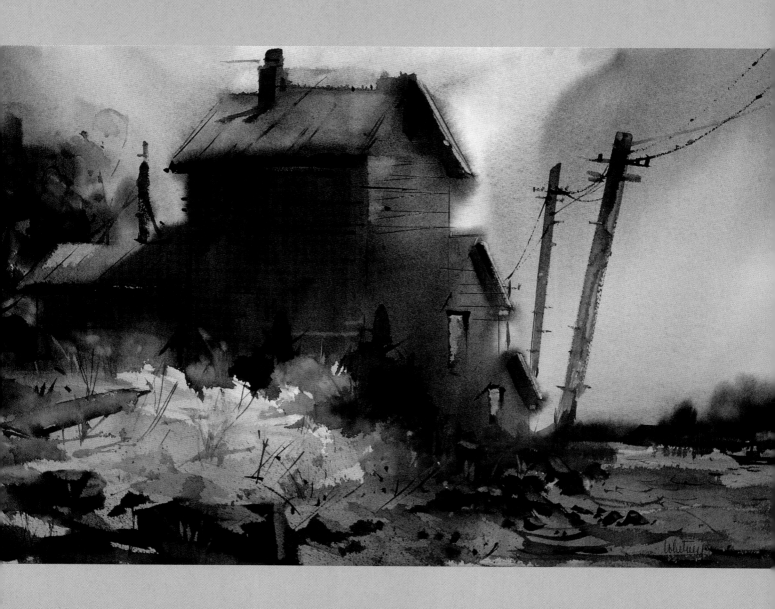

FOREWORD

"The flow of water is emblematic of vital force. Watercolor expresses flow, life as transparency, the ineffable, the transient air, motion, life moving. Watercolor, itself, is a force of nature.**"**

— Joseph Raffael, Artist
From Ellen Simak's *Reflections: The Water Related*

In the old Coca-Cola plant in Dallas, in a room where people crammed together like sardines, my life changed. It was 1980, and I was just about to witness the first brushstroke of legendary artist Edgar A. Whitney, often nicknamed, "the Granddaddy of Watercolor Painting." At that time, Ed was in his late eighties, but he had the energy of a thirty-year-old. His brush slammed into the sopping wet paper, and blue paint spread like a virgin squall beginning to rise. Each brushstroke took my breath away, as blue merged with green, and yellow exploded into the mix. In my excitement, I grabbed my then-husband's arm so tightly that he looked down at me and smiled. Before my eyes, the blue became sky, the plethora of colors dashed onto the paper became the ocean. It was magic conjured by Edgar A. Whitney, a true aesthetic alchemist. That unforgettable night in Dallas opened my eyes and my heart to a new way of expression.

I remembered my first watercolor painting at the age of eight. I copied Botticelli's *Birth of Venus*, in recollection a somewhat ridiculous but noble attempt from my tiny watercolor box straight from Brammer's ten-cent store, with its brush of one or two stiff black hairs. Between Whitney's masterpiece and my childish attempt, I intuited a startling segue, a daring glimpse into what could be accomplished if I worked hard. That night I was hooked. My future shimmered before me like a shiny wet, road, a road where my brush would travel for the rest of my life.

This book is the result of my love affair with watercolor and watermedia, the great artists I have learned from, my admiration for some of my most inventive colleagues and my desire to make something that was "writ in water," a lasting homage to not only the painters represented in the book, but to the watercolor and watermedia world itself. As artists we are aesthetic alchemists, and instead of turning objects into gold, we make the invisible visible, the ordinary extraordinary as we explore the pixilated magic and eloquence in the symbolic language of watercolor and watermedia.

◀ **Serenade in Blue and Gray**
Ed Whitney
(Photo courtesy of
Naomi Brotherton.)
15" × 22" (38cm × 56cm)

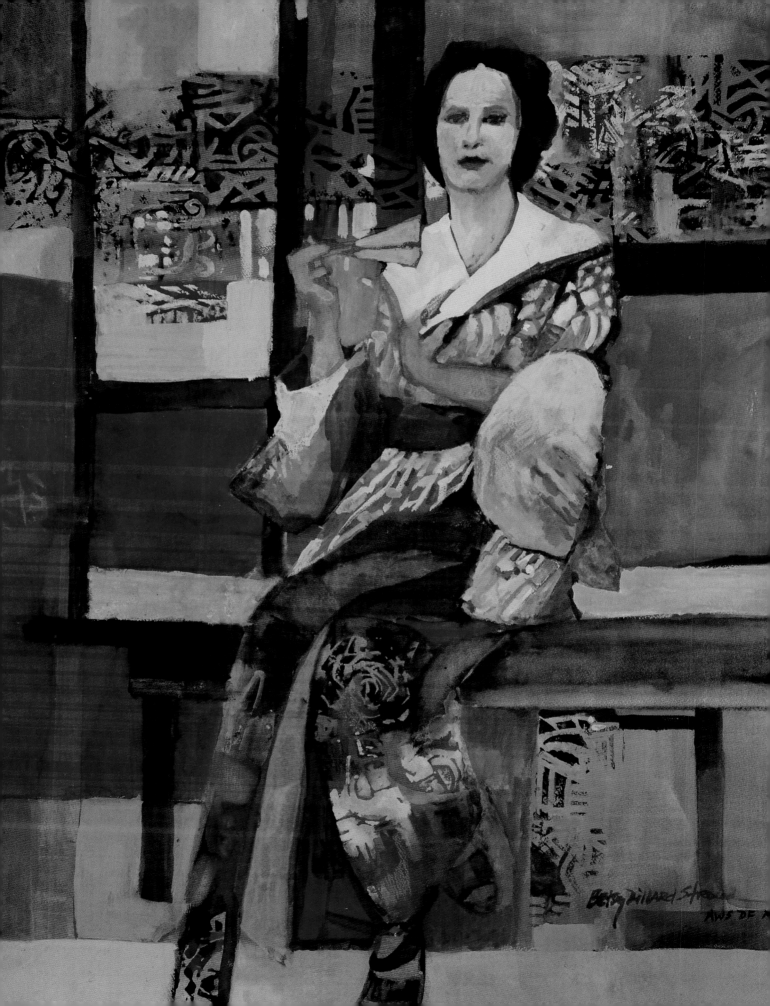

INTRODUCTION

If you are reading this book, you, too, have been lured by the magic of watercolor and watermedia. If you are reading this book, you are either an artist, aesthete or fledgling who longs to pick up a brush. Or perhaps you haven't picked up a brush in a long time, yet there is a strong, intuitive desire to get back to it. For, once hooked, one is forever in its embrace. You won't be disappointed, for in this book, we are those who have devoted our lives to this fickle medium, so idiosyncratic and demanding. We have followed its meandering ways, loved its eccentricities, intoxicated with its ability to show us who the real master is. We gravitate toward it, trying to unravel its mystery. As a result, this book comprises many approaches and many artists— both legends and masters. Whoever you are, remember this: All the artists in this book took risks to develop their art. They strove to find their individual expressions, which you will see in their myriad images, and they generously shared their wisdom.

Art gives us a glimpse of the world we can't get any other way. It is the visual zeitgeist. Because art is visual, it is a universal link to all mankind, a linchpin that unites hundreds of thousands all over the world.

Despite the glorious works of Joseph William Mallard Turner, John Cotman and Thomas Rowlandson, despite the seascapes of Homer, the genius of Prendergast, the expressive John Marin and the myopic look at American life through the eyes of Norman Rockwell, watercolor remained the foster child of the arts. Then in the 1950s, something happened. Something changed.

That change came from all directions, especially westward from the California School. By the next decade, watercolor societies popped up. Well-known artists became peripatetic, wandering far and wide, and sharing their expertise and their mastery with students. They are some of the many who blazed a trail for us. Like wildfire, news spread, and like the Western watercolorists, great teachers and artists from the North, the East, the Midwest, the Southwest and the South came up with their own inventions, their own desire to solve the mysteries of watercolor. With new watermedia products on the market and an improvement in acrylics, an explosion took place—a visual explosion of such diverse and intriguing methods that it has changed the course of art history.

There are many great artists and teachers who are not in this book, and that is why I limited the artists to those legends I learned from and/or have kept connections with over the last thirty-some years. I can never repay the debt I owe to them for their guidance and encouragement.

The masters are colleagues I chose because of their inventiveness, their creativity and their devotion and mastery of the medium they work in. Many are already legends but chose to be put in the master category.

For those who don't know, watercolor is the oldest medium. Cavemen dug mud and sand, and mixed it with water and possibly blood to paint the totemic images in Lascaux and Altamira. The Chinese experimented with soot and water for their Sumi-e paintings. In Egypt we see the remnants of color on their walls and tombs. And it was probably on Cleopatra's palette and perhaps her lips and cheeks. There is evidence that the Greeks painted their statues, and of course, it was with water-based paint.

After 1950, watercolorists opened the door to a new way of looking. They introduced us to technical approaches and experimentations that make them an integral jewel in the tesserae of the sparkling mosaic—the watercolor and watermedia world of today. That world is uncompromised in its excellence and in its beauty. Like the Pied Piper, it beckons artists to follow it to untraveled and unpainted territories of the imagination and of the future. We are all artists who choose to follow the medium wherever it takes us, especially, as Scott Peck would put it, "on the road less traveled."

Betsy Dillard Stroud
Phoenix, Arizona | August 12, 2015

The Painted Veil
Betsy Dillard Stroud
30" × 22" (76cm × 56cm)

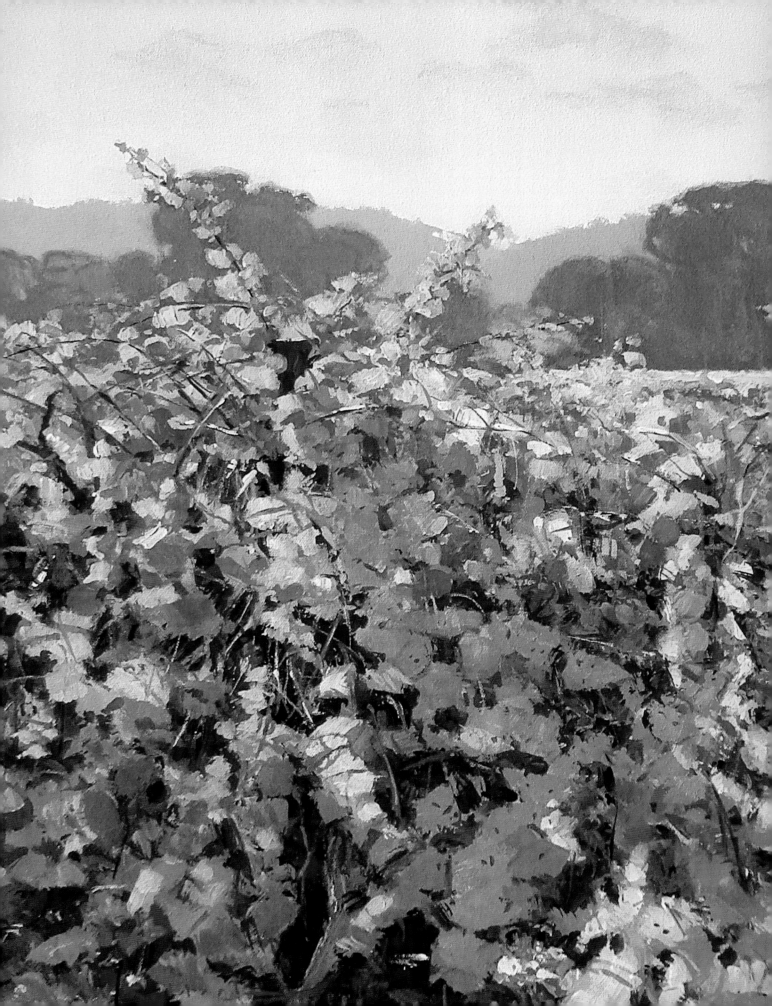

PART ONE
Masters

The masters selected for this book are all inventive, creative and productive artists. We have all mastered the basics long ago and have driven ourselves far beyond what we could imagine. We are without a doubt masters of color, design and technique. But we are something more. We are storytellers of the first order. And whether we tell our stories figuratively or through color, light, abstraction and content, our paintings transcend the idea of painting reality as it is, but as we see and feel it. Whether it is an expressive depiction of a horrific fire, a crowded street in New York or a decorative mission in Texas, those representations bring to life that scene, that emotion that drew us there in the first place. Perhaps you will see things differently as you view these works. Perhaps you will never look at a sidewalk or concrete the same way. Perhaps you will lose yourself in the textures and colors of abstraction or the transparencies of a wash. Our mission: to present you with a pictorial expression that expands your idea of what is and what can be.

We are widely diverse, each with a vision, each exploring an aesthetic path of his/her choosing. Each exploring not only the zeitgeist of the times but our take on that zeitgeist. We aspire to the William Blake quotation: "He who does not imagine in stronger and finer lineaments … than his perishing and mortal eye can see does not imagine at all."

Enjoy our journeys.

◀ PLANTER'S PUNCH
William Cather Hook
24" × 24" (61cm × 61cm)

Miles Batt

Miles Batt combines his incredible drawing abilities and unmatched creative mind to produce some of the most intriguing, sometimes humorous and mystifying paintings in the watercolor world. His subject matter is a captivating mixture of caprice and reality. Juxtapositions of trompe l'oeil objects, chromatic areas and a distinct but oblique reference to place often co-exist in "Batt World," a world of incredible shapes, bold and brilliant colors and unpredictable designs. These magical paintings are inspired by observation of the so-called real world, yet Batt's reinventions of this world transport us to a playful paradise where we can luxuriate in a labyrinthine mixture of pattern, color and simulated textures. Moreover, somewhere in these sparkling paintings, we find his token leitmotif, a painted button—always positioned in the midst of an ornamental framework—painted with stunning realism, a silent witness to his whole process.

Miles Batt grew up in Allentown, Pennsylvania, that is one of two cities (Oklahoma City is the other) that offered various and art programs for students and gave them two weeks to work on their projects. Because of his artistic prowess, Batt got an extra bonus. He was excused from classes to work on his art projects. By the first grade, when he was chosen to draw images in chalk on the blackboard, he felt that gave him his identity. His father was a great copyist, and that gave him, he says with a laugh, something to watch.

"Imagination is a release for me. I reject a lot of things before and during the process of painting."

One of the most successful exercises he uses in his classes is random mark making, an exercise during which each student places a mark in any color onto his paper. Then he creates a stunning painting from those idle marks. Batt states, "Everything you put on the paper is a lie anyway, so you might as well lie well. I'm always trying to recreate something, and at the bottom of recreating that new world is really, I think, the fear of death, which is what it is all about." We try to make life mean something, and our art does that.

Batt discusses his great admiration for Paul Klee and Picasso. "They are my strongest heroes," he says, because of the liberty they took and the expressive nature of their work, which at the time some people automatically rejected.

"The subconscious works on things when you are not in control. It will create answers when you least expect them to emerge." In order to be creative, he advises artists to find the connections between disparate things."

"In the beginning," he adds, "you have to set this kind of thinking up for yourself because it goes against academic training. For example, set aside time to connect things that don't seem to connect. Keep a book and write all your silliest ideas in them with sketches." He often finds himself looking in those books he has created to find an idea. "You'll never be at a loss for an idea," he muses. "Creativity seems complicated to most people."

When I ask him how his art has changed him, he replies, "It's invigorating to get up in the morning with a constant interest in life. Art teaches you content and form—the same things we need in life. In art there must be a happy marriage between content and form. It is a balance of forces which somehow find an equilibrium that is preferably not perfectly balanced.

"Rhythm crops up in my thinking as in music and song, as do the geometrics of painting. I'm not consciously thinking about them, but when I look at the painting, they are there. And," he asserts, "there is no avoiding design. You should know what the rules are, so that when you break a rule, you know what that rule is."

When I enter the world of Miles Batt, I, too, am always entertained, amused and in awe of the phantasmagoria. Color, design, imaginary or real, he captivates the viewer emotionally, visually and intellectually. Batt World is *sui generis*.

MARSHALL & BROS., ME ◗
30" × 22" (76cm × 56cm)

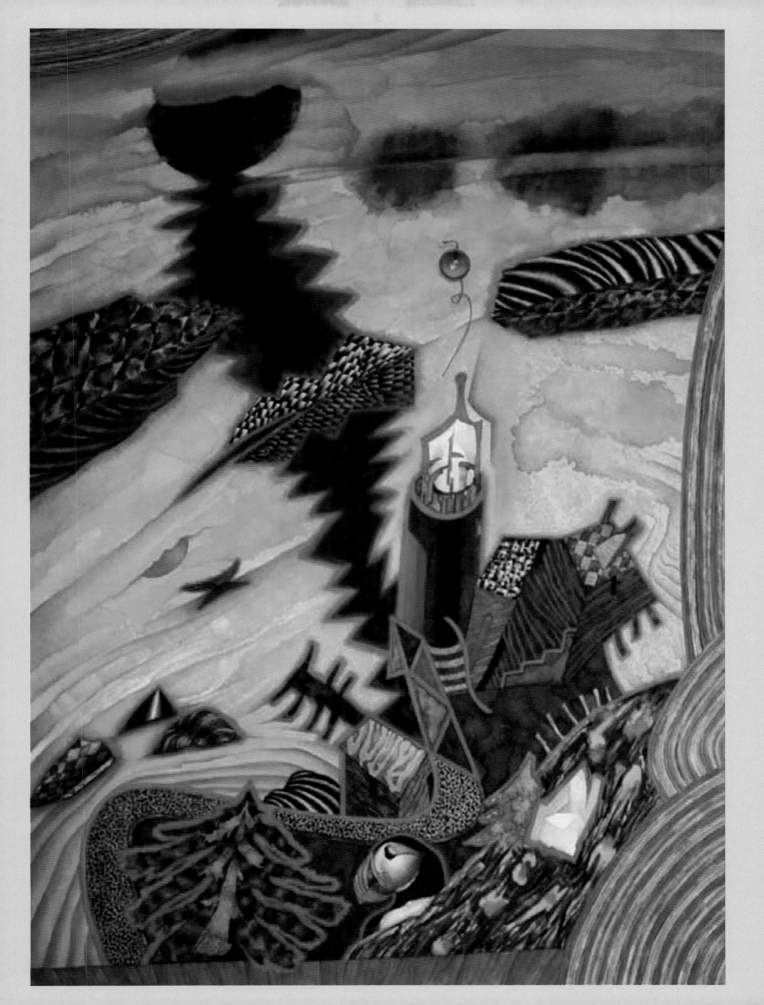

OFF A MAINE ROAD

Miles Batt parks his car by the side of the road, inspired by a scene close by, and begins to sketch.

1 Batt's whimsical paintings evolve from a brief sketch to get the emotional and physical feel of a road in Maine. Here we have such a sketch done on notebook paper; it is loose, interpretive, unexpected.

2 With bold, loose brushstrokes, Batt begins to paint around shapes, allowing the water to have its idiosyncratic way, color flowing into color, making a variety of blooming, textural shapes in the paint. Notice the variety of greens and blues and differences in value. Some are very subtle, but they are there.

3 With a whimsical slant and an unmatched creative flair, Batt finishes the painting with somewhat recognizable but abstracted landscape images. He juxtaposes saturated complements, and the result is a painting that vibrates with an uncanny but gorgeous shimmer. His famous trompe l'oeil button is in the left bottom quadrant, a witness, as Batt is himself, to his unique expression of a landscape beside the road. The dark gray, almost black of the road provides a necessary resting place for the eye, allowing the other pigments to glow with abandon. The melodic harmonies of complements, Batt's sense of humor and his ability to create intriguing shapes captivate the viewer, all salient characteristics of this artist's genius.

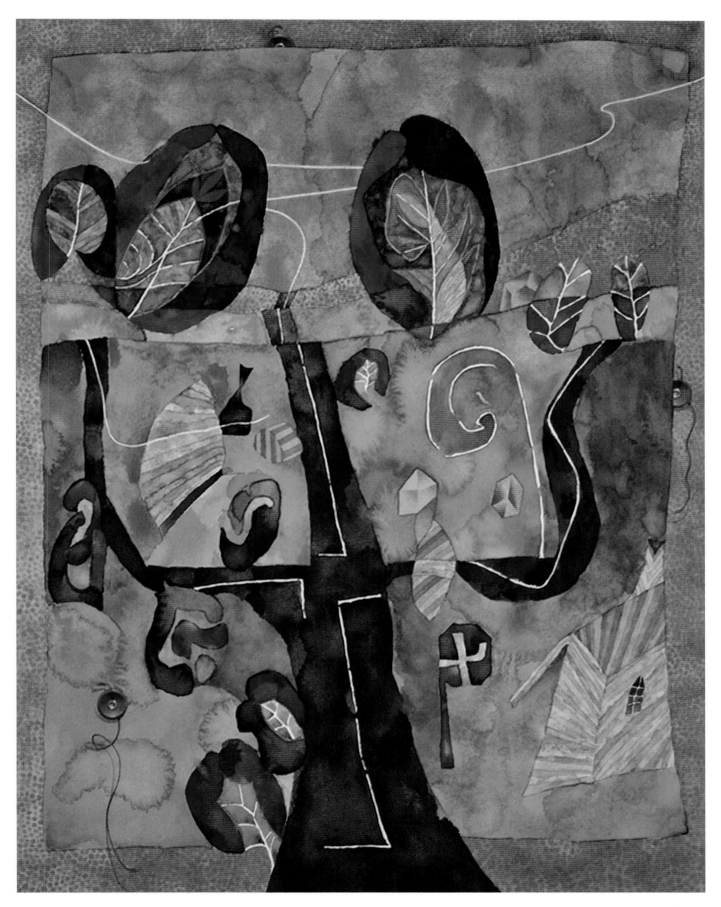

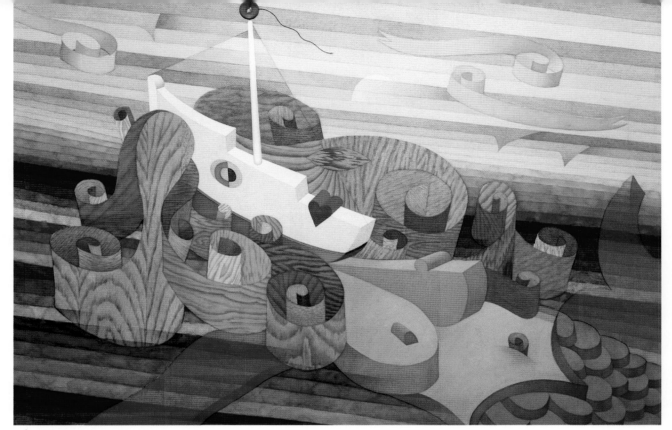

● **SOLILOQUY**
 22" × 30" (56cm × 76cm)

● **HARBOR RAIN**
 22" × 30" (56cm × 76cm)

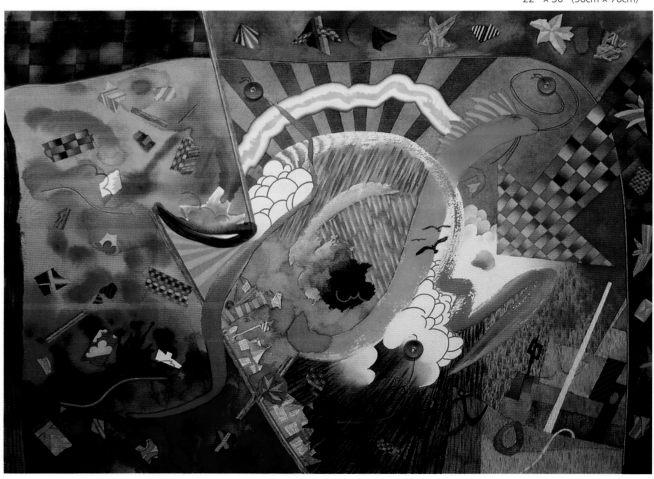

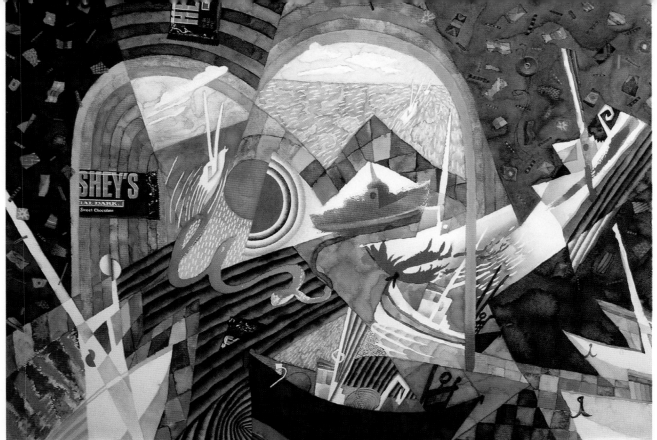

💧 **SWEET HARBOR**
22" × 30" (56cm × 76cm)

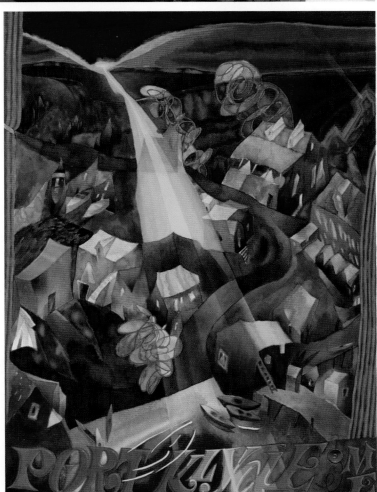

POSTER PORTRAIT ▶
(PORT KLYDE, ME)
30" × 22" (76cm × 56cm)

Judi Betts

Judi Betts, an extraordinary colorist, paints in a palette that separates her from most artists; most of her paintings are high key and composed of unexpected colors and diffusions in unexpected places. There is always a feeling of place in her paintings, as if you could be standing right there. Her surfaces are flawlessly painted and emanate the light and mystery that emerges from using layers of transparencies. Betts has more than earned her place in the hall of fame of great teachers and artists.

"Some of my use of color and design comes from cloisonné," Betts explains. "I started with three-dimensional design, making jewelry, especially doing silversmithing. Then, for seven summers, I spent two weeks with Barse Miller. I also studied with Milford Zornes, Ed Whitney, George Post and Rex Brandt. In California, I saw all the artists I admired doing a painting from start to finish. As they painted, they verbalized and philosophized. I got to see their sketchbooks, and for me, in the early days, sketching was a chore. Now I'm hooked.

"Klee said, 'A line is a continuation of a dot,' and I love line. We all see differently, and I see pieces of color and shapes in the landscapes, although some are partly inventive. I think I see purple and pink, and I put it in air. As artists, we can magnify anything we want to.

"I learned so many important things from my teachers. For example, from Millard Sheets, I learned to change color and value every inch. He'd often say, 'Change it as a mosquito's eyelash.' When I taught my first workshop, I simplified what I learned from Millard and from Barse and from Rex Brandt. Will Barnett says, 'Make the paper work,' and that's what I try to do."

I ask Judi about her approach and how it has changed. She replies, "I paint what I want to paint. I have a driving urge to create. If I want to paint twenty-nine cow paintings, I do, but I do it differently every time."

"I have been teased about doing small paintings," Judi says with a laugh, "but I allude to that as having a sandwich instead of a big meal. Millard Sheets told us to do 6" × 9" paintings, and if you like them that size, work on a bigger sheet.

"My paintings display an arabesque. In my paintings, pieces are tied together like pearls on a necklace. My work looks richly embroidered, and that comes from my interest in interior design. All my paintings are autobiographical. I like high-key paintings of local genre, and this tendency comes from living in the South. I have no desire to do a snow scene. I don't like sweeping views. I zoom in close. 'Don't paint the whole world,' as Barse said.

"To do anything great, you must have an extreme passion for it. My husband, Tom, was so good to me. He would say, 'Go paint. I'll hire somebody to rake the leaves. Stay focused.' We had fifty-three marvelous years together.

"And dogs. I always paint better with a dog around. They bring such joy and energy."

Judi Betts sets such a high example for us all. I was in her workshop the day her father died. She came in after lunch and told us the news. I had to turn away so she wouldn't see the tears in my eyes. Her integrity about teaching, about her art and her attitude toward her students helped me to continue when my own mother died when I was teaching in San Francisco.

Betts' paintings glow with an ethereal light that comes from combining heart and spirit in everything she paints. The mood and ambience in Judi's paintings allow to content and mood marry with lovely painting skills to bring her compositions to life.

FISHERMAN AT REST ▶
30" × 22" (76cm × 56cm)

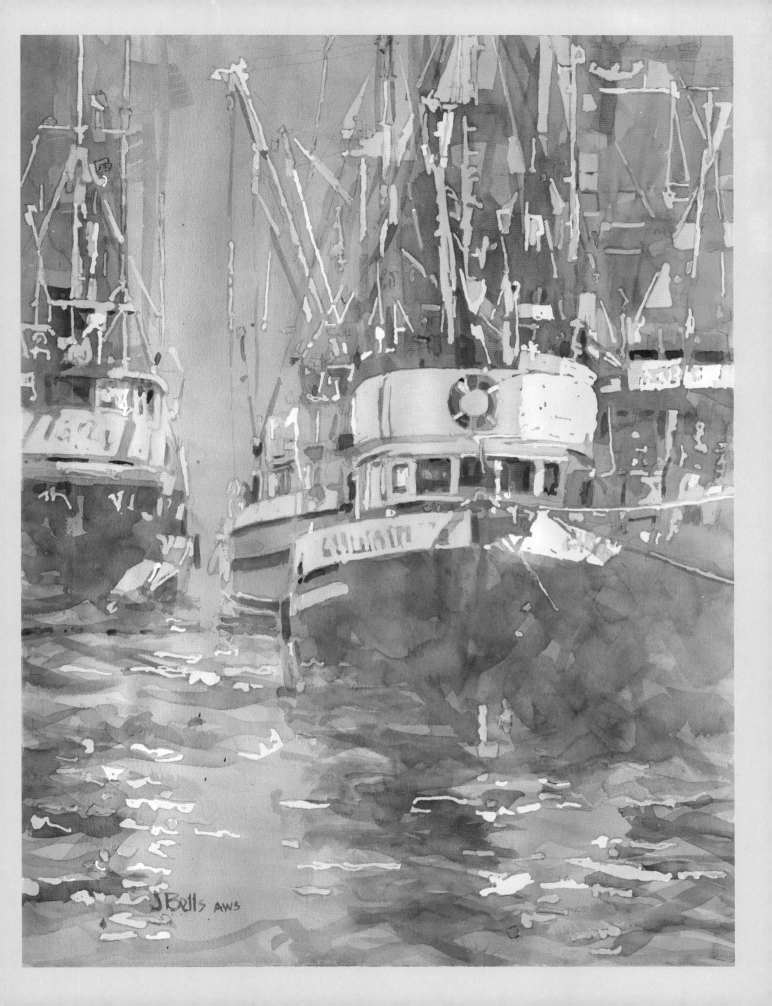

SEA FEVER

Judi Betts' small demonstration paintings reflect her approaches to her larger paintings.

1 It's important for Betts to have gradation in her paintings. She is always very excited if she can accomplish this in the first wash. Note also the deliberate and pleasing diagonal gradation in the upper left of a warm yellow-orange to red in the lower right corner. A rich but light midtone cool color in the upper right corner moves to a cool gray in the lower left corner. In the focal point, the center of the painting, there is a blend of all the colors. This underpainting enhances the overall project.

2 As she plans large paintings, Betts often enjoys varying the format of her idea using both vertical and horizontal designs. In this small composition, the focal point moves more toward the right with drama in the orange and blue colors. The warm purple in the lower left corner provides a surprise element in the underpainting.

3 Betts says she has always been fascinated with building layers of paint. Much of this small composition is still in a midtone, but several light midtone layers have been applied. Once again she changes the composition slightly. At this point she applies a graded transparent colored wash on the corners of the composition. It helps her make decisions about color dominance and areas that may need to be glazed.

4 Betts' early training involved saving white paper in watercolor. As she approaches the final parts of a painting, she often uses pure color, light and bright. This wouldn't work if she hadn't saved a lot of white. She intensifies the orange in the upper left corner to bring attention to the upper third of the painting. For Betts, adding those colors is a decorative element.

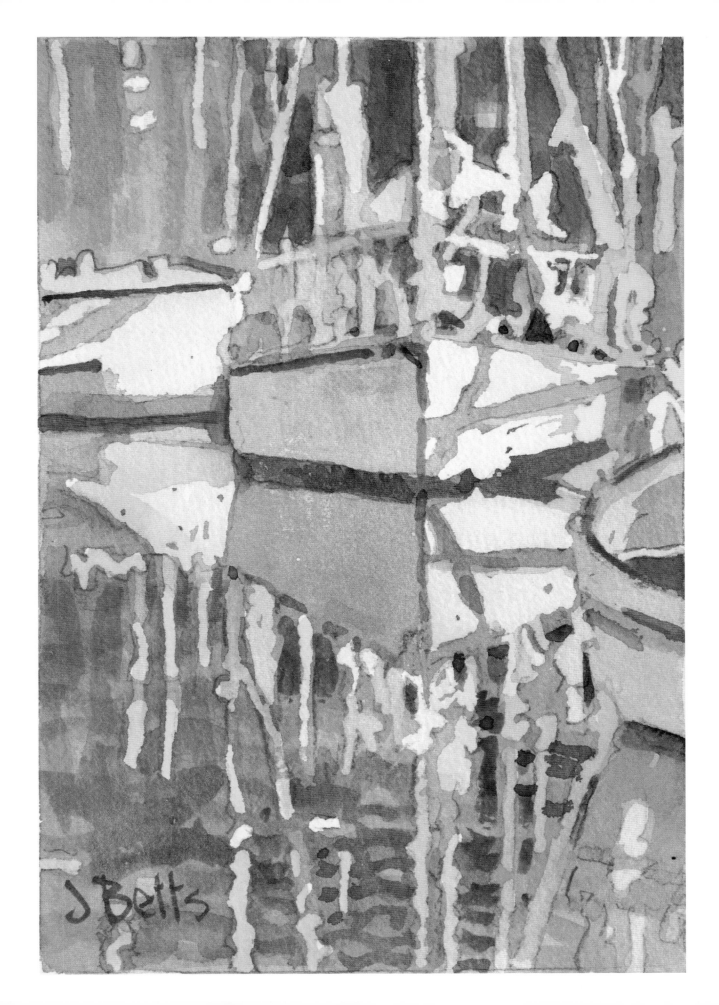

J Betts

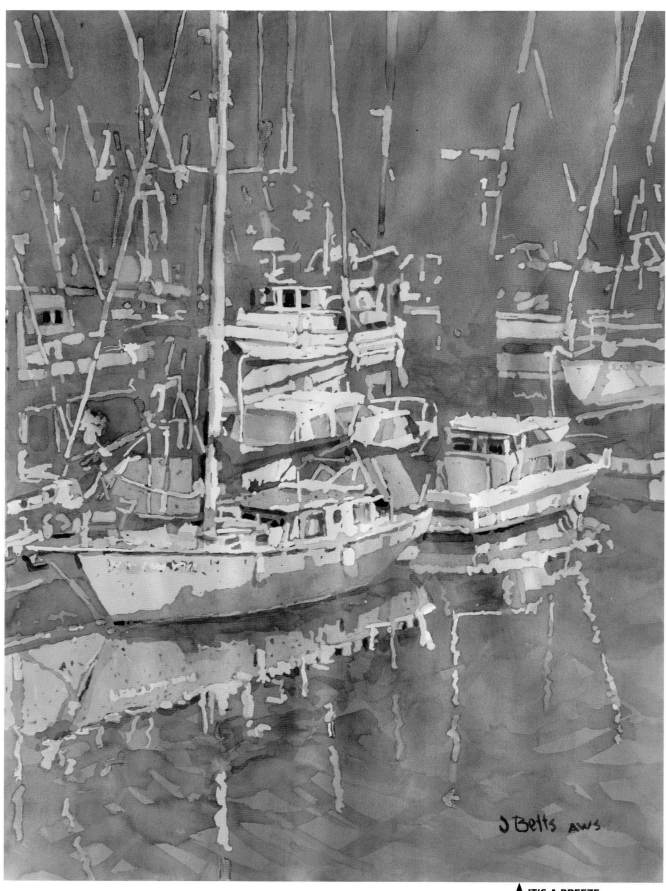

IT'S A BREEZE
30" × 22" (76cm × 56cm)

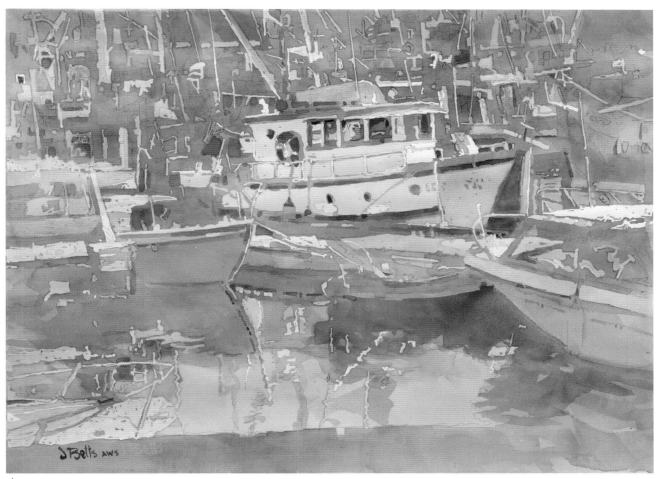

● **HARBOR HARMONY**
 22" × 30" (56cm × 76cm)

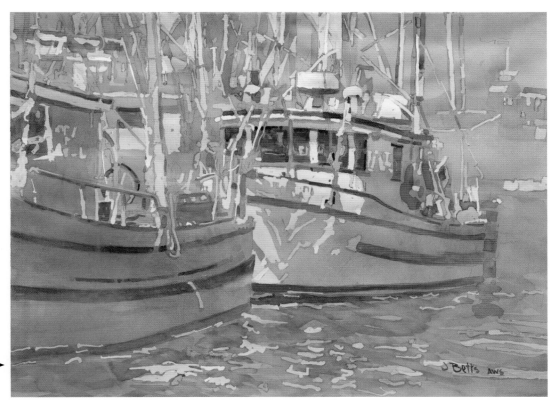

DAY IS DONE ►
 22" × 30"
 (56cm × 76cm)

Dan Burt

Dan Burt's paintings are a chromatic mosaic of broken color, and his brushstrokes are loose, yet paradoxically structured. His paintings are exaltations of the spirit of watercolor, and his use of broken color has earned him hundreds of awards, critical acclaim and the revered respect of all who know him or know of him.

In every painting, the quintessential characteristic of Burt's work is his use of color and light. The flickering sparkle of the melding paint and the overstated contrasts present a scene shimmering with an electric charge. Brushstroke melds with brushstroke, and bold, expressive color contrasts with the white of the paper, left bare for startling optic results.

Dan Burt epitomizes the artist in every respect. Although he wanted to become a farmer, his dream crumbled when he got polio. Drawing saved him, and then he began to dabble in oils at the encouragement of Joy Carrington, who studied with Robert Brackman at the Art Students League. Burt told himself, "Keep going, and you will improve." With tiny baby steps, he went through miles of canvas. After painting for some time with oils, he found himself doing transparent washes, a prescient augur of what was to emerge in his watercolor paintings.

His first watercolor class was with Ed Whitney, and he credits artists William Henry Earle and Ray Froman as being essential to his growth as an artist. Burt also took workshops with Frank Webb, Morris Shubin and Jean Dobie. But he knew that he wanted to make his own mistakes and not become a workshop groupie.

According to Burt, the drawing is paramount, as is saving the white of the paper. He remarks, "When I got in the habit of covering up everything on the surface, I began concentrating on negative space. Then I used Burnt Sienna and Burnt Umber, and they were the first pigments to go.

"I became obsessed with high chroma. I use pure color, and I always work from light to dark, although recently I began to experiment with starting the opposite way." He continues, "I begin with the focal point; I usually add one of the darkest pigments for contrast." Burt describes his process gently but passionately. Basically, he loosely sketches in his subject with pencil. In stage two, he puts in his high chroma colors with opposite light- and medium-colored values, and in stage three, finishes with the darkest darks. He likes to keep it simple. For example, he puts down transparent pigments like Permanent Rose and Aureolin, and then drops in Cobalt Blue and Viridian. Describing this process, Burt says, "I put the warms in and let them dry a bit, and that's when I drop in blue or green. Then I put the painting away, sit and watch what happens."

His subject matter is almost always the landscape. And when you look at his landscapes, they are often filled with people wearing colorful clothes loosely washed in so the whole painting is an amalgam of gorgeous diffusions and seamless passages. The only demarcations are ones where buildings arise or the rigging on fishing boats touches the sky. One given is that he likes his subjects to take up at last three-quarters of the composition.

When I ask him how his painting has changed him, he responds, "I feel I'm not in charge anymore, and I say a prayer every day. Patience is important. When you're eighty-five, you've got to loosen up or it's all over."

As loose as his paintings are, Burt has an organized approach, which begins with using four separate palettes: one for the beginning of his painting, two for the midtones and one for the finishing touches. He keeps his water pure and never dips a brush into dirty water to paint. Like Leonardo, who advised every artist to look for the beauty in mud puddles, Burt's work is rife with loose puddles of paint—but very clean puddles. He extols the gorgeous diffusions of paint dropped into wet paint. "You will never have a mud puddle as long as you keep the surface wet and drop in new colors," he explains.

This consummate artist has some suggestions for fledglings. "Learn the mechanics," he says, "and the principles of design. After you take a workshop, jump in and just do it. Make your own mistakes." His last statement is an eternal truth. "You can't just talk about being an artist. If you want to be a painter, shut up and paint."

Dan Burt and I met thirty-seven-years ago when we judged an exhibition together at the Coppini Art Academy in San Antonio, the beginning of a wonderful lifelong friendship. Although we met first on the telephone, I felt an immediate kinship with this wonderful, gentle man. Without a doubt, the light and color in Dan Burt's paintings are straight from the light and color in his heart: pure, brilliant, saturated and genuine.

LAREDOSCAPE II ◄
22" × 30" (56cm × 76cm)

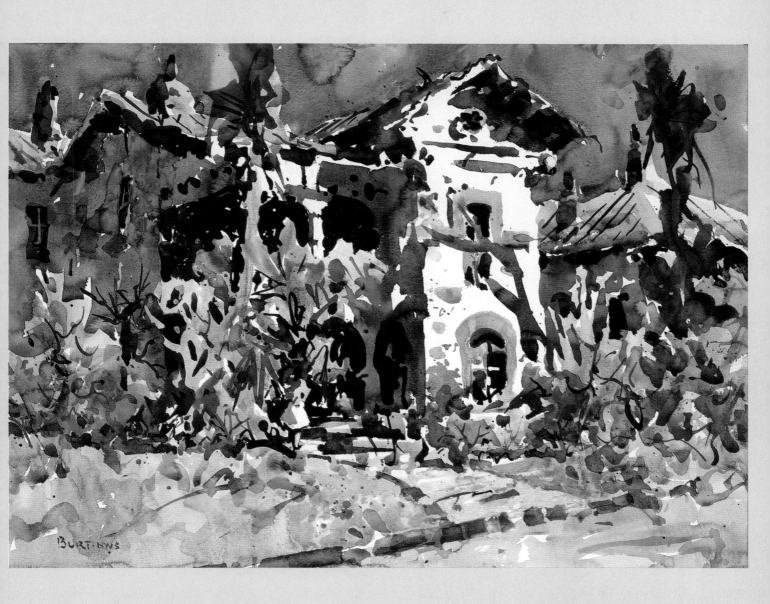

Guanajuato, Mexico

In this demonstration, Dan Burt exemplifies his complex but extraordinary approach to broken color.

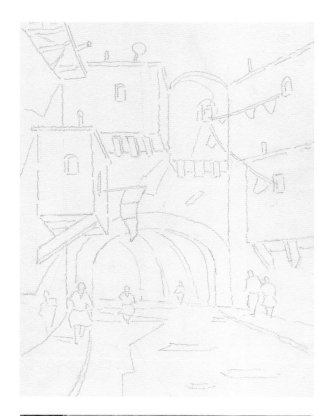

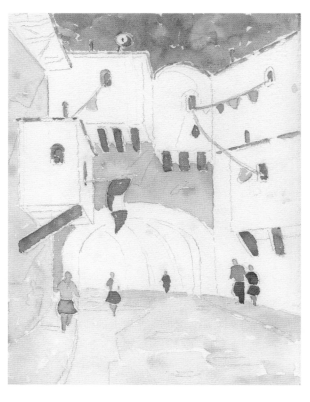

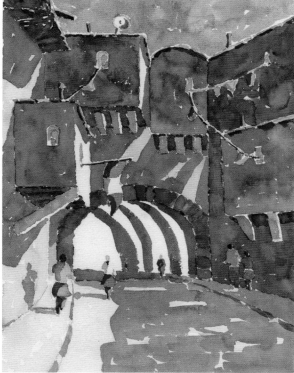

1 The Drawing: Keeping in mind Edgar Whitney's rule of "unequal measures or dominance," Burt draws his subject with a variety of lines: curved, straight and diagonal. The drawing is only a point of departure for the painting.

2 Light- and Medium-value Pure Colors: Using colors from dissolved puddles of Vermillion, Hansa Yellow Light and a light wash of Phthalo Blue, Burt begins to paint the central figure in the tunnel. He uses Permanent Rose and New Gamboge for the figure on the left and Alizarin, Phthalo Green, Permanent Rose and Viridian for the figures on the right. For his memorable skies, he allows New Gamboge, Alizarin, Cobalt Blue and Viridian to mix. His plan is to save some whites for the next stage.

3 Darks: Burt uses combinations of Alizarin, New Gamboge, Phthalo Blue and Green, which he allows to mix, for the eave at the top left, the four rectangular shapes and the wall at right. The cast shadows are Phthalo Blue and Alizarin. The dark sides of the figures are combinations of the above colors with the addition of New Gamboge and Phthalo Blue.

4 Darkest Darks: For the darkest darks, Burt paints wet-into-wet, using Alizarin and Phthalo Green for the windows and for the area under the tunnel and the tunnel itself. The top of the figure in blue and orange is the darkest. With these darks, he establishes the focal point.

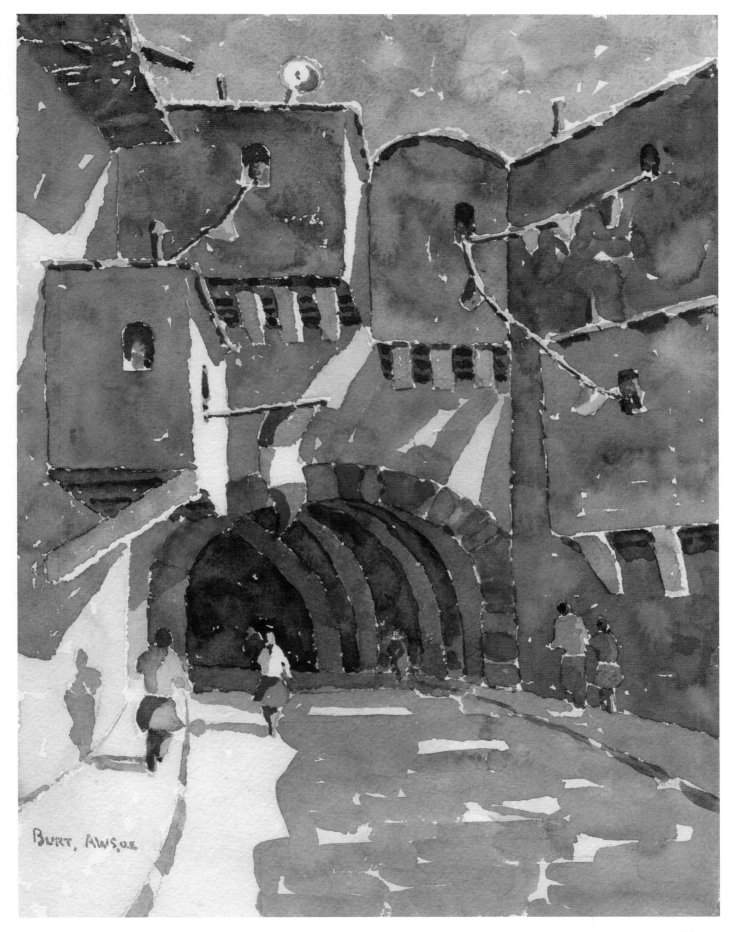

BURT, AWS.UE

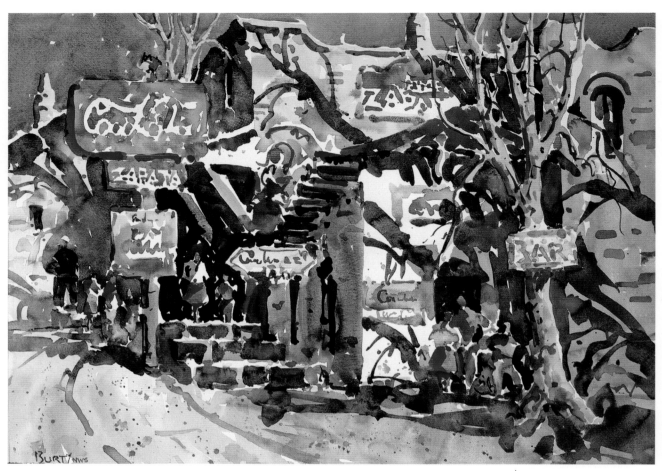

● **LAREDOSCAPE**
22" × 30" (56cm × 76cm)

◄ **FAVORITE THINGS**
25" × 41" (64cm × 104cm)

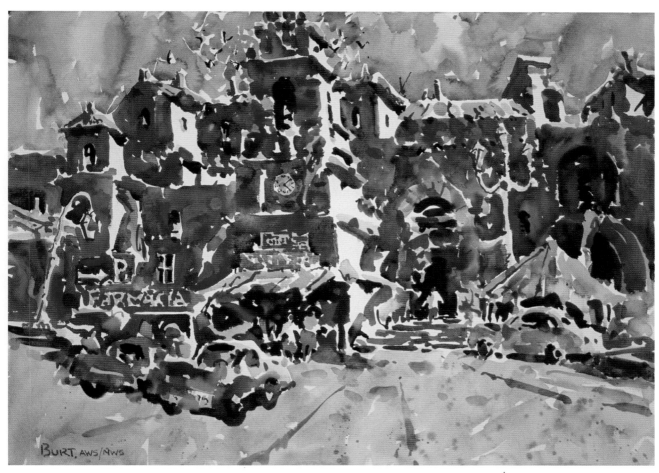

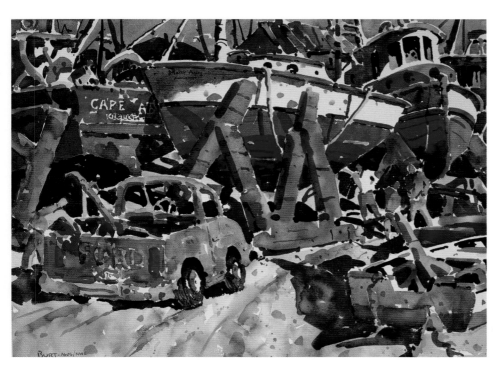

◄ **GLOUCESTER DREAMSCAPE**
22" × 30" (56cm × 76cm)

Cheng-Khee Chee

The revered Chinese artist Qi Baishi (1864–1957) told his students, "If you learn from me and do not paint like me, you live; if you learn from me and paint like me, you die!"

Cheng-Khee Chee is a renowned painter whose influence is ubiquitous. He is eclectic in approach and paints and experiments in many different ways to express himself. The first time I saw him demonstrate, I was spellbound. He walked in with two muffin pans filled with pigment he had watered to a certain intensity. Then he began to wet his paper. I have never seen a piece of watercolor paper so wet. When it was just dripping, he wrote the names of two friends on the surface, and of course, the paint disappeared into the wet surface. Then he began to paint with abandon, big strokes of color, dipping his brush into a spectrum of pigments. The beauty of his surface did not diminish as he continued to add pigment. Each stroke was dazzling and changed the surface. Finally, he began to lift out the shapes of koi with a thirsty brush. They appeared like magic. In the last stage, he glazed colors over them, and in an hour and a half, he created a true masterpiece. His treatise to me is educational, engaging and so eloquent that I have left it as he wrote it:

"When we contemplate the complexity of interconnectedness of human activities, it is impossible for us to sever the ties between the past, present and future. My training in Chinese calligraphy at the early tender age is still with me when I paint.

"When in college, I studied Chinese classics and representative literary works of the dynasties. I carefully examined the philosophies of Confucianism, Taoism and Buddhism. This knowledge helped shape my way of thinking, my outlook on life and world, and my artistic concepts. I also carefully studied the life and work of great Chinese master painters.

"In 1962 I was encouraged to come to the University of Minnesota to pursue a master's degree in library science and then return to work for my alma mater in Singapore. In order to receive some practical training, I was offered a job at the university's Duluth campus after receiving my degree. After two years, instead of returning to Singapore, I stayed on at the University of Minnesota, Duluth, because of the political uncertainty at home at that time.

"Coincidentally this is also a period that was considered the renaissance of American watercolor.

Each year the Tweed Museum of Art on the University of Minnesota, Duluth campus, held the American Watercolor Society's Traveling Exhibition. The fifty paintings in the show were among the best and most representative of contemporary American watercolor. I studied these paintings, greatly expanding my horizon.

"The teacher who had the most direct and profound influence upon me was Edgar Whitney. In the summer of 1978, the Midwest Watercolor Society (now Transparent Watercolor Society of America) had its second exhibition in the Tweed Museum of Art at the University of Minnesota, Duluth. Ed came to Duluth to serve as juror of awards and conduct a one-week painting workshop. In the process of judging the awards, Ed asked me to accompany him at the museum. Together we looked at each of the one hundred pieces in the show. Ed painstakingly and patiently analyzed the merits and weaknesses of each work. I felt I had learned more about design and art appreciation on that day than in the previous ten years. Afterward I attended his workshop to put the design theories into practice.

"I am deeply indebted to the profound statements Ed made during the workshop. He said, 'Substances obeying their own laws do beautiful things,' and 'The wet method is the most forthright subscription to the nature of watercolor. It gives the medium a greater chance to obey its own laws, achieving lovelier effects than you can paint.' These statements helped me connect the creative process to the Tao philosophy and to the innovative painting methods practiced by the early Chinese masters. I was inspired to formulate my own goal in painting: to pursue the essence of Tao, the state of effortless creation beyond craftsmanship and artistry.

"The most effective education is when the classroom or workshop studio becomes a two-way street of teaching and learning. Good teaching should include four important ingredients: It should be entertaining, engaging, educating and empowering. Only when the presentation is interesting and entertaining can you engage and hold the audience's attention. Only when the contents are meaningful and inspiring can you empower the audience to go beyond what they have learned."

KOI 2011 NO. 5 ◗
30" × 22"
(76cm × 56cm)

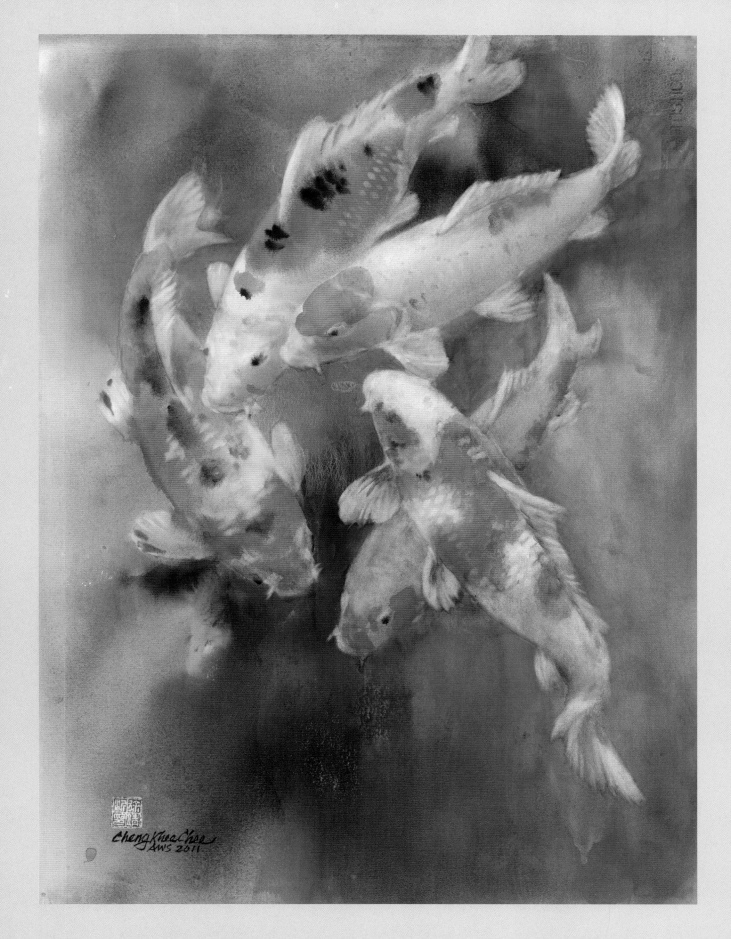

KOI 2013 NO. 3

"Art is the visual realization of an artist's inner being and a portrait of the artist. If your art looks exactly like your teacher's, then where are you?" So says, Cheng-Khee Chee, master, legend and extraordinary teacher.

1 Luscious color covers the wet surface, a kaleidoscope of beauty and richness just waiting for Chee to begin his process.

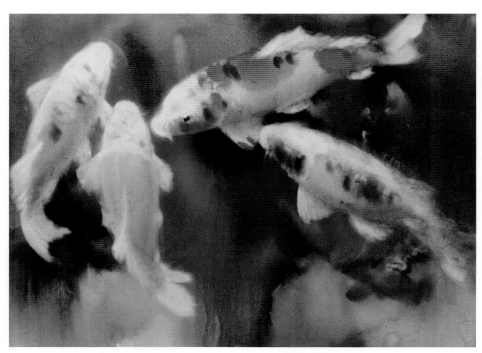

2 Chee begins to lift out shapes. Taking his brush, he squeezes all the water out and with effortless movement begins to make his koi shapes by lifting color out from the profusion of pigments.

3 Chee uses a cut shape of a koi to see if it fits the composition.

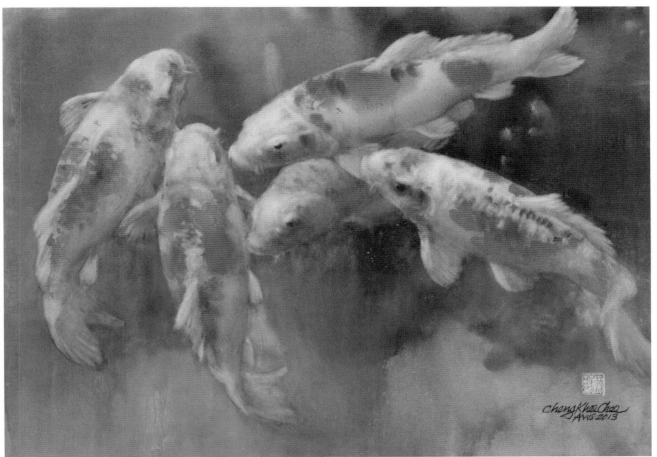

4 The koi come to life in a sea of color. Chee exemplifies one of the most exquisite and exciting ways to use watercolor in his wet-into-wet approach.

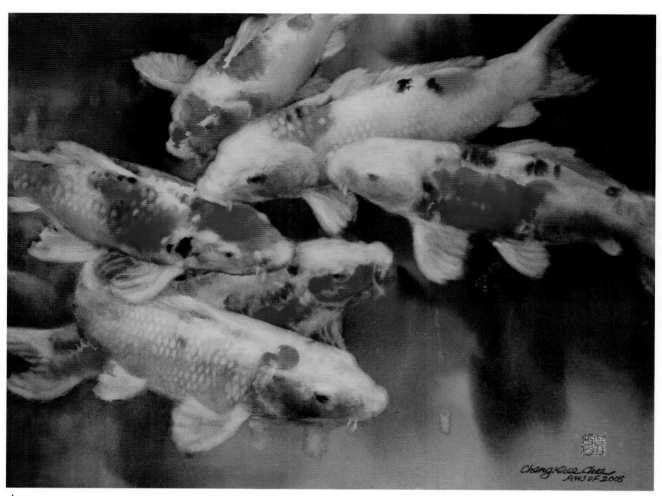

💧 **KOI 2008, NO. 5**
 22 " × 30 " (56cm × 76cm)

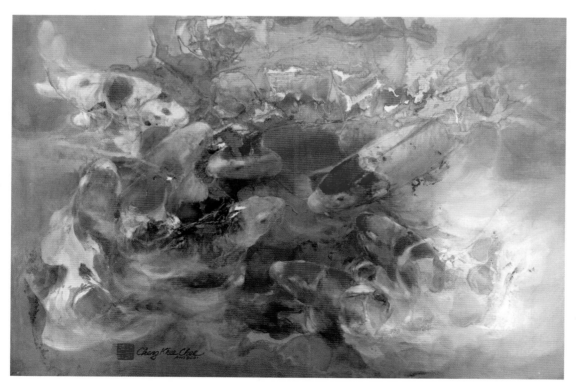

◄ **KOI POND
2001, NO. 1**
27 " × 37 "
(69cm × 94cm)

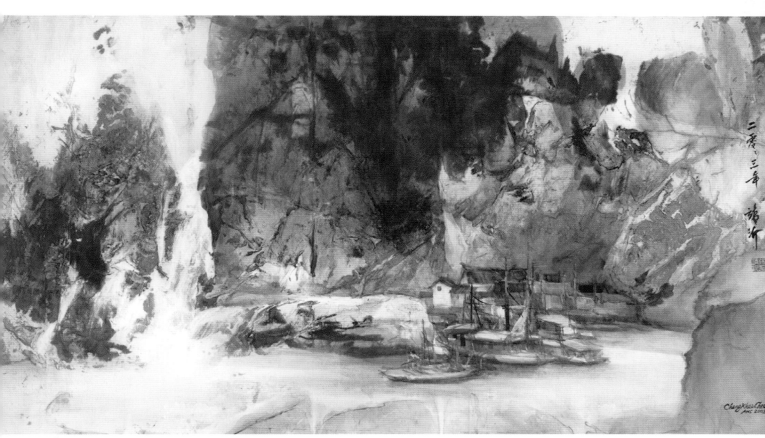

ALONG THE LI RIVER
42" × 72" (107cm × 183cm)

WHITE IRIS
30" × 40" (76cm × 102cm)

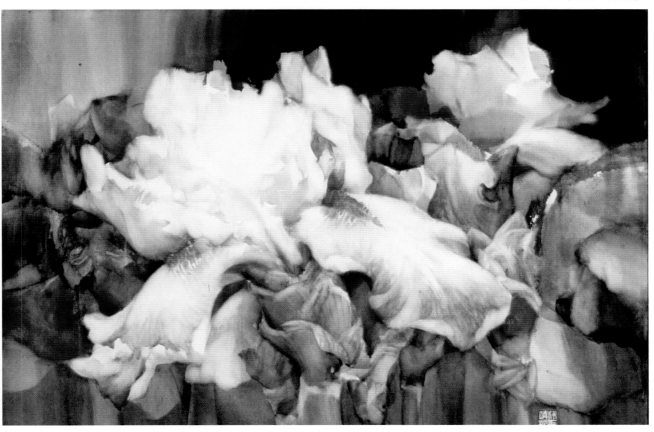

Jean Grastorf

Jean Grastorf is a painter whose process produces magnificent visions of light. Her process is meticulous, yet not without its spontaneity and hazards. Her paintings feature many layers, and yet her palette is limited to reds, blues and yellows.

Using frisket to save her lights, her process is complex and tricky because of the eccentricities that product can produce. Her subject matter is vast, from the sunlit, dazzling flora of Florida to city scenes and portraits of interesting people. Her favorite Christmas present was an easel, and with it came some chalk. She tells me she "was in heaven," explaining that she discovered art would be a blessing for her. "I believe it was innate," she says.

Talking about her art background, she says, "I studied at the Rochester Institute of Technology, where a lot of European artists taught after the war. Their photography school was founded by Kodak. Because we had such a diverse faculty, there was a gamut of inspiration.

"I was one of sixteen people in the class of art and design, which was wonderful for teaching us great compositional skills, design and color, but also myriad ways to use the brush.

"We learned 'the sketchbook habit' from someone else. Sketching activated another part of my brain. We sketched with different pencils. Other mediums we used were charcoal and oil. We also used acrylic, but they didn't have the buttery feel of oils. From department to department we went, even learning printing, so I got a wonderful education there.

"Although I worked in watercolor for years, I was not happy with it until I took a class with Maxine Masterfield. In that class we used frisket as a shape finder, and I learned I could save large areas, which to me was like killing a gnat with a large sledge hammer. I could finally see the carrot!

"As I developed my technique of pouring, I found that light comes through the paper. I begin with a drawing, and then I switch to what I call my chaos-and-control stage, during which I save whites with frisket. Starting with a pour of first yellow, then red, then blue, I work in value ranges from light to dark. Between the layers I take off frisket and pour again until I have the painting that I want. I love the freedom of pouring and the pleasure of painting. Painting this way is like working a crossword puzzle.

"Painting is in your DNA. I don't know where I would be without it. It has made me more confident, more aware of my surroundings and what I want to say. It has made me a kinder person."

Here, Grastorf gives the fledgling artist her advice: "The more you put into the study of art, the more you will get out of painting. It is one of the few things we can become better at as we age. Why? Because we know what is important to us. We learn how to leave behind and leave out those things that hold us down and take away our time and energy.

"We need to concentrate on what we want to say and the best, simplest way to say it. By learning our craft through reading, videos, workshops and most importantly, painting, we learn the bare bones. This is the skeleton. From there we build, increasing the vocabulary of artmaking. We may not be able to paint every day, but we can do something each day that is art involved.

"Learn to appreciate your personal journey as you paint. Art should not be about comparing your progress against another. We all develop at different paces. What matters is the journey. Thinking and planning before we paint can be time-consuming. But, if we do that, we are prepared to let colors flow and brushes fly. No one else can paint like us—we are unique. When we paint ourselves into corners, we create problems. Then, through the decisions we make, problems are resolved. Art is problemsolving, and unlike math, there are many correct answers.

"Learn to love your work. Appreciate it for what it is. It may not be what you planned. Sometimes objects take on unusual shapes and colors. Tell yourself that they are beautiful, something no one else could do. There will be times when we cannot seem to find success. The answer is to take a deep breath, relax, clean your art space and do some small color studies. Do not be intimidated by the white paper. Toss a bit of red and black spatter and you are painting."

SUN-KISSED ▶
20" × 28"
(51cm × 71cm)

SPIKE

After she completes the drawing, Grastorf uses frisket to save lights. Her first pour is always yellow, then red and last blue. Notice that Grastorf has composed her entire painting with a good drawing and the environs around it.

1 Step 1 shows the drawing and the first masking (using Incredible White Masking Fluid) to protect the whites from the first pour. Before pouring, the paper is wet down with a soft brush. The three colors (American Journey transparent watercolors) are poured while the paper is wet. Each pigment is mixed in its own cup, and all colors are allowed to mingle on the paper. After the colors have blended, the paints are poured off. This step shows a strong yellow. This is Joe's Yellow. Joe's Red is mixed weaker, as is Joe's Cobalt Blue. A bit of Quinacridone Burnt Sienna was also poured.

2 In step 2, more masking is added to protect the lighter areas. Mask is also left on the original whites. Colors are mixed stronger and are poured on the paper, which has been wet down once more. The same pigments are used; all are stronger except for the yellow.

3 During step 3, masking is added again to save the next lightest color. The same pigments, except the yellow, are again mixed, this time a bit darker. For a darker blue, Ultramarine is added, along with Rambling Rose. The paper is once again wet before pouring.

4 Step 4 offers another chance to mask and preserve shapes. A stamp is used with mask to add a bit of texture to the background. Note the warmer tones; Quinacridone Burnt Scarlet and Indigo are the final pours. Some brushwork may be used after all mask is removed.

NOTES FOR SUCCESS

It is important to give the paint time to dry between steps and especially before masking. Masking fluid should be white, not lumpy, and as fluid as milk. Patience is needed.

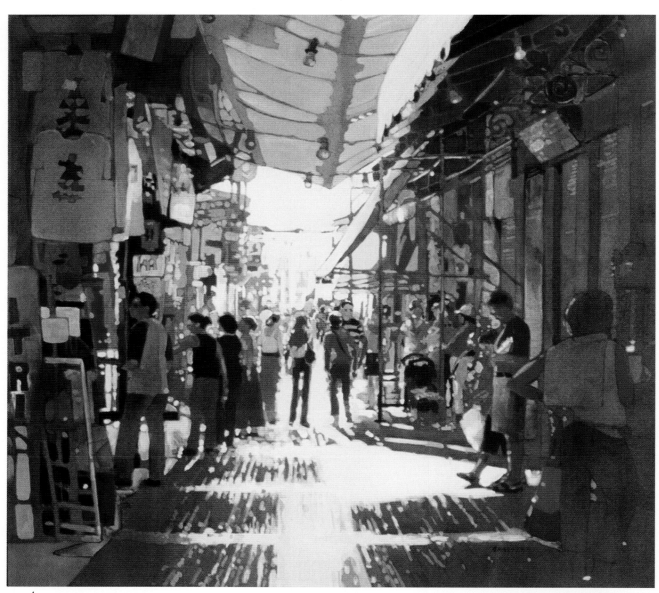

PLAKA 2
20" × 22" (51cm × 56cm)

GRECIAN LOOM ◄
22" × 25"
(56cm × 64cm)

● **A PLACE TO REST**
20" × 28"
(51cm × 71cm)

◄ **CHICHEN ITZA**
28" × 22" (71cm × 56cm)

Ken Holder

Well-known for his iconic landscape paintings that often combine both representational and abstract qualities, Ken Holder searches for the real, which Robert E. Wood called "the reality of the painting itself." His effort is to make a painting, and that painting might be illusionistic or representational or both. What motivates him is not technique or craft. It is the process of painting that he strives to understand, and the experience of that process teaches him more about himself and what he is trying to express. He believes that repetition is one of the keys to understanding your work. By that, he doesn't mean painting the same painting twice, but rather exploring that subject in different ways: chromatically and spatially. Experimenting is the key: to go as far as he can go with a concept—milking one idea.

At times, he works on irregularly shaped canvases. Often with his canvases he combines a paper border that he molds with his hands, and often that border is painted with watercolor. Visually striking and dramatically conceived, the border intrudes into the viewer's space, pulling the viewer into the painting. Collage then becomes a device to connect with the viewer literally and figuratively.

At the age of four, Holder received a Gene Autry paper doll set, and that is when the wheels of art began turning in his brain. He played with that set until the dolls were ragged, but his dad traced the images on cardboard for him many times. Seeing those forms and manipulating them led him to create herds of horses, and the horse is still a metaphor for him today. By the time he entered school, he could draw a horse perfectly.

He engages in a conversation with whatever is in front of him. His materials may be unconventional or conventional. Sometimes he uses the unconventional tools in a conventional way and vice versa. "Your materials," he says, "your vocabulary and your syntax have to jive collectively to make sense. Ideas come through developing what is at hand."

Holder has a strong penchant for creating illusion in his work. For example, after stretching canvases, he'll place two or three different stretched pieces at different levels. He has, for most of his career, wanted to create an aggressive space, as he does with the paper borders of watercolor, making them three-dimensional.

"Early in my schooling, I felt a commitment to making art, although I had no idea what that meant in a career-sense. When I was preschool age, my family had moved to Amarillo, which had an excellent art program in its school system. It had been developed by Georgia O'Keefe in the early 1920s when she was hired to be the first art teacher and supervisor there. Aside from that, I had very little exposure to any significant art. Upon graduating from the public schools, I attended Texas Christian University, and received a BFA in 1959, whereupon I went directly into the United States Army. I was stationed in Europe for three years, during which my art education expanded greatly with my first real access to world-class museums and art. The leadership training that I received also encouraged my self-confidence and helped clarify my career ambitions. I returned to civilian life and immediately pursued an MFA at the School of the Art Institute of Chicago, and ultimately, my teaching and painting career."

In the 1990s, Holder undertook a six-year project for which he traveled the Louis and Clark Trail, creating more than five-hundred paintings to honor the bicentennial of the adventure. Those works were exhibited widely, including at the Illinois State Museum in Springfield.

More recently, Holder has been engaged in making paintings, watercolors, collages and constructions, and books that employ the horse metaphor more explicitly.

He compares creating art to a stream starting down the mountain until it hits another stream or a rivulet and becomes something else. Perhaps it turns into a river, and all these waters absorb each other. Then the waters go through swift, flowing streams and get dammed up. Channels then feed off of it, ever changing, ever moving, until finally reaching the ocean. He reminds us that when painting, you are not the same person that you were yesterday.

"As I change, my art changes," he says. "Life changes, and your view of life changes, as do your values. My painting has to be a continuation of where I am today. Painting is metaphysical, and you must question yourself about your art." Quoting Leonardo da Vinci, Holder says he believes that art is on the plane with philosophy. With a chuckle he says, "But philosophers have all that stuff in their *minds*. Painters and artists have the physical means to express their philosophies and questions through their materials. There is not a conceptual answer. Answer that question through your painting. You have the power and a means to address those thoughts."

CLOUDS OVER MOUNTAINS #24 ►
22" × 30" (56cm × 76cm)

GRAVEYARD

Holder's unique style involves collaging painted pieces together to create a one-of-a-kind representational landscape.

1 Holder liquefies his paint before he begins. His board is blank, just waiting for him to begin. He begins with washes of yellow and blue, leaving an intriguing unpainted shape on the bottom right.

2 Combining total abstraction with representational landscape, Holder's inventiveness involves cutting out shapes. He will innovatively construct his painted collage to enhance and introduce abstraction into his main representational piece.

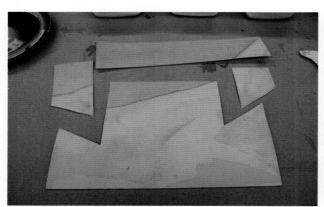

3 Holder cuts geometric shapes from his original piece.

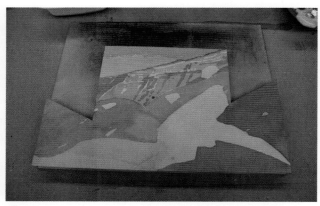

4 Representational landscape images emerge and are combined with other pieces of cut board.

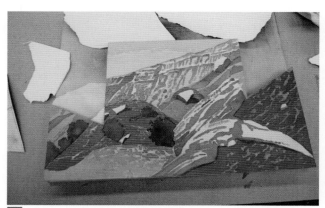

5 Holder adds representational elements to the painting, suggesting rocks and sharp crags.

6 He begins to add the collage shapes around the painting.

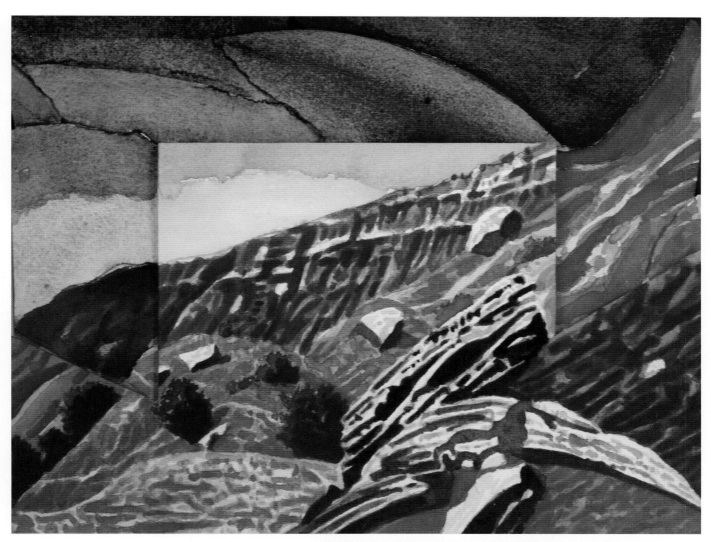

7 The collaged pieces surround the landscape, imbuing it with a surreal look, and as you can see from the side, the landscape juts out in bas-relief. Holder's process joins both the abstract and the realistic in a fascinating marriage of ambiguity and fact.

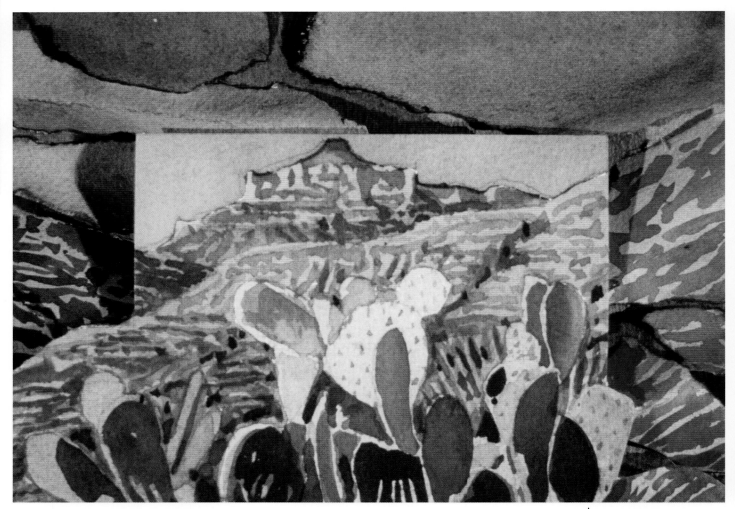

CASTLE ROCK #2
5" × 6"
(13cm × 18cm)

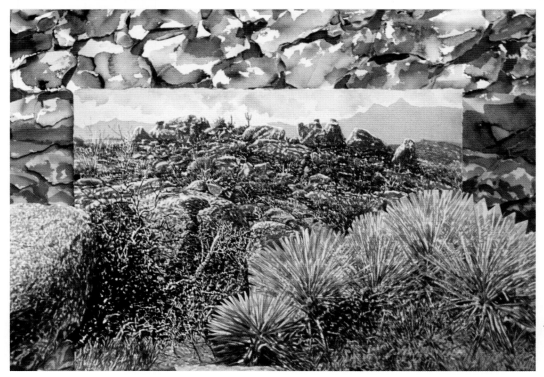

◖ **CLOUDS OVER
DESERT #33**
30" × 42"
(76cm × 107cm)

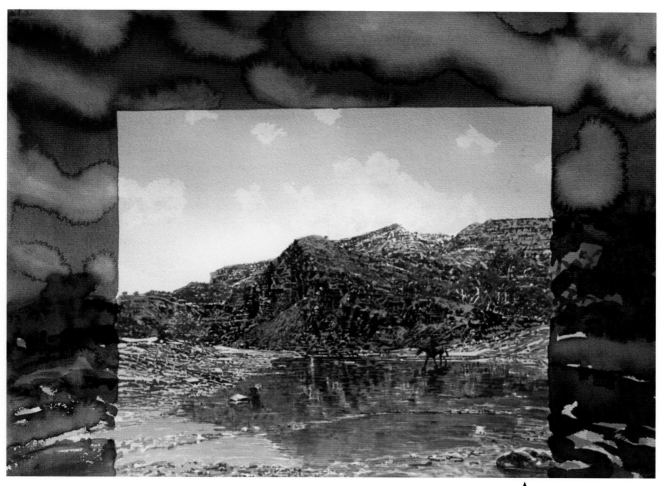

◗ **PALO DURO
CREEK**
22" × 30"
(56cm × 76cm)

◀ **LIGHTHOUSE #5**
5" × 7"
(13cm × 18cm)

William Cather Hook

William Hook has the uncanny ability to put the correct value down with one brushstroke. When you watch these magical brushstrokes, it is easy to believe that his talent and sensitivities are innate, for he inherited his visual wizardry from a well-honed artistic family. His grandmother was an architect, and his father, a photographer. In fact, he was in his first art show at the age of ten or eleven and received an honorable mention for an acrylic painting on glass.

While living in Kansas City and before going to college, Hook took art classes at the Kansas City Art Institute. After attending classes there, Hook left his hometown to continue his study of fine art at the University of New Mexico, where he received a BFA. Hook went on to complete his formal education at the Universita Per Straniere (Perugia, Italy) and the Art Center College of Design (Los Angeles, California). He went into advertising as an illustrator with a focus on advertising design. For sixteen years, he did work in Los Angeles and Denver. The New Mexico scenery made an indelible impression on him, so much so that he returned to make it his second home and frequent subject. Now an acclaimed landscape painter, he pays homage to the exquisite color and majesty of the West.

"After my book came out, I realized how much my work has changed," Hook muses. "And now, I feel it is changing again, becoming looser, more spontaneous. It is that change that has helped me understand other artists more.

"New Mexico is a natural place for me," he remarks. "Although I also like painting in Arizona, California, Colorado and Carmel, where I also have a studio. My wife, Kate, and I split our time between Carmel and my studio in Santa Fe.

With broad brushstrokes and bright, bold colors, Hook creates the swiftly changing sunlit skies and the reflected light of the towering mountains with their crags and crevasses, always paying attention to the reflected light and shadows of those mountains. With close values, he expresses eventide, a contrast to the brightness of day with subtle neutrals and mysterious darks. Once, as I watched him paint that magic moment right after sunset, I honestly thought the canvas was finished, but then Hook added an extra subtle value to a place on the canvas and in doing so gave his work an incredible sense of the moment distilled in quiescence and cloaked with the mysteries of the encroaching darkness.

Discussing color, he remarks, "Color is like harmony in music. With the correct color and value, hues vibrate. A halo around things (halation) combined with secondary, tertiary and quadranary areas bring so much to the work. That's why I like Whistler's work, especially the way he used raw canvas and left something untouched."

Referring to his approach to achieving halation, he says, "If you look at a photograph of pine trees, for example, behind the needles on the tree, there is a brilliant light, which I first block in with a different color, which will emphasize the rim light." Compositionally, Hook prefers low horizons, and as he passionately explains, "All those grasses in the evening light—the pinks, lavenders and a glint of turquoise—all those touches of pigment bring back the memory of place and time." It is those unexpected colors and nuances that also add such expressiveness to his paintings.

In Hook's paintings, there are no transparencies, but there are layers. His canvases shimmer with low light and incandescence when he paints a darker scene. I watch as he paints a glaze of Phthalo Green over a white house. A few minutes later, after it dries, he adds a veil of white mixed with a minutiae of Ultramarine Blue. The house glows with a lambent light emphasized by the juxtaposition of the surrounding tertiary landscape.

"Formulas are death knells," he asserts. "They keep an artist from learning lessons on his or her own." His advice: Don't get attached to your artwork. As a painter of the Western landscape, Hook continues to portray its vividness, its wildness and its inherent grace. That is his legacy.

Down Stream ➤
30" × 30"
(76cm × 76cm)

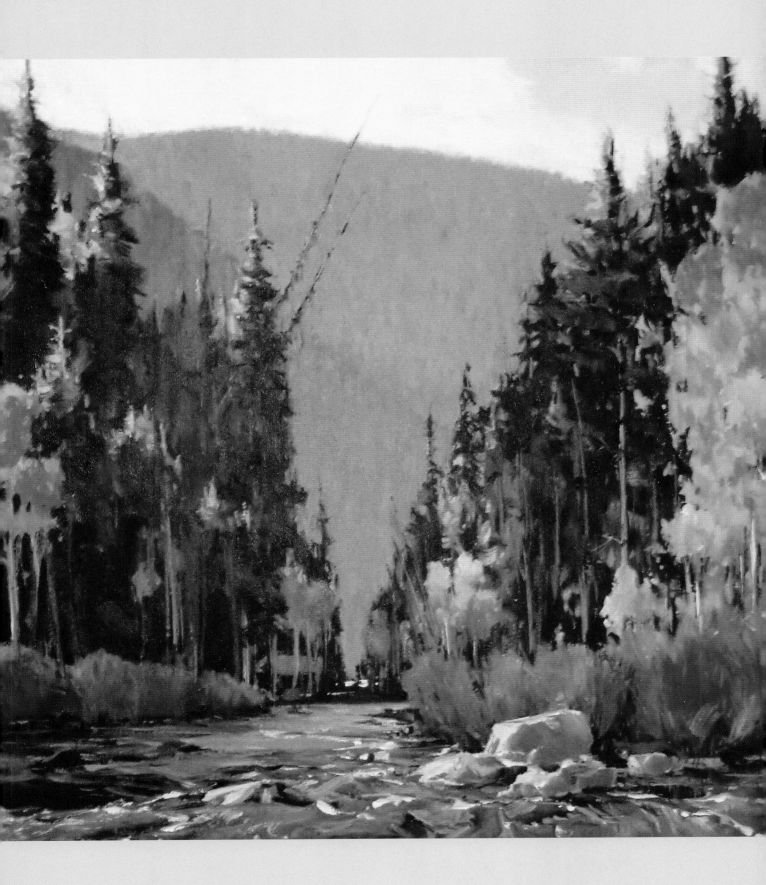

FROM THE FOREST

Hook's process is didactic. Beginning with a Stabilo pencil, he establishes the structure of his painting with a sketch. He always paints alla prima, and his first focus and main concentration are shapes.

His palette includes several yellows: Cadmium Yellow, Light and Medium. Other pigments are: Medium Magenta, Ultramarine Blue, Cadmium Red Light, Alizarin Crimson, Hooker's Green and Burnt Sienna. Sometimes he uses Dioxazine Purple. His alla prima approach expresses the beauty of his brushwork and the mastery of that brush, the light and the color. He encourages students to go for it with deft brushstrokes. He says with a laugh, "Bad experiences give us perspective."

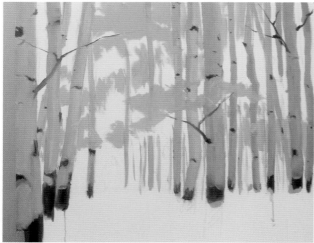

1 Starting with a Stabilo pencil, Hook lightly sketches the basic shapes of his landscape. His palette is simple, laid out from left to right with Hooker's Green, Ivory Black, Burnt Sienna and Ultramarine Blue. With flat brush-strokes, he indicates the trunks and bright yellow foliage of the aspen trees. His white is Titanium White, which he mixes with various pigments to get the beige-like color of the tree trunks.

2 Hook begins to paint negative shapes in a dark green mixture, bringing out the shape and augmenting the color of the foliage. He adds a soft neutral beige trunk shape on the left, a deft way to stop the viewer from leaving the picture plane. Next he adds foliage and flat shapes, which indicate shade on the foliage.

3 Working in layers, Hook paints more foliage, adding more depth of color in places as appropriate. A lone figure in red becomes the focal point of the painting, an intriguing foil against the copse of aspen trees.

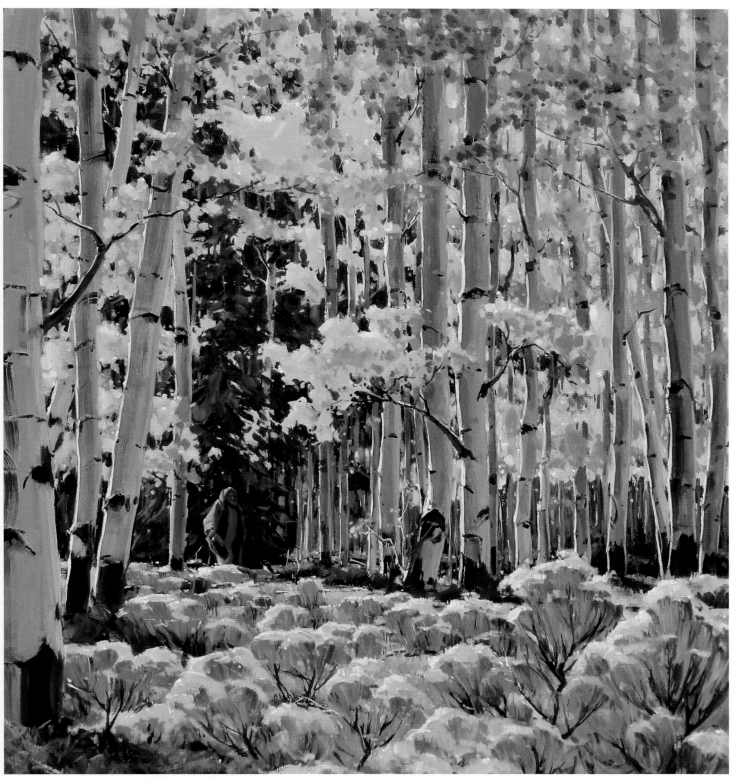

4 Notice the abstract quality of the brush-laden foreground, which employs interesting horizontal brushstrokes that contrast with the verticality of the aspen trees.

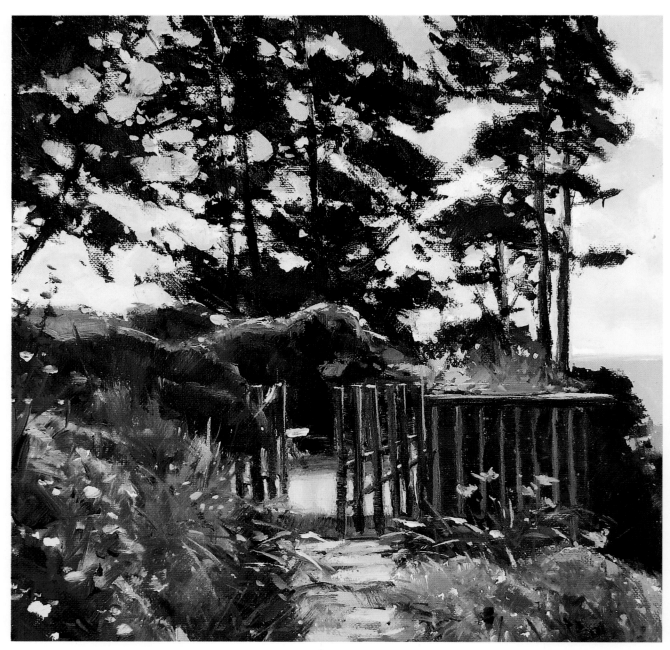

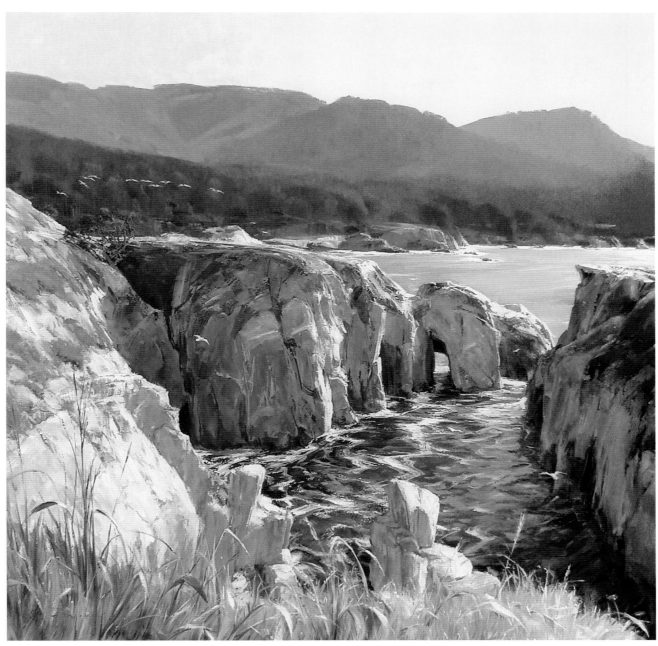

HIDDEN COVE
48" × 48"
(122cm × 122cm)

Kathleen Jardine

Born into a family of extraordinary dysfunction, alcoholism and sexual and emotional abuse, Kathleen Jardine was abused and neglected. But this fascinating artist turned her Dickensian childhood into a visual garden replete with images and color. "My own inner world was rich as a child," she explains, "because I felt that maybe I could become another person." She held this thought sacrosanct, and to this day she keeps a journal that arose from a "Great Thoughts" notebook she created as a child. Upon reflection, she says, "If everything had gone right, maybe I wouldn't have done what I am doing today. I live in an idyllic world."

Jardine describes her images as those of a person in love with the models she paints, in love with the depiction of a scene filled with light, and in love with those objects that personify her emotional attachments to the model and to the interior.

In arriving at her composition, Jardine describes it theatrically as a mise en scène in which all objects, including the models, are specifically placed for drama and visual effect.

Employed by an ABC affiliate in Charlotte, North Carolina, Jardine made the money she needed to strike out on her own. She learned much from her experiences drawing and painting in courtrooms. Sometimes her job took her to prisons. Often she would turn out four watercolors a day, and she would have to produce paintings from interviews with people about what they saw. Soon she was winning prizes and awards and selling her work, which gave her the impetus to become a full-time artist.

"My paintings are big, as is my idyllic life," she remarks. "If I explain the content of a painting, it ruins it. The speakable is not the Tao. What you think it means is what it means. The children I paint are like me when I was a child. They reflect a period of innocence similar to Victorian thought. Sometimes people try to sexualize my work, and it couldn't be further from the truth.

"In my process, I always work from life, which in ways is a statement about our culture, as we tend to see things through a lens. I make no preparatory sketch with watercolor. It all is a dreamscape. The dream world comes to me, and I will find the perfect model to fit that dream world. Often I set up a still life as part of my mise en scéne. My gardening plays a significant role in my paintings because I will pick lush things from it for the painting. My gardens are like four rooms, which like a house allows you to travel through those rooms."

Years ago, the art historian Charlotte Rubenstein said that women are natural pattern painters. Jardine exemplifies this idea in all of her paintings. One thing that Jardine does is to make a key as to what value belongs in a painting and where. She gives that key a number.

"I was twenty-two when I first went to a museum," she says, "so as an artist, I am museum taught. I studied the paintings of the Renaissance and adopted those concepts of composition that couple people and objects together. Vermeer remains my inspiration because he portrayed a world that was so beautiful, it didn't matter what happened. He enhanced and affected my ability to look at the world as a beautiful place.

"I reject the use of screens of filtered reality. Artists before us worked from unfiltered reality forever. That's why I work with live models. For years I didn't even know how to use a camera.

"In my paintings, every decoration or interior you see is an actual object or part of a room that my husband, Jim, and I built. We build and design solar houses, and it is from my surroundings that I choose my props.

"I am a happy person with a dark side," Jardine explains. But she is a person with strong beliefs, for she tells me, "You have to believe that you deserve the good things that happen to you in the world. You have to persevere through it all, even illness. At this point, I am where I am because painting brought me here, and it will take me where I am going. I just want to paint for the joy in this world. As for the mystery that surrounds us, I don't have to know the answers."

BEATING WINGS OF A LOST GARDEN ▶
51" × 48" (130cm × 122cm)

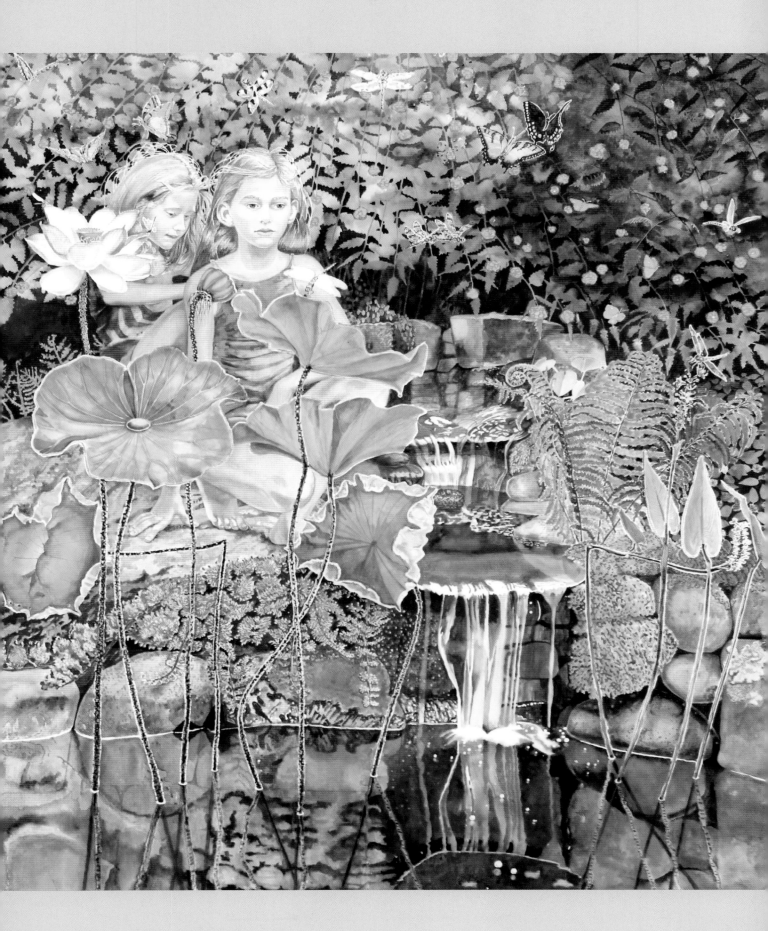

ROCK MADE OF WATER

In the painting *Rock Made of Water*, Jardine began with a haunting visual memory of her little neighbor, Samana, who was lying on the big rock next to her pond with her cat, Meemeeso. (That rock, Jardine says, is called "the children's reading room.")

1 Jardine does not make a preparatory drawing. Using just her brush, she begins to paint leaves and the cat, which she draws from her imagination, deliberately making a visual joke by balancing it on a lotus leaf. For this painting, Jardine did use a camera because the child model could not hold the position for more than ten minutes.

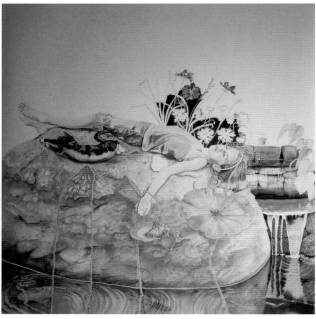

2 At this point, Jardine concentrates on value. If you squint, you'll notice that her figurative image and the rock are the same value. But what a range of colors in that same value! Some darks are begun at the top of the rock the figure is lying on.

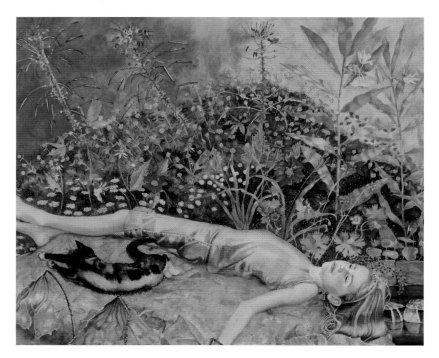

3 A master colorist, Jardine moves around the surface with mixtures of blues and greens, painting flowers that glow against the blue foil of the background.

"With oils I use a very limited palette. In watercolor I paint with about 35 tube pigments because two close watercolor hues can lie so differently on the paper. Unlike many watercolorists, I love sedimentary grainy pigments. Stains are wonderful, and I paint with a full complement of them, but a stained glass effect isn't what I'm personally after. "

— KATHLEEN JARDINE

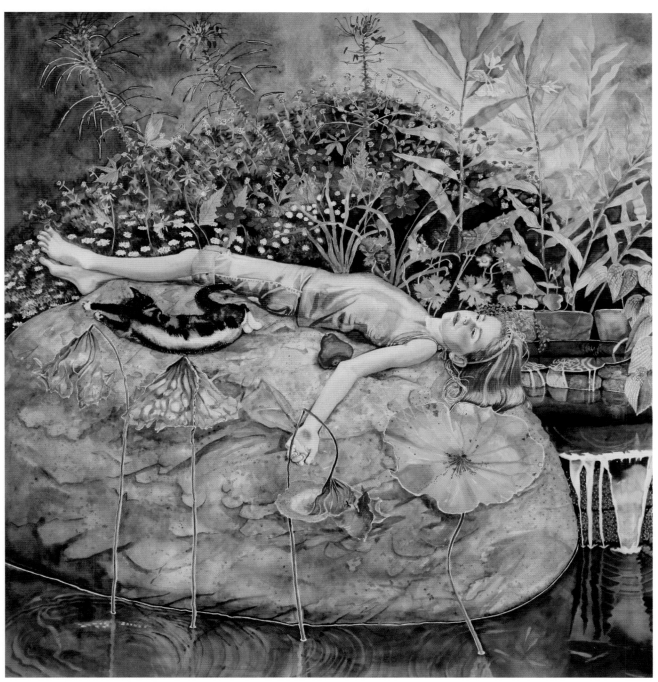

4 Glaze after glaze after glaze are trademarks of this amazing artist as she deepens the richness of color and value with transparencies. She admits to using about thirty-five tube pigments, and she also admits that she loves sedimentary pigments. It is with great skill that she presents us with such an imaginative scene— representational, yet enigmatic, and lush in color harmony and design.

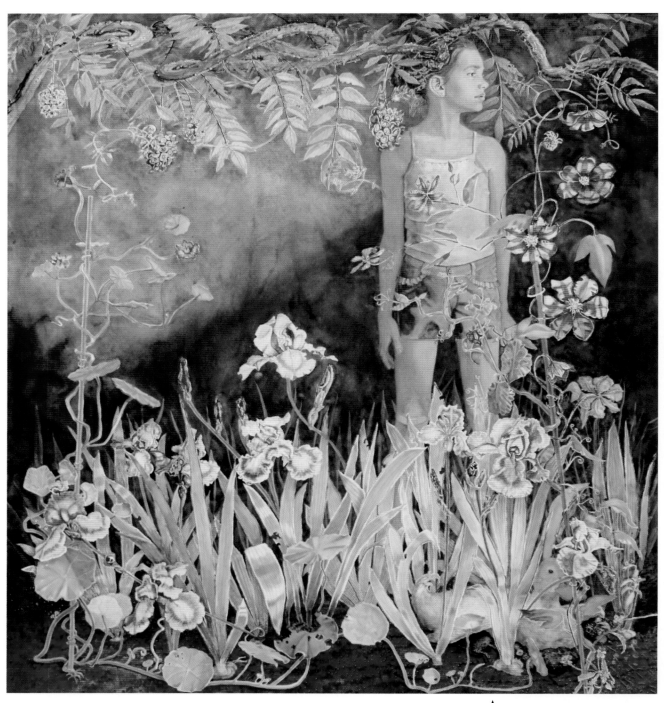

💧 **LOST GARDEN WITH THE DRAKE AND HIS GET**
51" × 48" (130cm × 122cm)

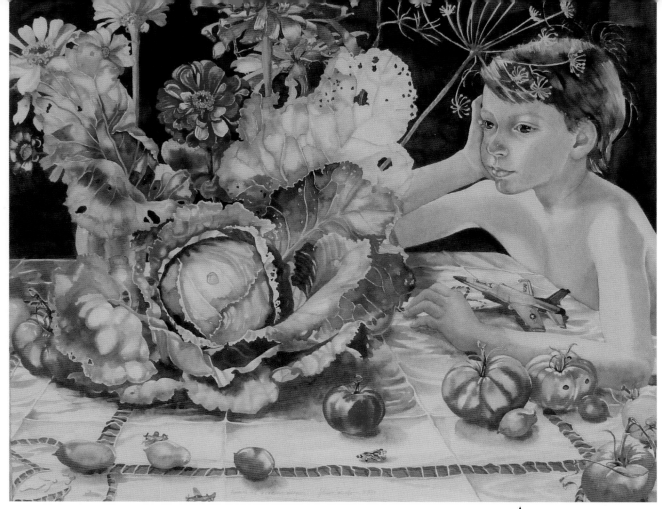

🔸 **HUMMING WILL WITH ENORMOUS CABBAGE**
24" × 30" (67cm × 76cm)

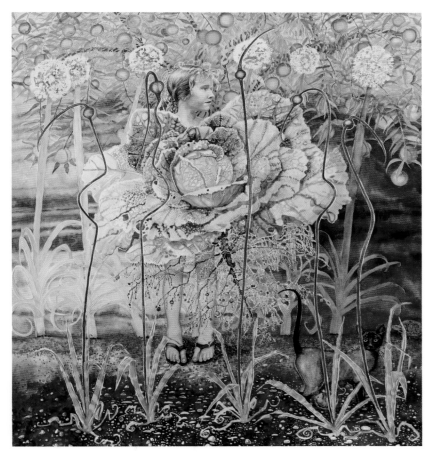

◄ **A LARDER IN A LOST GARDEN**
51" × 48" (130cm × 122cm)

Stan Kurth

There is a complex simplicity in Stan Kurth's paintings that is both paradoxical and straight forward. As he works with multiple layers of watercolor and gesso, his provocative images emerge. Ambiguity and form coalesce into a singular, cohesive vision that holds the viewer spellbound.

As a renegade, Kurth is not attached to any methodical way to begin or finish a painting. All of his paintings bespeak of his unique viewpoint. Kurth admits that in the '80s he gave up on doing serious fine art and turned to graphic art. Now he is a different man who travels a more intriguing road with no boundaries or stringent methods. Kurth now lives in the world of subjective art. He allows each emotion, each conscious and subconscious nudge to materialize on the surface of his painting. And these nudges can be a thin line rapidly drawn with an oiler boiler of watered-down black gesso, a structured line executed with a regular crayon or a plethora of spontaneous splashed colors, unplanned, dropped or painted. Then the painting begins. Where it will go, nobody knows, not even Kurth.

He asserts, "What I like in the painting, whether it be symbols, colors or the value in the painting, I want the ambiguity and the mystery to emerge, as they are the essential elements in my work."

Every day Kurth draws in his sketchbook, and his drawings represent the masterful way he handles line and drama. There is a subtlety about Kurth's paintings that is not seen in the drawings, but each is equally compelling and expresses the moodiness, the ambiguity and the skill with which Kurth draws and paints.

For example in *Coastal Anxiety III*, Kurth explains, "It is soft, but it has a strength about it." Perhaps that strength lies in the subtlety of the painting. In its nuance and softness, it stands so stalwartly paradoxical to his aggressive emotional drawings. "Something happens to me during each process," he explains. "I'll be working on something that doesn't work, for example, and perhaps I'll spill something or smear something. That's when the magic happens."

In real life, he describes his awakening to art and God as his ride to Damascus, a metaphor for his painting life and his spiritual life.

As a child, his aunt exposed him to art, which he says, "Blew me away." But he battled with himself. "Is this viable?" he'd ask. Thus he began his college career in pre-law and describes changing to art in his last year as a "blink" experience.

"Painting is spiritual. It is personal. I ask myself, 'Where is this coming from?' Mine is a melancholy experience," he says broodingly, looking off into the distance. "And it is not a step-by-step procedure."

What he has accomplished is an aesthetic feat in which form and color coalesce into intriguing shapes resembling figures or abstract landscapes. Unexpected lines appear to float beneath the upper surface of the paper, and because these are barely seen, his work becomes a palimpsest of all the marks, colors and shapes he has brushed, drawn and splashed into his painting. One enters his paintings, and "not knowing" is the linchpin that draws you into his mysterious surfaces and keeps you there. The odyssey the adventurer follows in his painting, he hopes, makes "not knowing" a knowable experience.

BLUEBLACK COLD ▸
30" × 22"
(76cm × 56cm)

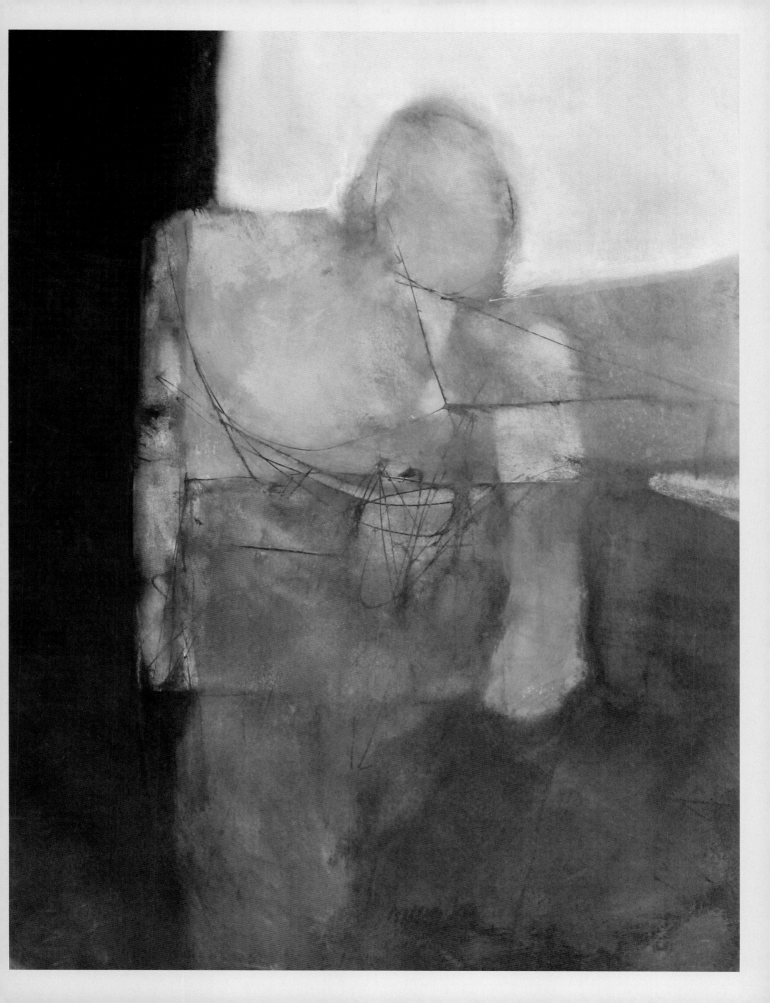

DEMONSTRATION
ORANGE SUNSHINE

Kurth's abstract beginnings belie any indication of the end or finished painting. Spontaneous! Daring! Loose! These are all adjectives that describe his approach. Line is important and enhances the coloristic passages as a delicate contrast to the strength in the rest of the painting.

 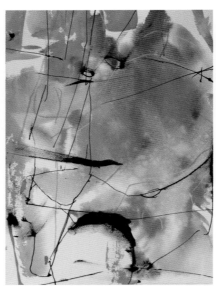 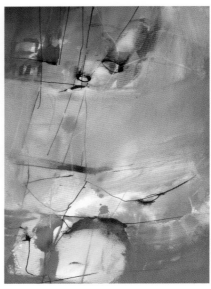

1 Kurth fills the surface with a wet-into-wet wash of orange and red and a grayed-down yellow, leaving scattered whites. His beginning is always a random one in which he has no plan.

2 Kurth then begins to draw with an oiler (a syringe attached to a small plastic bottle) filled with watered-down black gesso. He constructs a web of lines, which may or may not be part of the final composition.

3 The painting becomes more complex as he adds a veil of gray over part of the middle of the painting and a darker gray in the upper left. Notice that parts of the original painting are left as they were. The gessoed line recedes when covered by the veil of gray. Note that the veil of gray has made the upper passage yellow green.

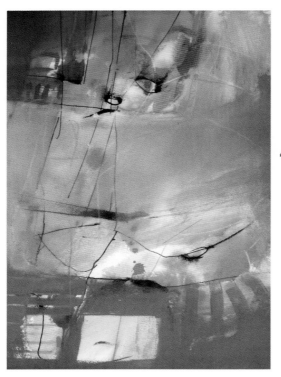

4 Kurth really cuts into the painting with more grays. The amorphous light green shape on the bottom right is now a square, and the pink shape has more lines added to it. The square protrusions are painted around, forcing them into prominence.

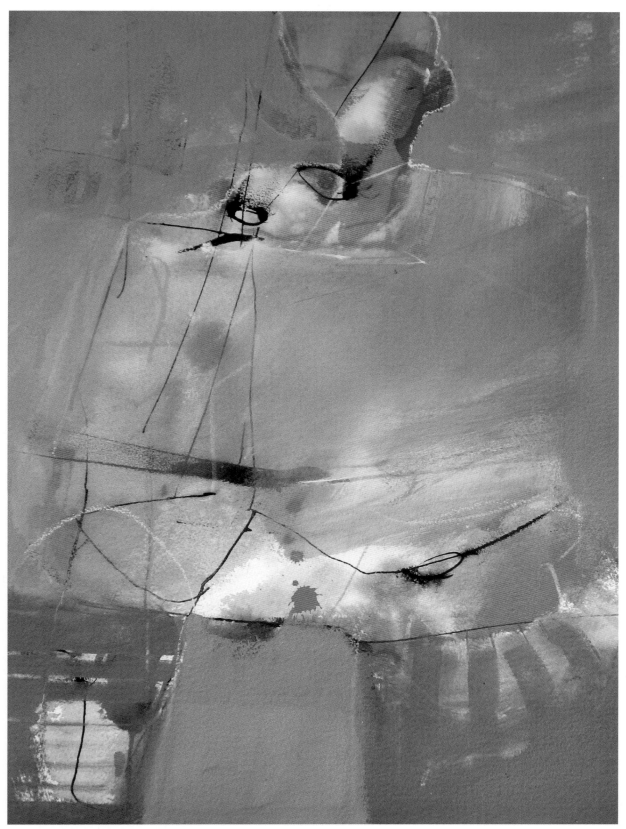

5 Kurth obliterates the left upper quadrant of the painting, leaving only snippets of shapes from the previous step. He paints negatively on the right, creating a figure who magically emerges from the chaos. A rectangular mid-gray added between the bottom shapes brings the painting to completion. In *Orange Sunshine*, Kurth takes us on an exciting ride to what Robert E. Wood would call "an unexpected ending."

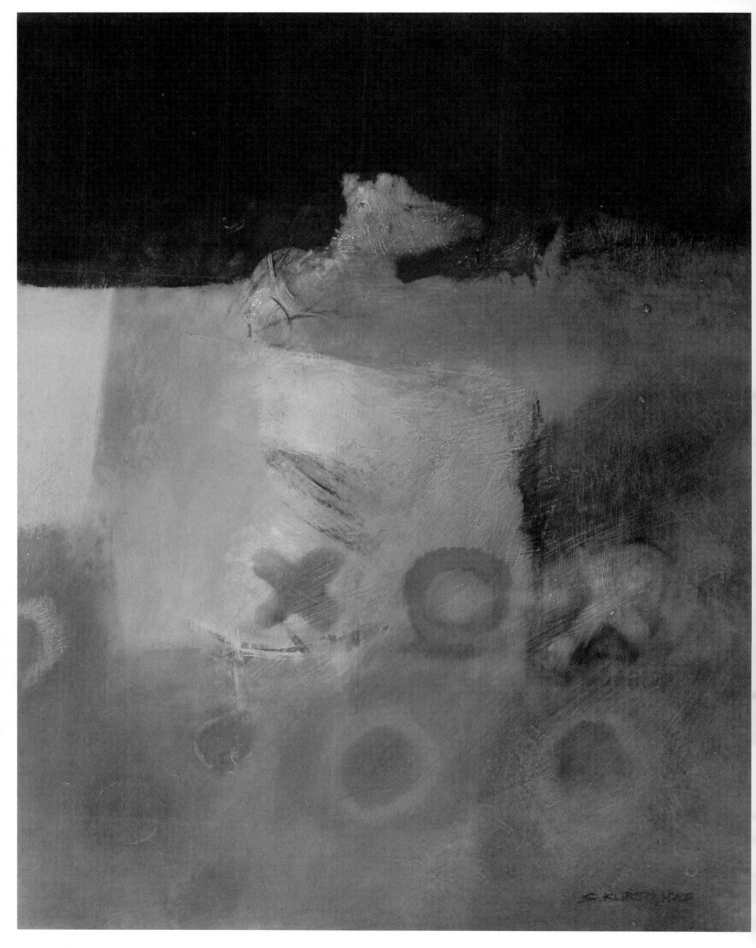

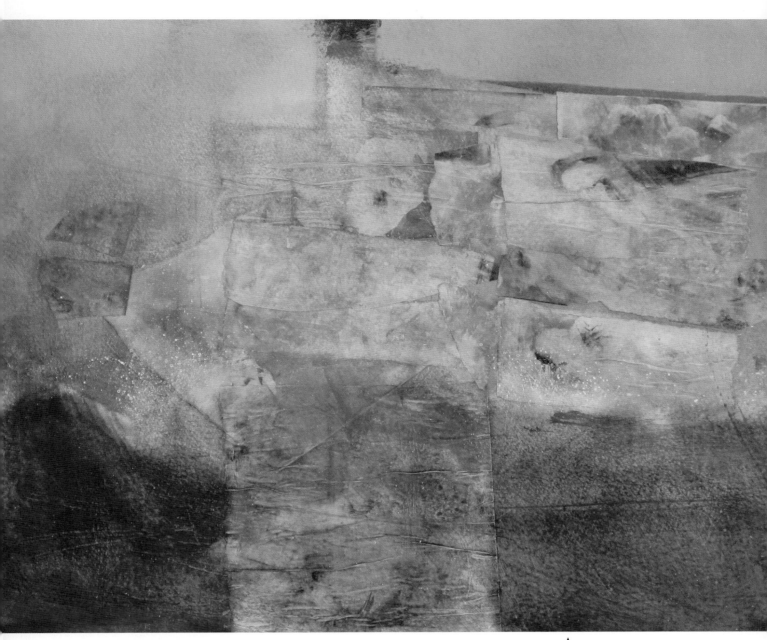

COASTAL ANXIETY #1
30" × 22" (76cm × 56cm)

DANGEROUS GAME #3
30" × 22" (76cm × 56cm)

Lynn McLain

Lynn McLain, from west Texas, began thinking artistically in the third grade when he carved something—he doesn't remember what—out of a bar of Ivory soap. By the fifth grade, he was drawing animals with colored pencils, and he was hooked. Next came his hot rod phase, which began in junior high. We break into laughter when he tells me that he used to draw naked women for some of the guys. But McLain admits freely that nothing stuck until he tried watercolor. By that time he lived in Lubbock and met a friend who was quite a good watercolor painter. The friend pushed him, and they got together every Wednesday night to paint in his friend's spacious and gorgeous studio.

With his masterful drawing skills and his love of architecture, it was no wonder that McLain became an architectural designer. At that time, he used colored markers for the renderings and watercolor only for his fine art.

When he and his wife Ann moved to Dallas, he began to teach and did that for twelve years. He reminds me of the day a group of us from the Southwestern Watercolor Society were painting at the Dallas Arboretum. I sat in front of him with another creative artist, Bill Reed, and

Bill and I teased Lynn because it took him all day to do his drawing. His story is that it took him all day to paint a leaf while I painted five paintings.

McLain describes what painting means to him: "My painting really comes from my background because whatever I am painting I want to tell a story. A painting has to speak to you. My passion is to expose abstract forms that exist in nature and our environment that most people may not notice. Through the use of design, texture and color, I feel that I achieve this. My teaching objective is to share my gift and impart a better understanding and confidence of painting with the watercolor medium. What I am intrigued by in a subject is texture, light and dark because together these always imply a specific mood."

McLain's trompe l'oeil works exemplify a mastery of the watercolor medium, and at the same time, his iconic treatment of the most ordinary subjects exemplifies his extraordinary skills as a painter. As Cezanne wrote, "One objective of the painter is to make the invisible visible." Lynn McLain epitomizes this tenet and does so with a wry sense of humor.

ROAD CHATTER 25 ➤
30" × 22"
(76cm × 56cm)

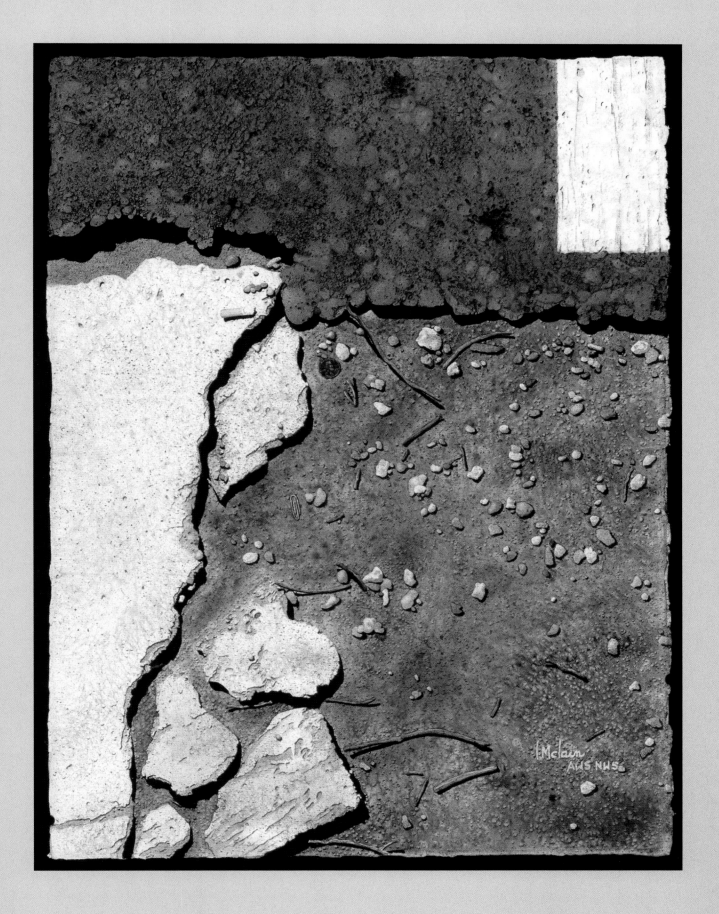

Road Chatter 46

After selecting the basic subject matter, McLain starts to work on the design. After deciding on the paper size and orientation early in the design and drawing phases, he considers if he needs more elements and where to place them to make the design and composition work. Basing his composition on the division of the paper surface into thirds in each direction, he makes decisions about color and texture because these play a big part in making the design work.

1 After the final drawing is transferred to Arches 300-lb. (640gsm) cold-press paper, McLain uses a drawing gum to mask individual elements. In this case the metal parts, the sticks, the stones, the cigarette pack and the cigarette are all masked. He also masks his signature, which will be revealed once the masking fluid is removed.

2 After he is confident of what the final painting will look like, he paints the gray area, which represents asphalt paving, using a mixture of Prussian Blue, Sepia and Payne's Gray with a wet-into-wet application. While the paint is still wet, McLain applies salt that, when dry, will become pot marks. Then he spatters with various colors.

Next he paints the dirt area using a mix of Vandyke Brown, Sepia and Prussian Blue. He paints wet-into-wet. While the paint is still wet, he drops in various colors, including Caput Mortuum Violet, Burnt Sienna, Yellow Ochre and Prussian Blue. He sprinkles salt into the wet mixture, which this time will emulate small pebbles and spatter, achieving even more texture. He drops in color for each individual stone. While wet, he adds Prussian Blue to the shaded side and drops in a little salt.

When the paint is dry, he rubs off the salt and removes the masking. Some masking will need to be reapplied where a stick or stone overlaps the areas that he intends to resemble metal and the cigarette pack, which is on top of the metal.

3 To get the rust color for the metal, McLain uses a mixture of Burnt Sienna, Prussian Blue, Caput Mortuum Violet and New Gamboge. The application is a wash of this mixture applied to small areas of the metal. While this application is wet, various colors, including Quinacridone Gold, Prussian Blue and Caput Mortuum Violet, are dropped in, and a small amount of salt is added. Proceeding to the next adjacent part of the metal, McLain repeats the same application before the first application has time to dry. He continue this process until all the metal is complete. The marks left by the salt in this application will become pockmarks in the metal.

4 Last, McLain paints the cigarette butt, the cigarette pack and the sticks before applying the shadows using a mixture of Prussian Blue and Vandyke Brown for the shadow work. Keeping in mind where the light source is, he puts in all the shadows. To depict a pockmark, he applies the shadow on the side of the mark left by the salt, closest to the light source. To depict a pebble, he paints the shadow to the side of the salt mark facing away from the light source.

As a final touch, he applies a light gray glaze over his signature.

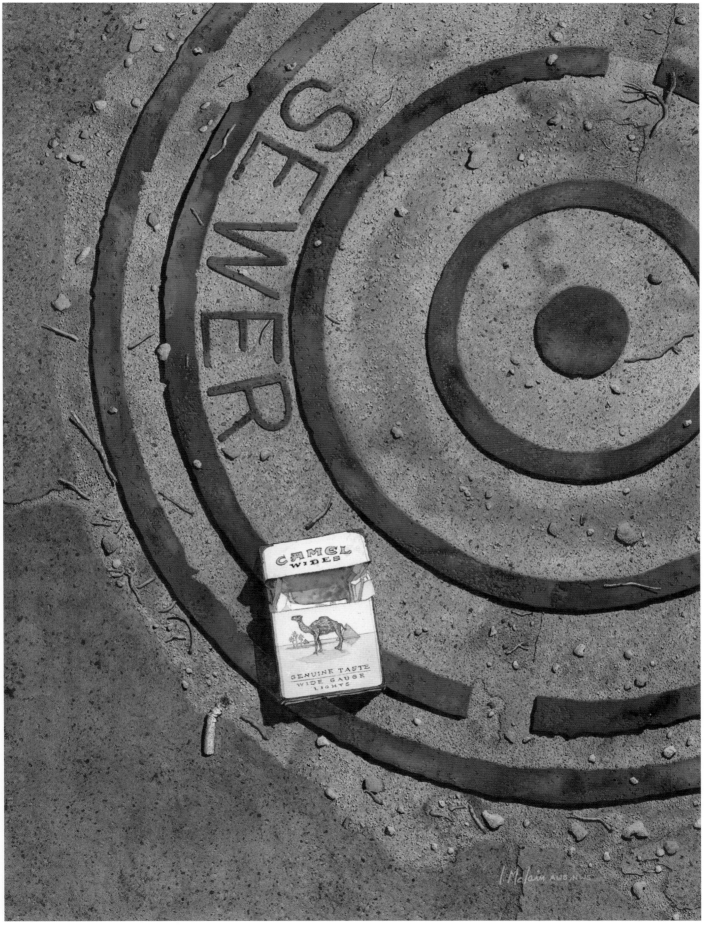

● **ROAD CHATTER 23**
22" × 30"
(56cm × 76cm)

◄**ROAD CHATTER 30**
30" × 22"
(76cm × 56cm)

Road Chatter 21 ►
30" × 22"
(76cm × 56cm)

Dean Mitchell

In a tiny town of poor working-class people with a mainly African American population, a grandmother gave a young child a paint-by-numbers set. That child grew up to be award-winning painter Dean Mitchell. That gift was given long ago, but without a doubt, his grandmother's action set the course for the rest of Mitchell's life. Yes, he used that paint-by-numbers set. That was all he needed. After that, he painted everything freehand and without any formal training. He has accomplished what most artists can only dream about. Mitchell grew up in Quincy, Florida. Both of his parents abandoned him, and he was lovingly raised by his grandmother.

"I fell in love with art and being creative," Mitchell says. "I don't have a formula. I do sketches, drawings of things I'm attracted to, and then I zero in on the most important thing about the subject."

Coming from Quincy, Florida, Dean concentrated on ordinary things. His concentration has paid off; he has mastered the genre of painting ordinary things, imbuing them with an extraordinary beauty. In his work, you fall in love with the subtle values, nuances and brilliantly painted transitions of colors and contrasts present in all of his work. His subject matter varies from figures to landscapes and street scenes.

In anatomy drawing class, he fell in love with the nude, especially gesture drawings. Although he has never been interested in doing portraits commercially, he has shown in his paintings of people his mastery of the human form. And always there is both serenity and emotion in his art. The portraits he has painted are painted because of love for the person (his grandmother, for example) or for a personal reason.

Mitchell frequently relies on contrast in different ways. For example, in *The Tree in Arizona*, the primary focus is on a monument of strength and beauty, but in the background are the dumpsters and trash that surround it.

"I had to educate myself about art," he reflects. "I was told no black man can make a living from art. I just quit listening and built a platform to make a living from my art." But there were shining stars in Mitchell's life, people who supported him, lke Tom Harris, a white high school teacher who took his black students to art shows. Mitchell recalls that his group included the only black people there.

As a painter, Mitchell works in multi-mediums: watercolor, acrylics and oil. He feels that "jumping around in different media" is good for growth.

Before he begins a painting, he executes lots of drawings and sketches from as many as twenty different angles (and sometimes even more). "The subject may not be interesting as a whole," he says. His intention is to capture the essence of something by editing and depicting a kind of simplicity. His belief is that no matter what you paint, it is a portrait of some sort.

"I constantly challenge myself," he says. "I have to, because there is a slippery slope that exists where, the next thing you know, you're not saying anything different anymore. The painting must have a mood and a certain spontaneity about it."

Mitchell's wife came across a quotation from the famous British writer Iris Murdock, and he carries it in his pocket.

"Great art is connected with courage and truthfulness. There is a conception of truth, a lack of illusion, an ability to overcome selfish obsessions, which goes with good art … Good art, whatever its style, has qualities of hardness, formness, realism, clarity, detachment, justice, truth. It is the work of a free, unfettered, uncorrupted imagination."

SWAMP BOX
30" × 20" (51cm × 76cm)

LIVING IN THE CITY

Mitchell's mastery of the complex human form is depicted in this delicate, almost monochromatic treatment of his subject.

1 Mitchell begins with a light pencil sketch.

2 In this first step of painting, he starts to model the form with light washes.

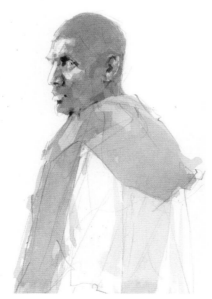

3 More pigment is added, and Mitchell introduces lights and darks to the figure. The form begins to take on more dimension.

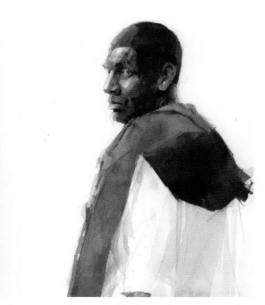

4 Darker colors are added, creating drama and emphasizing the three-dimensional aspect even more.

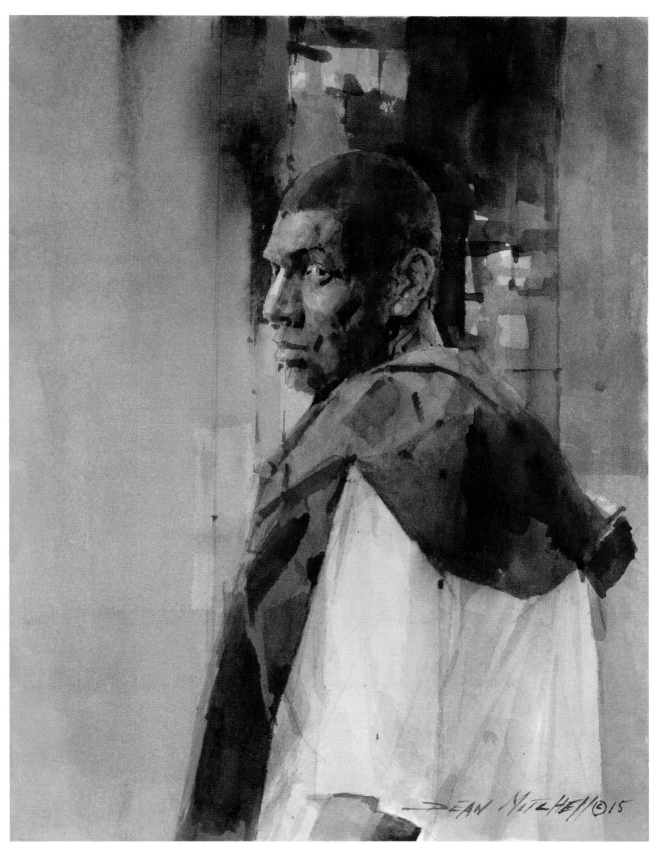

5 In the finished painting, the figure is placed in a neutral background filled with subtle nuance and subdued abstract shapes—a sublime and delicate contrast to the strong physicality of the model.

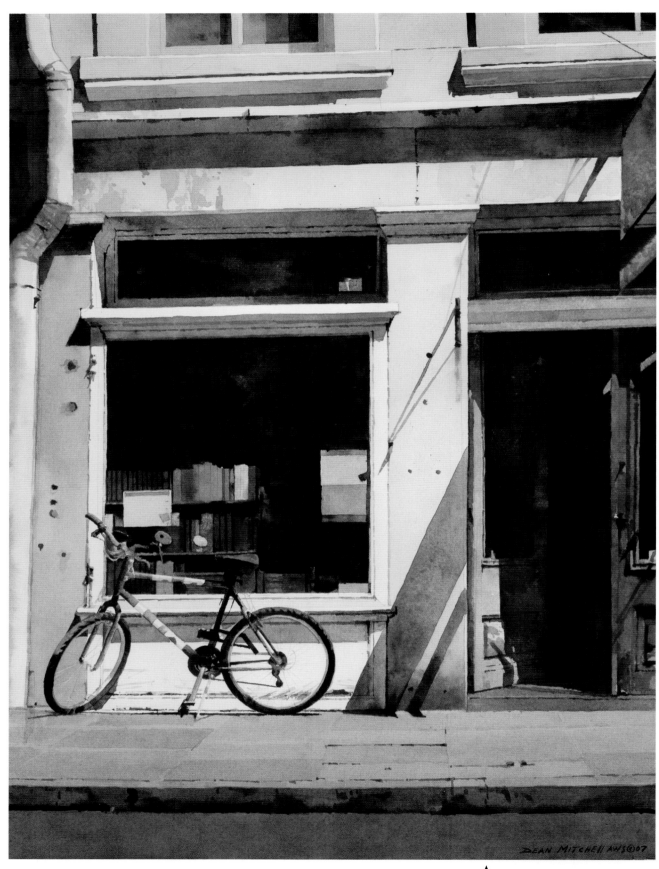

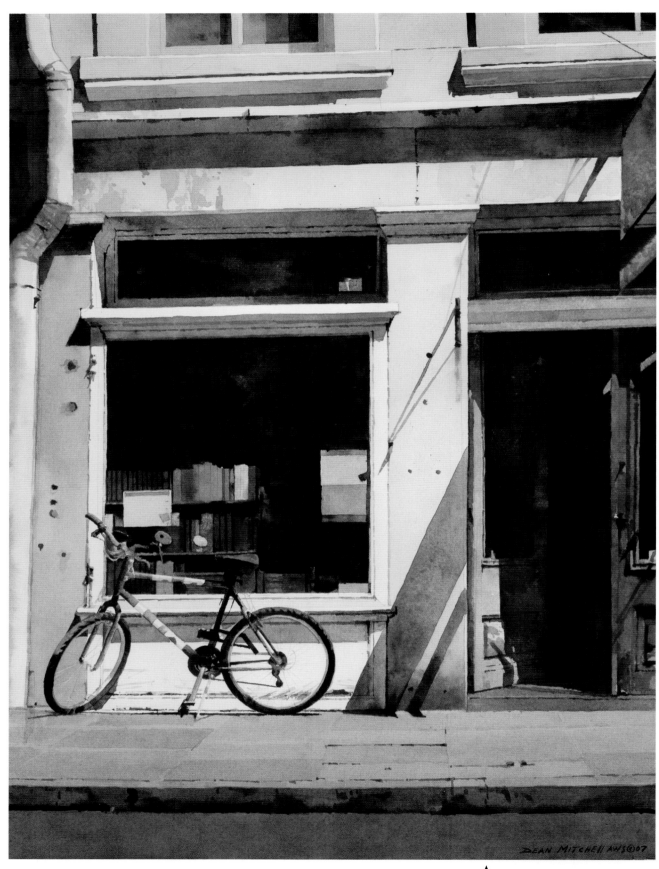

💧 **FRENCH QUARTER BOOKSTORE**
20" × 15" (51cm × 38cm)

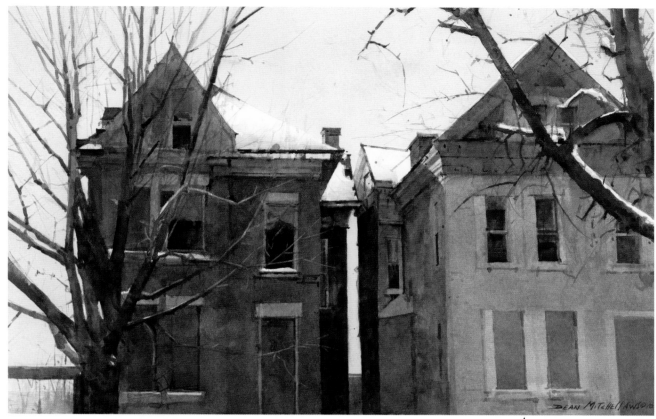

● **QUALITY HILL**
10" × 15" (26cm × 38cm)

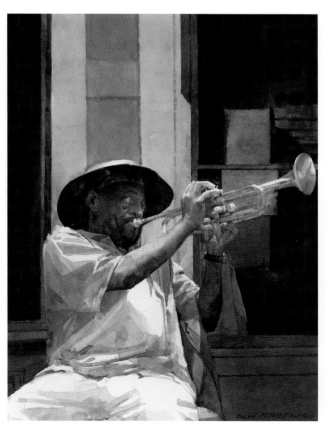

● **SOUNDS OF THE CRESCENT CITY**
15" × 11" (38cm × 28cm)

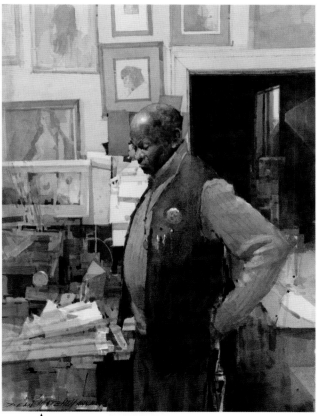

● **THE ARTIST BOB RAGLAND**
16" × 10" (41cm × 26cm)

Sebastiao Pereira

To explain how his background continues to influence his art, Sebastiao Pereira quotes Juan Gris, who wrote, "One's resemblance to one's parents is always strong enough without putting on their clothes." Born in poverty in the tiny village of Buarque de Macedo, Brazil, Pereira was mesmerized by his mother's woven blankets. She taught him how to match and layer colors to get the desired effect she wanted. Now Pereira exemplifies an artist who is in love with strong, bold color and complex and unusual designs. Clearly, it is in the strength of design that his father influenced him. His father not only wove bamboo baskets but also designed and constructed the intricately intertwined ceilings of their house.

Pereira reminisces, "I remember the bamboo ceilings my father wove. He created a different pattern for each room, and the designs were complex and intriguing. Painted white, those ceilings had a linear pattern and a two-dimensional quality. As a child, I spent hours trying to figure out how the bamboo was interlaced to create such beautiful designs.

"My mother's blanket patterns derived from our rural surroundings where she, too, grew up. She stylized animals, birds and plants. Dyeing the wool using plants and other natural sources helped my mother develop a sophisticated understanding of color. I remember her telling me, 'If you are making a second blanket using the same pattern and you change one color, that one color will change the whole look of the design.' My parents remain my greatest source of influence and inspiration."

Pereira continues, "My current work is shaped by modern technology and its applications. When I became acquainted with Benoit Mandelbrot's work on fractals and the possibility of infinite repetition, I began to rearrange and to reshape my images. I stretch them. I distort them, and I take them apart and then reassemble them using various computer programs. The transformation sometimes leaves no trace of the original image. When I arrive at the point where I am pleased with the composition, I project the computer-image, drawing shapes on watercolor paper. As the drawing evolves, however, I allow for changes, unexpected turns and detours so I am not committed to the original design I created on the computer. But the computer is an indispensable tool in my creative process and provides me with an exhilarating and unanticipated journey of discovery. True excitement always comes when I put load the brush with paint and the color comes in contact with the pristine white piece of paper."

When Pereira was nine years old, his father abandoned his family, and Pereira still experiences that loss to this day. As an optimist, Pereira states, "This kind of experience can make or break you, but your art can be the glue to hold you together."

After graduating from la Universidade Catolica de Minas Gerais with a BA in English, Pereira's fluency in Portuguese landed him a job teaching Peace Corps volunteers. Through his work with the Peace Corps, he met a lovely couple, Elden and Bethel Winkle, who sponsored him to come to the United States, specifically Arizona. They gave him room and board. They literally opened their hearts, their wallets and their house to him. Based on his grades, he got a scholarship to Arizona State University. There he received his BFA in art and his MFA in painting.

While working on his MFA, Pereira found himself psychologically executing works symbolically and subconsciously based on his feelings of abandonment by his father. At that time, his work was hard edged, in oil and on canvas. In a sense, they were Baroque in style and ultimately became his therapy. Through this work and the angst involved in creating it, he realized the severity of the physical and emotional abuse he had suffered as a child.

After this, he began to concentrate on watercolor, and it was through a series of watercolors titled *Ties to the Past* that he experienced a breakthrough and healing. About this time, he also began a seventeen-year career teaching art in high school.

Pereira's imaginative mind, his mastery of watercolor and his search for innovative expression will grace the rest of his life as it derives from an indomitable spirit and a forceful creative energy.

RED DELIGHT #2 ▶
40" × 50"
(102cm × 127cm)

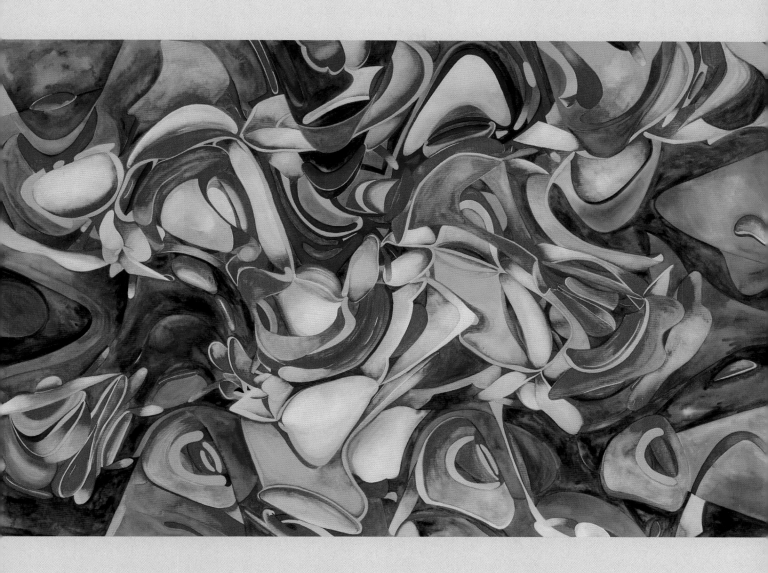

Red Delight

Pereira works out his design on a computer. Then he transfers the drawing to watercolor paper. He may make many changes to the composition as he draws, if he feels it is necessary.

1 Taping his paper to foam core, Pereira makes sure it is flat so he can apply a wash of New Gamboge. First he makes sure (8cm) the paper is uniformly wet. Mixing up a large puddle of yellow pigment and using a 3" brush, he begins at the top, overlapping strokes from top to bottom. He lets the wash dry.

2 After the wash is dry, Pereira projects a distorted computerized image of a plumeria that he has created onto the yellow underpainting. Using a 2B pencil, he draws the projected image onto the dried layer of paint.

3 Next comes the red, which Pereira allows to dry completely before moving on to the next step.

4 The green is painted and allowed to dry.

5 Pereira accents with a darker green, remembering that
he learned from his mother to put the yellow down first,
then the green to get a more powerful color. The result is a
powerful, rhythmic explosion of color and interlaced forms
that kaleidoscopically pulse across the picture plane.

● **CONGRESS OF JOY**
28" × 40" (71cm × 102cm)

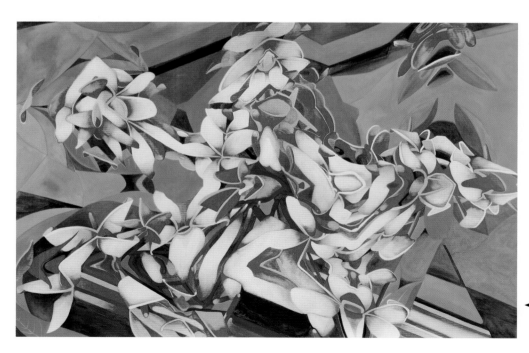

◀ **EXOTIC GARDEN #2**
27" × 39" (69cm × 99cm)

82

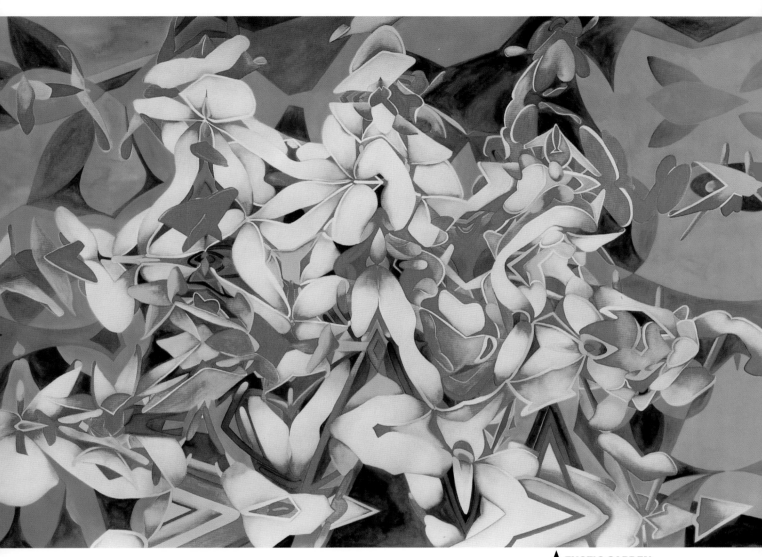

EXOTIC GARDEN
28" × 40" (71cm × 102cm)

Stephen Quiller

Stephen Quiller's heart lies in the landscape that he paints and loves. High in the mountains of Creede, Colorado, Quiller's brush explores every aspect of his beloved landscape, through approach and coloristic expression. The devastating Colorado fire in 2013 burned much of the woods surrounding Creede and affected Quiller emotionally and spiritually. His description of this experience is riveting.

"In June of 2013, the Colorado mountain area where I live was ablaze with wildfire. When the smoke cleared, one-third of our region had been blackened, our river filled with ash and the summer economy of our town majorly impacted. Since that time, I go to these areas to paint, sketch and then work in the studio on the series I title *Beauty in the Burn*."

In this series, Quiller captures both the beautiful and the sublime in the true eighteenth-century meaning of that phrase. His paintings are beautiful, and yet the expressiveness of his images also reflects the horrific damage caused by the fire.

For Quiller, "The groves were God's first temples," and his paintings are contemplative and evocative of the extraordinary spirit of nature in true Emersonian fashion. Quiller's mastery and resplendent use of color are dramatic characteristics of his work, as are his recognizable symbolic representations of trees, water and land.

In the *Burn* series, Quiller pays homage to the landscape of his heart, recording as landscape artists do his emotive, inventive and aesthetic reaction to the world he inhabits.

As the consummate colorist, to get the luminosity, color and contrast he wants, Quiller often uses layers of different mediums to execute his paintings with acrylic, watercolor, gouache and/or casein. A true visionary, Quiller is able to express the majestic spirituality of the landscape and his own spiritual and intimate connection to it. As Quiller's paintings evoke the quietude, the omniscient serenity that exists in nature, they also reflect the meditative serenity inherent in this superb artist.

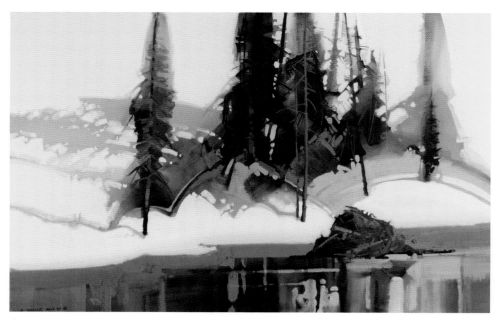

◖ **TRANSPARENCY OF SHADOWS**
23" × 33½" (58cm × 85cm)

LATE LIGHT ALONG THE RIDGE TRAIL ◗
30" × 22" (76cm × 56cm)

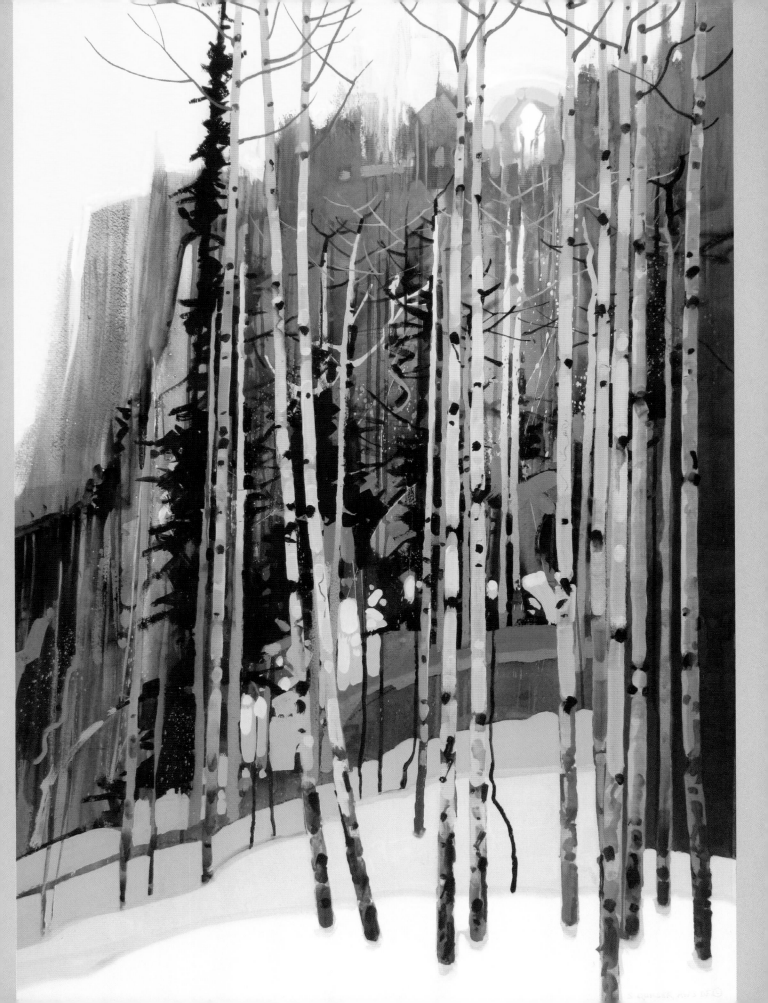

Spot Fires #4

This demo painting is only one of the explorative works Quiller executes of the terrible fires near Creede, Colorado. He is experimenting on a gold gesso surface.

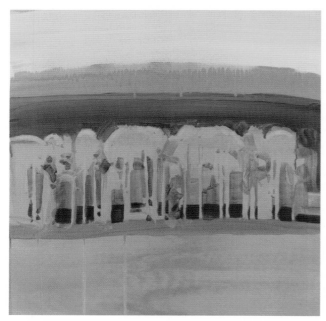

1 Coating the aqua board with gold gesso provides a beautiful undertone to express Quiller's burn paintings. When the gesso dries, working vertically on an easel, he charges a juicy wet, wide, juicy translucent curvilinear layer of Cadmium Yellow Medium, Cadmium Orange and Titanium White on the surface with a 2" (5cm) brush.

Next he introduces a juicy wet blue-violet midvalue complementary color and washes a band touching the bottom of the first band, which is still wet. This allows the top light warm color to break into the darker cool mix. Thinning the cool mix, he brings it two-thirds of the way down the panel, leaving the bottom third untouched. While wet, he paints a darker opaque blue-violet mix and paints around and through to form the aspen tree stand. Lastly, he lifts some vertical trunks and lightens the tops of tree shapes with a clean ¾" (2cm) flat brush and then allows the paint to dry.

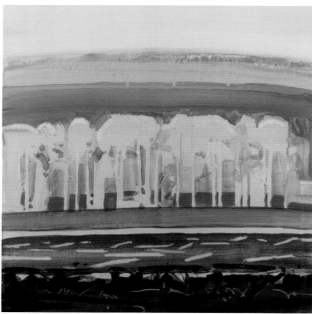

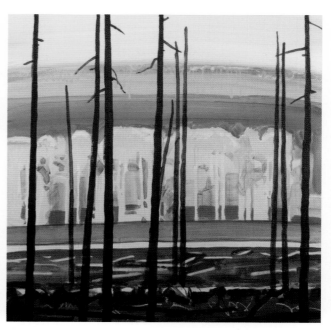

2 On the dry board, Quiller washes thin but cloudy horizontal bands (Ultramarine Blue, Pyrrole Red Light and Graphite Gray), leaving a thin, open band of gold undertone. Using a cotton swab, he lifts the horizontal pattern of fallen logs with rubbing alcohol. Washing a thin layer of rubbing alcohol on an area while it is moist, he then scratches back to the gold. When dry, he glazes the lower areas with Pyrrole Red Light and Quinacridone Magenta and paints some fallen black fallen logs with Payne's Gray.

3 Using a warm mix of Ivory Black and Quinacridone Magenta, Quiller paints in the vertical burnt spruce trees in the middle. He uses Payne's Gray for the cooler black trunks. A thin layer of Cobalt Blue and white cools down the light logs as he paints negative dark shapes around them to emphasize the pattern.

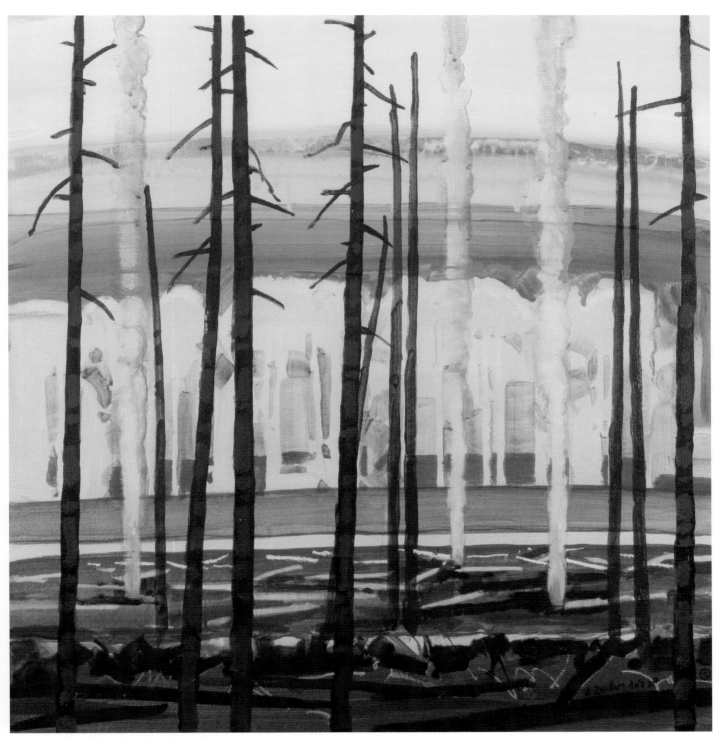

4 Applying alcohol, Quiller scrapes more logs in the light fallen log area. He paints the spot
fires next by taking a no.10 round brush, dipping it into the rubbing alcohol and lifting the
dark paint back to the gold gesso. Using the same brush, he lifts paint, creating smoke
in front of the mountain. Then he paints blue-violet upward into the sky. Finally, at the
bottom of the board, he paints a warm transparent fire, and in the foreground of black
tree trunks, some cool textural patterns using Cobalt Blue, Ivory Black and Titanium White
to represent the burned patterns on the trees.

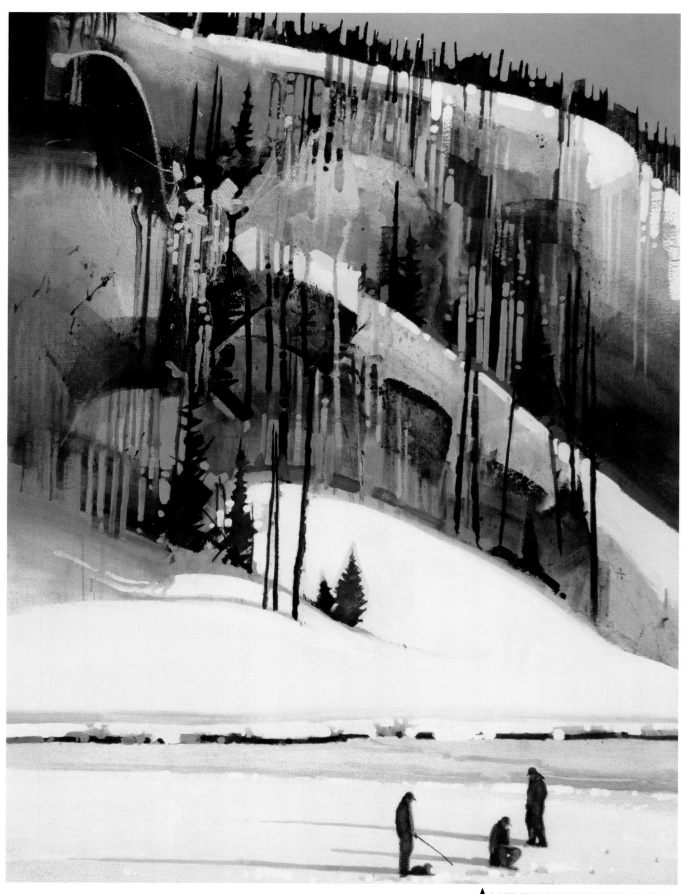

 LATE SUN ON THE BACHELOR TRAIL
36" × 26" (91cm × 66cm)

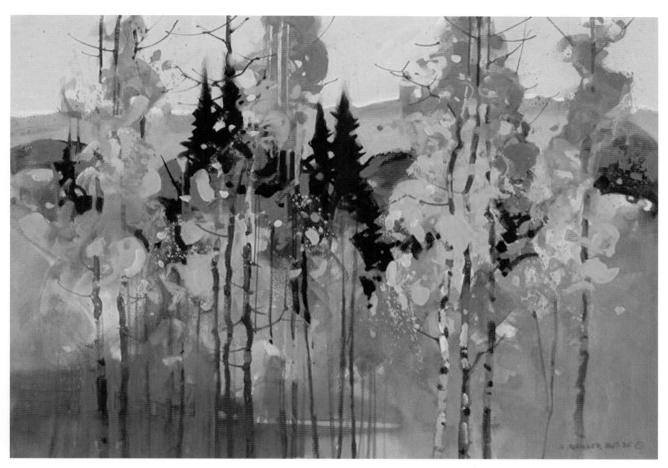

🔹 **ASPEN PATTERNS IN LA GARITA**
22" × 30" (56cm × 76cm)

Quiller's masterful use of expressive and interpretive color unites with his innate and unmatched ability to evoke in the viewer the sense of the majestic that resides in all of nature.

John Salminen

John Salminen's cityscapes, scenes and landmarks bespeak of the smells, textures and ambiance of place. Read along as this internationally acclaimed artist tells his story:

"My dad was a mechanical engineer, and he taught me two-point perspective when I was just a little kid. When I was in the second grade, I brought a drawing to school of a Dick Tracy squad car that I had drawn in perspective. The teacher raved about it, and it was such a big deal that I decided to become an illustrator when I grew up. What an incentive.

"But when I got to college, illustration was a dirty word. The word was abstract expressionism—in other words, paint for paint's sake was at the heart of everything.

"I went through a phase, however, of drawing hot rod cars, very sophisticated ones that I saw in a custom car magazine. I was always mesmerized by the reflections,

the intricate details on the cars and the technical aspect of drawing. I drew Elvis and played his music. My Dick Tracy squad car had migrated to Elvis. I also started teaching, and thirty-three years later, I retired.

"A turning point happened when I saw Cheng-Khee Chee give a demonstration with ink and a brush. He did a painting of squirrels. In his watercolor classes, I learned so much about design. We repeated some exercises six times. Cheng-Khee Chee brought in artists like Frank Webb, all design-based painters. He taught

me, in a sense, that every time you sit down to paint you can reinvent the wheel. He taught me that there is a difference between 'seeing' and 'looking.' In the seaport of Duluth, with all its boats and ships, I fixated on details that gave me design information and lots of choices to explore, just as Chee was doing.

"When Dong Kingman came to Duluth, he declared that it was a watercolor city, juxtaposed with a harbor and a tilted perspective. This was my first introduction into the complexity of a subject like a harbor. New York City blew me away with its visual chaos—with its propensity for geometric forms and shapes. Those shapes were not organic shapes. The architecture was amazing, and that drew me in. I avoided trees.

"Then one day I was in Central Park, and the low winter sun was shining through the trees. I was struck by the abstract quality of organic shapes.

"As artists we are always changing. Change comes in increments over a long period of time.

"When I first began painting representationally, I drew constantly around the harbor. Sometimes I would draw through the windshield to get a drawing technically accurate. Then I would go back to my studio, and to design a good composition, I'd move items around—that's where abstract painting comes into play.

"Here's a lesson both practical and profound: If you paint every day, something will happen. Everything will fall into place, and also painting that much causes you to pause and reflect. I recommend spending as much time looking at the painting as you do painting it. If you do this, you will see something in the painting that is a challenge—something that sparks your interest. Finally, I always deal with the most challenging aspect of the painting first."

The skillful Salminen evokes through his intricate and compelling city and landscapes, a memorable and visual moment frozen in time. As we enter his painting, we too become voyeurs to that exquisite moment and sense of place.

EIFFEL TOWER ●
37" × 24"
(94cm × 61cm)

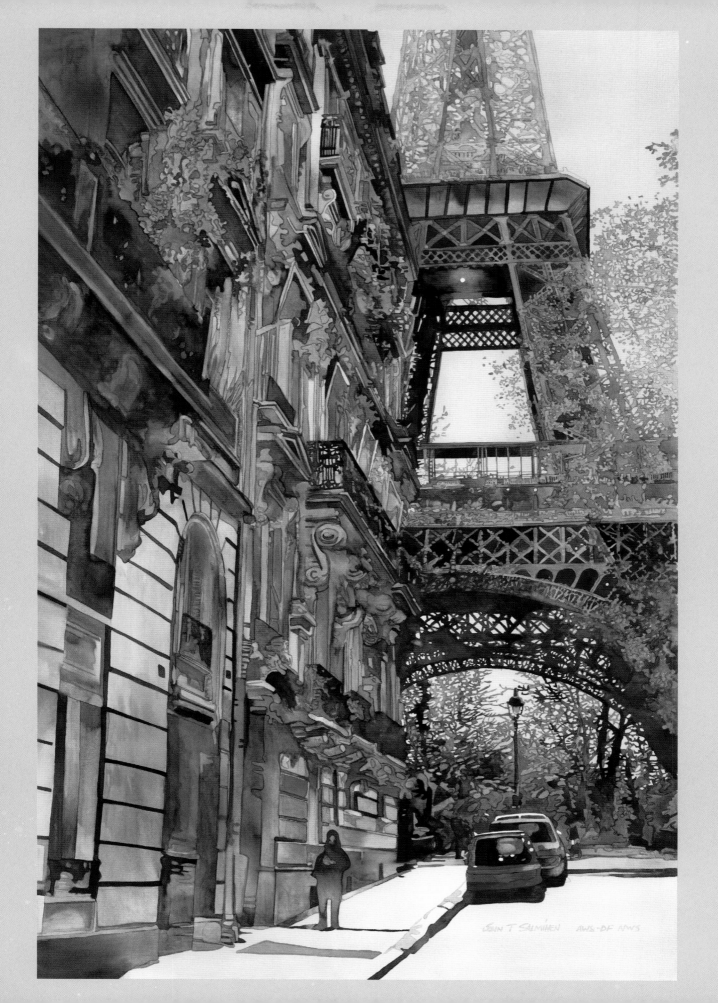

MAIN STREET QUEENS

Salminen's paintings of picturesque scenes usually include figures that help impart the tonal ambience of the scenes.

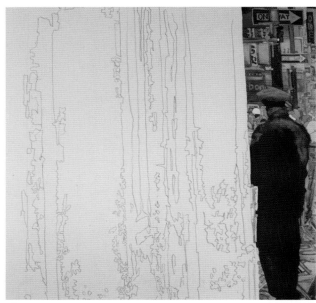

1 A simple line drawing predicts the final composition of Salminen's painting.

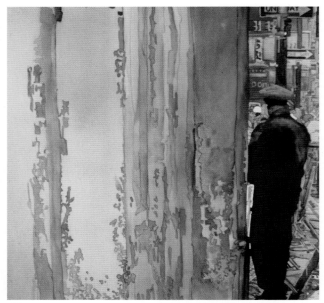

2 Salminen underpaints the wall using both warm and cool colors to provide a middle-value surface.

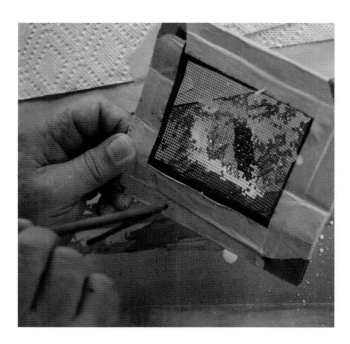

3 He paints full strength Winsor & Newton masking fluid onto a piece of ordinary window screen taped onto a cardboard frame. Holding the screen fairly close to the surface of the painting, he blows a strong column of air through the screen, causing the masking fluid to hit the paper in a random pattern. Next he creates some masking fluid shapes to suggest the remnants of old graffiti and stains left on the wall by natural aging.

 He then floods the area of the wall with dark neutral washes and waits for it to dry.

4 When he removes the masking fluid, a very natural and credible textured wall appears.

 To complete the process of aging the wall, Salminen adds sprayed texture using the same mouth-atomizer technique he used to force the masking fluid through the screen.

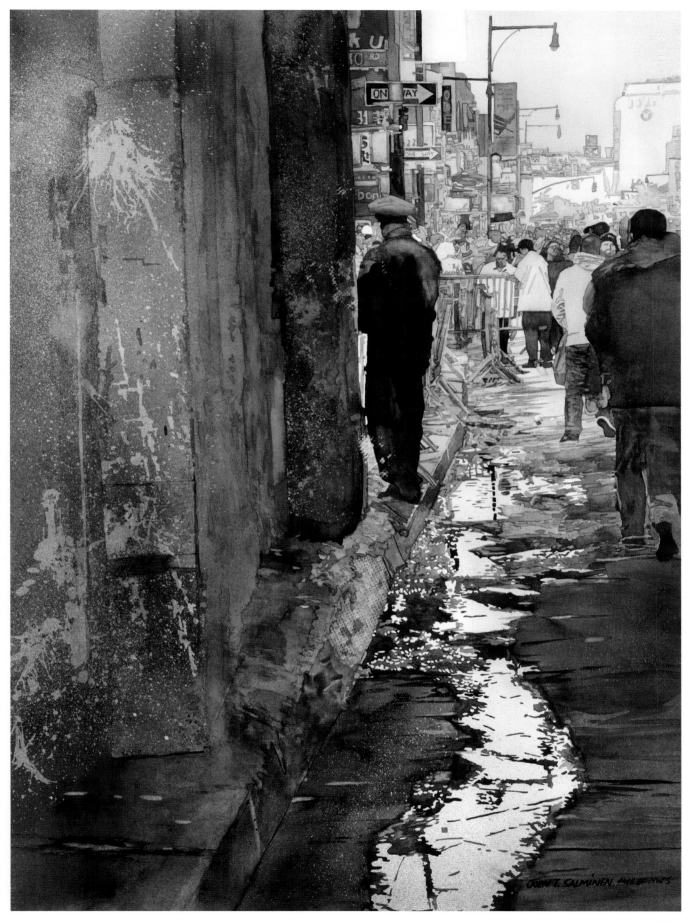

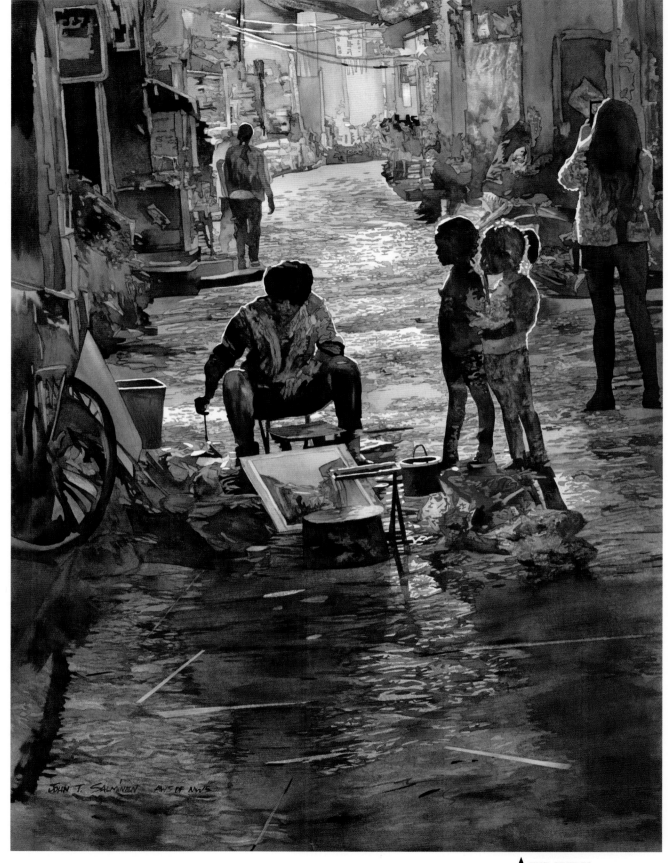

💧 **THE CRITICS**
33" × 24" (84cm × 61cm)

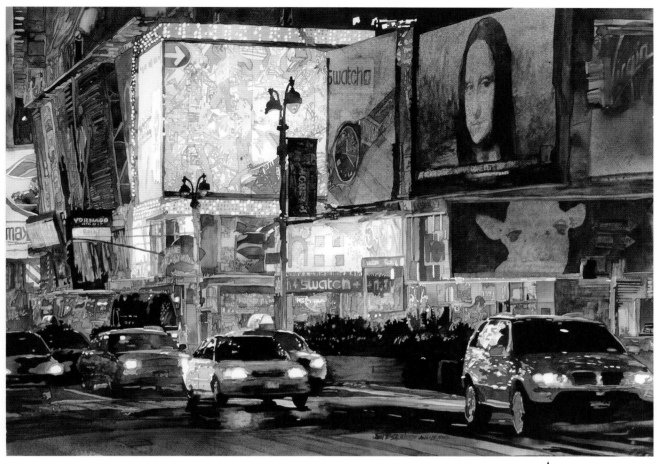

SWATCH
26" × 36"
(66cm × 91cm)

HONG KONG MARKET
24" × 38" (61cm × 97cm)

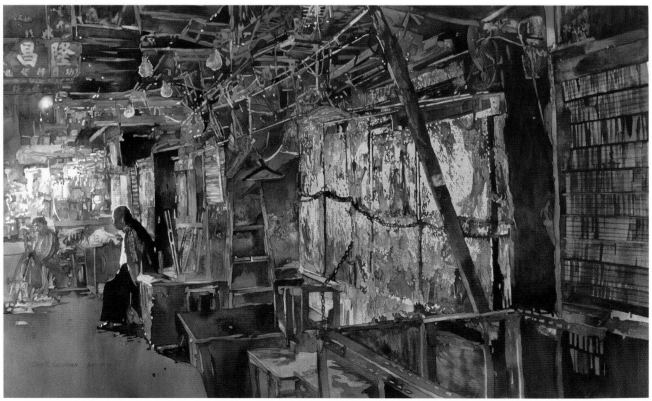

Michael Schlicting

Michael Schlicting's paintings reflect the articulation of thought, process and imagination. Behind his sometimes unexpected bold color combinations and his strong design sense is an equally strong structural support that comes from his mastery of drawing, which he feels is somewhat innate. That mastery comes, he feels, from good hand-eye coordination.

In his thirty-five years of painting, Schlicting reflects that often "his ideas morph and take on meanings other than the original plan." An important factor affecting his success as an artist is his sports background, which gives him the discipline to understand the process of gaining mastery.

He states, "My art informs how I see the world. For me, it is a seamless transition to look at the visual world outside myself and transform it into my own inner world. As an artist, you are never finished. It's a moving target. You never seem to get to the point where you are ready to close up shop.

"My ideas about painting are these: I am a process painter. I don't have a picture in my head that I am painting. I like the dialogue with the unconscious, and my goal is to be in tune with that small voice that pops up from nowhere, to listen to it and go with that prompt."

Often he starts out by doing a thumbnail sketch with a loose division of space. For Schlicting, painting is intuition, and the theme is the process. When he discovered gouache, it added a depth and richness to his paintings that he hadn't had before. Much of the time, he depends on the rich interplay of transparent watercolor and gouache to transform old paintings.

Schlicting admits that it's the joy of discovery in the painting process that excites him—the joy without his conscious output. He chooses to paint from photographs, and he always wants the painting to have a connection with the source material—not in a didactic way, but in an engaging way—both for him and for the viewer. For Schlicting, the circuit is complete once he sells the painting.

Schlicting represents his world in many different ways. At times, his compositions are completed with strata of different objects. His color is expressive, diverting from representational, local color to a moody ambience designed to captivate his audience. He paints in both acrylic, gouache and watercolor, and there is always the same theme, represented with many different subjects. That theme is life, and always it is through the color and the images that you get a glimpse into his world.

HOMEWRECKER 2 ◀
22" × 30" (56cm × 76cm)

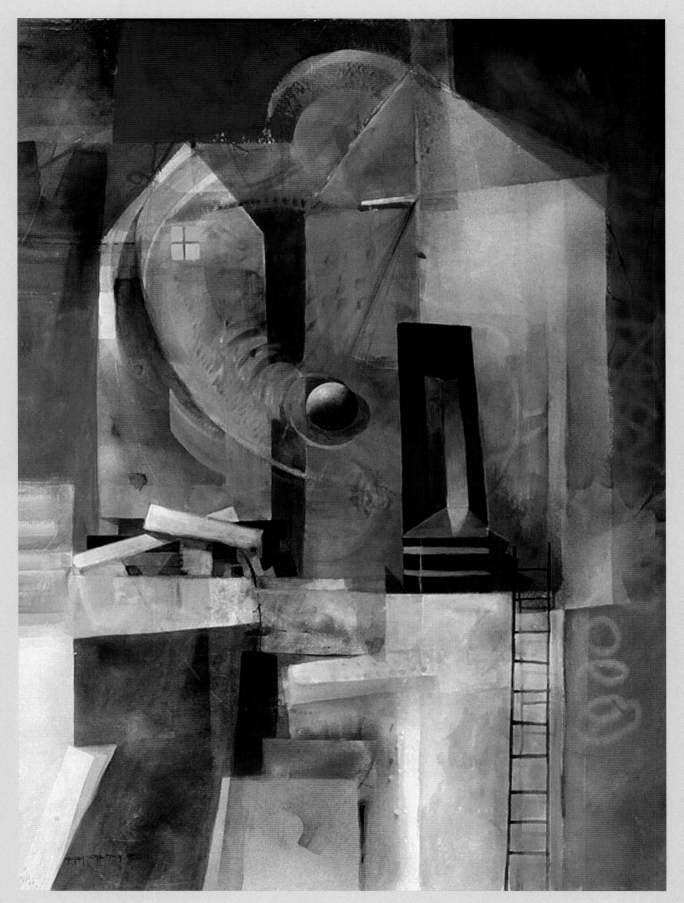

Venice Nights

With his demonstration, Schlicting executes an exciting painting that exemplifies what one can do with a painting that is not completed or one that is not "up to snuff."

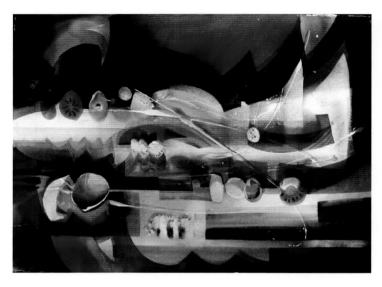

1 Beginning with an unresolved painting that already imparts a richness, interest and textural quality to the surface, Schlicting looks for movement and shape relationships. He uses various of watercolor pencils freely to find these movements, making gestures.

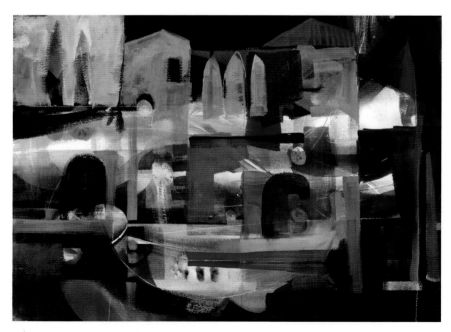

2 With the abstract armature complete, Schlicting washes on broad strokes of color using a combination of opaque gouache and transparent watercolor. He advises using several palettes to separate the gouache and transparent watercolor so as not to muddy the watercolors with the opaque paint. Aware of a general compositional layout, at this point Schlicting is more interested in finding strong shape development, delightful color harmonies and delicious textures. Color choices are rather arbitrary, more about a remembered experience than locational fidelity.

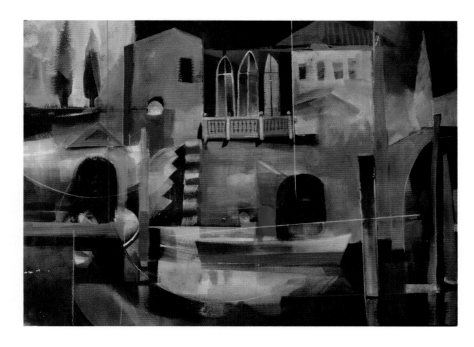

3 Schlicting uses the qualities inherent in gouache to paint light-over-dark, creating varying color harmonies and values. The geometric lines drawn with watercolor pencil are a way to break up the composition and give it a more formal abstract quality.

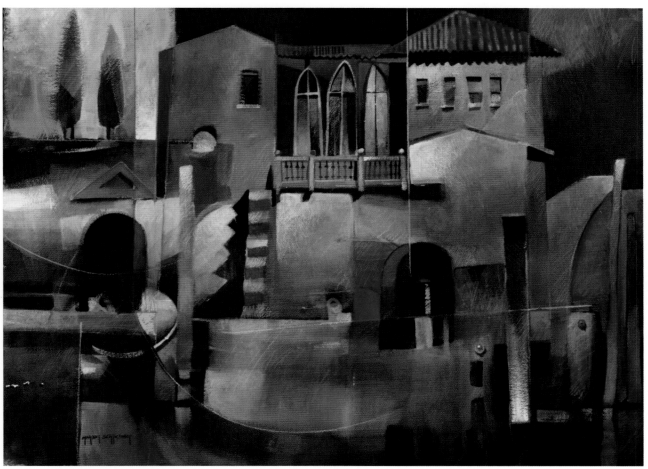

4 To finish, Schlicting brings more light and color into the middle of the painting, brightening the orange/reds and adding contrast within the shapes. Now the painting is starting to pop! Finally, watercolor pencils add another textural element to the piece. Although these marks are not too visible from a distance, up close the viewer is rewarded with exciting surface variety.

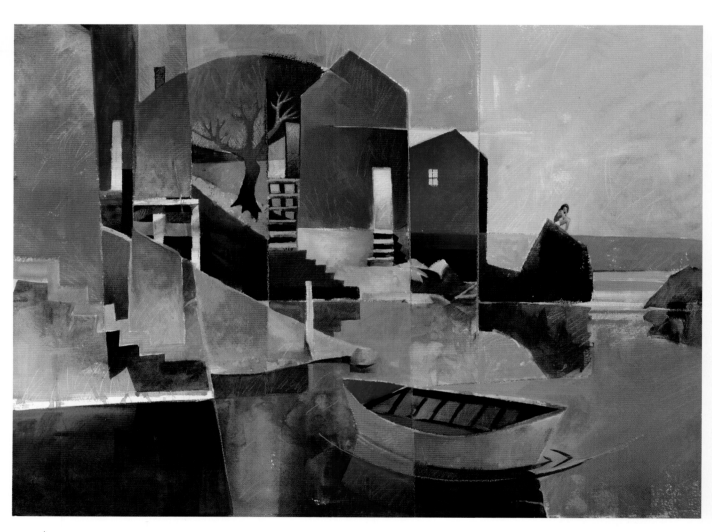

RETHINKING IT ALL
22" × 30" (56cm × 76cm)

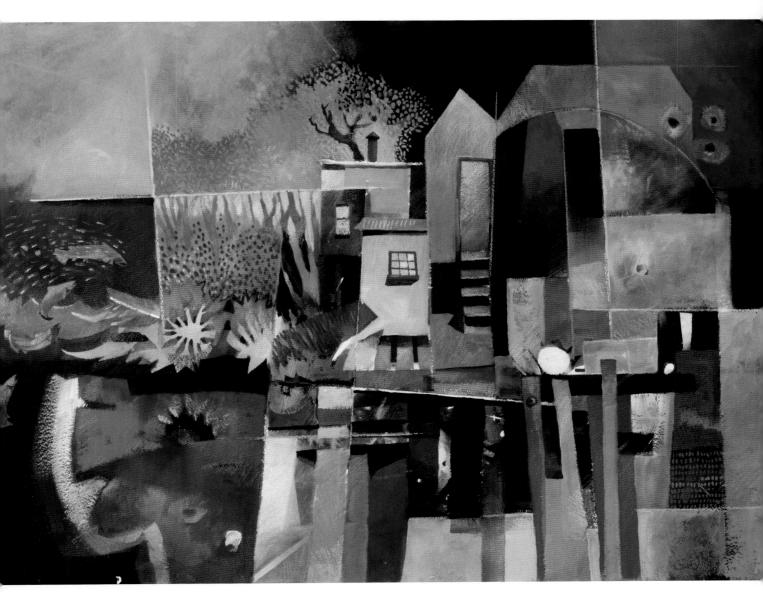

💧 **RETURNING HOME**
22" × 30" (56cm × 76cm)

Ann Smith

When you look at the representational or abstract paintings of Ann Smith, you are immediately drawn into the enigma. With delicately layered shapes, surprising color diffusions and a hypnotic ambiguity, she masterfully depicts her subject. It is those lost and found areas, the flawlessly beautiful surfaces and the paradoxical combinations of spontaneous painting and absolute control that mesmerize the viewer.

How did Smith come to art? She describes her family as one that greatly valued solitude, which made her upbringing the bedrock for her development as an artist. Everyone in the family read, sewed, drew or made music. Even on her earliest vacation excursions, she always packed up a new box of crayons, freshly sharpened pencils and pads of paper. Like most of the artists in this book, she says the desire was innate, an irrepressible urge to express through the brush, the pen, the pencil.

"As a child," she remembers, "I always loved to draw, and I loved to doodle and play, never worrying about criticism. At first, I emulated reality but ultimately got a degree in biological illustration from UCLA. But measuring with calipers and painstakingly rendering microscopic details for scientific papers belied the thrill of freehand drawing and experimenting with color. After working as a medical social worker for several years, I rediscovered the joy of playing with watercolor as a means of relaxation and method of meditation."

I met Smith in 1981 in a workshop at Artisan's Studio Gallery in Texas, and she was wetting her paper on both sides with such gusto that I was amazed. (It would be many years later before I would see Cheng-Khee Chee put even more water on his surfaces.) Smith's results were always stunning—improvisational manifestos for unbridled creativity and intuitive painting.

After Smith and her husband, Graham, left Dallas in the early '90s and moved to a small town in New Mexico (and later Colorado), she missed the effervescent group of artists in Dallas, the successful shows and opportunities to sell art. In her new surroundings, Smith lost all motivation to enter competitions and instead turned her attention to placing other artists' work in the local hospital and nearby cancer treatment centers. She established an ongoing program of loaned art for patient exam rooms and successfully got funding to purchase spiritually uplifting permanent artwork for her town's large public spaces.

While her own painting seemed to be on hold, Smith was absorbing the stunning Southwestern skies, vast landscapes and brilliant wildflowers. During this period, one quotation—a quotation from Robert E. Wood—kept repeating itself. That quotation was "Trust yourself," and she took that to heart. Smith asserts, "You have to be ready to spring forward and become who you are." As she began to paint again, there were no holds barred. She explains, "I had a different attitude toward painting landscapes, and I returned to representational painting for quite a while. It really wasn't me or the free style I had developed—but it became a linchpin to get me back into my own way of working."

Reflecting about her career, she says, "In my thirties, I was tentative, trying to follow rules. In my forties, I was going with the flow and trying to raise four children. I began hearing people label me an intuitive painter. In my fifties, I was looking for strength and richness of color. In my sixties, I did gigantic commissioned paintings, inspired by the spectacular vistas of the Southwest. I haven't lost my robust attitude toward big, brave starts, but in my seventies, I now do fewer but better paintings. I can honestly say that most of the time, I don't know what my paintings are about until six months after I've finished them. I really think that painting has always been a journey of self-discovery for me."

Smith advises beginning artists to get into as much trouble on a piece of paper as they can and then challenge themselves to find solutions to those problems they have created. "The work that survives will be a unique reflection of your true spirit. When you get to that place," she feels, "you have reached a pivotal point in your development as an artist."

In looking at Smith's work, the shapes, the colors, the rhythm of her paintings are melodic, swirling around in an atmosphere of intrigue and mysterious spatial depth. Sometimes images emerge like whispering sonnets, alluding to meaning, and sometimes the narrative reveals itself only in a mellifluous mélange of shapes, textures and color. There is always a spirited movement in her approach, and what remains is a treatise giving the intuitive mind and heart full reign. One thing is for certain, and Smith states it best: "I'm my paintings, and my paintings are me."

PASSION ➤
30" × 22"
(76cm × 56cm)

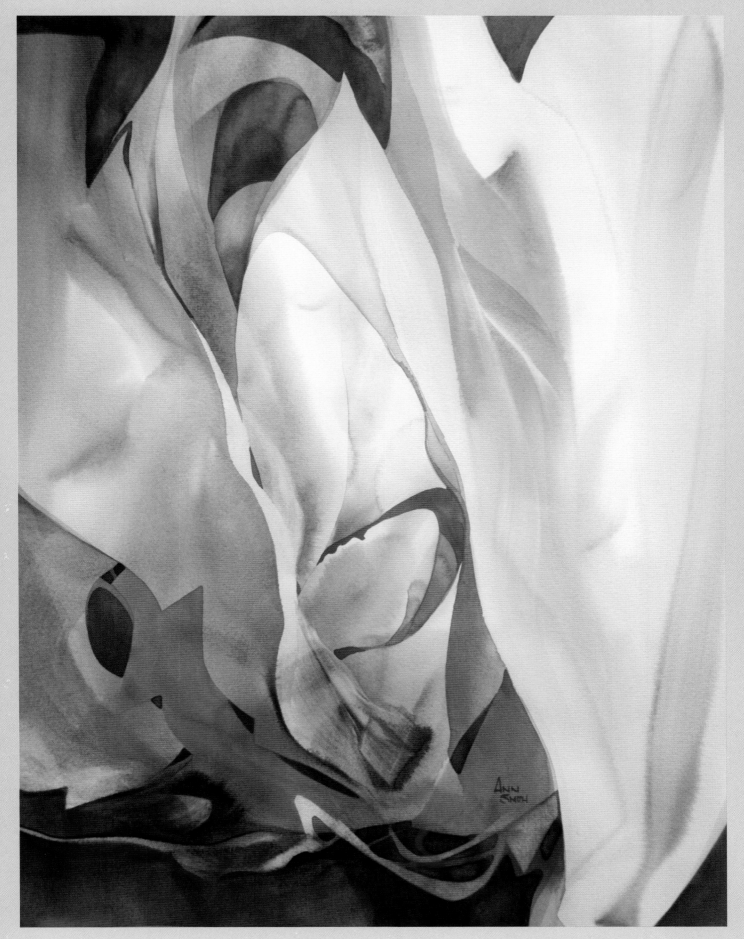

Hummingbird

Smith always begins by wetting the paper on both sides until it is sopping wet. As a result, her process leads her on an adventurous journey of unexpected collisions of color. Allowing drying time between layers, she works with diffusions and shapes that appear in each layer.

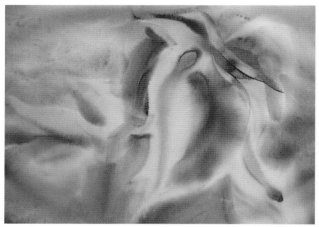

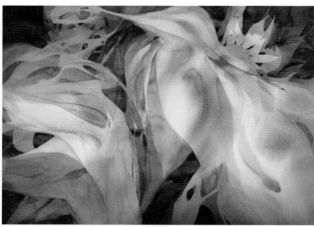

1 Remembering the flurry of brightly buzzing hummingbirds encountered on a trip to Costa Rica, Smith sloshes on patches of Rose Madder Genuine, Aureolin, Permanent Magenta and Cobalt Blue, adding plastic wrap texture, toothbrush spatter and credit card scrapes while the paper is dripping wet.

2 After the painting is completely dry and using midtone values, Smith makes tentative bird and flower shapes, establishing a general feeling of movement. Early on she leaves most of the bottom right side of the painting almost completely undeveloped because to her, magically, the whole area seemed to suggest the blurry whiz of those quickly beating little wings.

3 Adding more texture and sponging out refinements using hand-cut stencils to protect the nearly finished painting, Smith adds light glazes of Cobalt Blue followed by darker layers of Windsor Green and Alizarin Crimson, highlighting the glowing hummingbird against the richly mysterious background.

4 Note the shapes lifted out by looking at the contrast of this step and the finished painting.

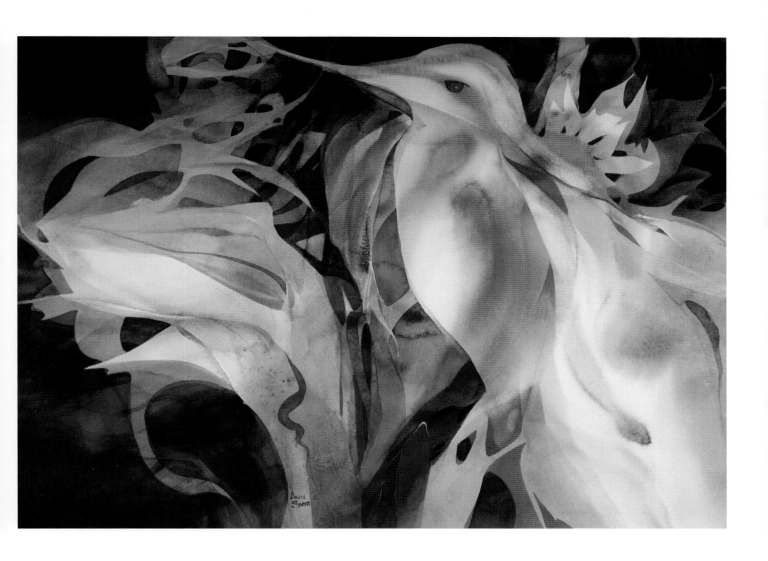

SPECIAL NOTE TO BETSY FROM ANN SMITH

"As you know, Betsy, I usually have no plan when I begin a painting, but the backstory on this one is that I was asked to do a commission for someone who wanted one of my *Bright Birds* paintings. So there was a bit of an idea as reflected in my very beginning wash strokes. When I do commissions, I always do two paintings, and then somewhere around the 75 percent point, we consult, and they choose one of the two pieces and I fine-tune decisions about color, level of detail, etc. This painting is the one not chosen, and the other painting went its own way, ending up looking very different from this one, which I plan to keep. And, by great good fortune, I happened to decide to photograph this one in progress for an artist in the Netherlands who wants to introduce my work to her students there so that we might get a workshop together eventually. The final thrill was my sighting of that Colorado hummingbird in a May snowstorm on my fully blooming pink cherry tree while we were talking on the phone that day about this painting! Was he a messenger? Chills."

105

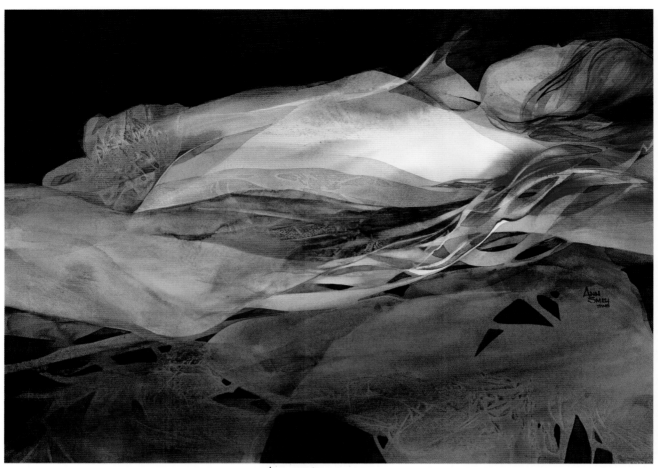

RECLINING
22" × 30" (56cm × 76cm)

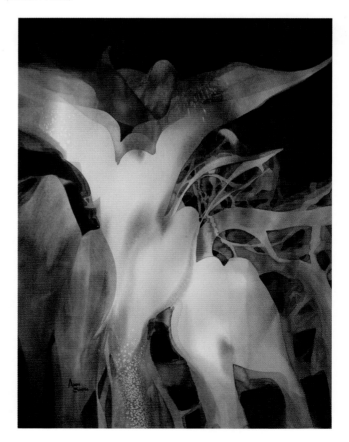

FLIGHT ▶
30" × 22"
(76cm × 56cm)

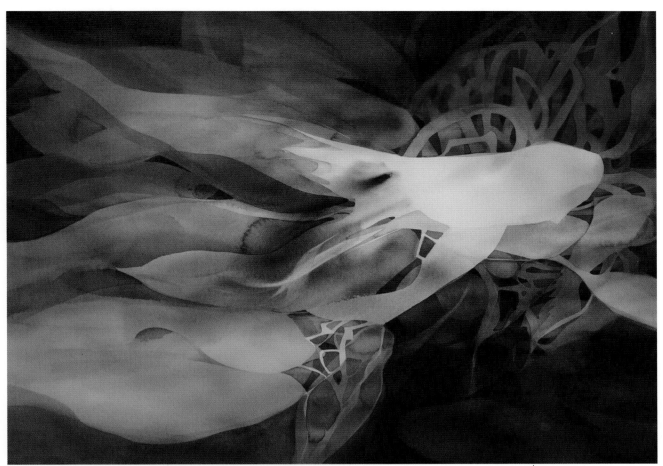

● **RIVERBED**
22" × 30"
(56cm × 76cm)

◗ **TANGLED**
30" × 22"
(76cm × 56cm)

Betsy Dillard Stroud

At about the age of three, Papa supplied me with some big red-lined books (the kind lawyers and judges use), and I began drawing unrecognizable marks, scribbling relentlessly in my cryptic, unreadable script. I filled every book and page with an indecipherable language that now reappears in some of my abstract paintings. Clearly, it is on the pages of those lined, bound books that my journey as an artist and writer began.

As a child, I also drew murals of owls all over our living room walls. Fate intervened when my uncle Herbert, my father's brother, said, "For goodness sakes! Find this child a tutor." And they did. In our tiny town of Rocky Mount, Virginia, the only person who painted was a lovely woman named Marge Willis, a tole painter who painted Baroque flowers on trays. Between my eighth and ninth birthdays, Herbert gave me a set of oils and brushes, and I painted my first still life, a vase filled with chrysanthemums. Marge painted the first flower, and I painted the rest. When Herbert looked at my painting, I cried. "Hers is so pretty, and mine are so ugly, " I said. "Nonsense, darling," Herbert retorted. "Yours are a Monet."

During my turbulent teenage years, my beloved father, who was a judge, shot himself, only to live through this violent, horrible action and then kill himself two years later. By then I had left my high school and was enrolled in an Episcopal girl's preparatory school. With the encouragement of my art teacher, Nancy Jo Ferguson, who was fresh out of Randolph Macon's Women's College (now Randolph College), I managed to ameliorate my feelings through my artwork. I had her all to myself, certainly a gift from God at this time in my life.

When I was in graduate school at the University of Virginia, I met my lifelong friend, artist Jean Sampson, who introduced me to two teachers, Morton Traylor and Irmgard Arvin. I learned trompe l'oeil still life oil painting with Arvin, who had been Jacques Maroger's assistant, and expressionistic drawing and painting with Traylor, who had studied with Rico Lebrun. Many of my happiest days in Charlottesville were driving with Jean to Crozet to paint or draw with Morton.

In 1976, Herbert's sudden death in his classroom at Virginia Military Institute and my desire to pay tribute to him changed my life. Even though I had completed all of my course work and my orals for my doctorate in art history, I decided to write a book about him. Like the trappings in a romantic saga, my future and last husband,

the late Ethan Stroud, read the book, arranged for an introduction, swept me off my feet, married me, and all of a sudden, I lived in Dallas.

I left the erudite academic world that I loved, but never quite felt was totally right for me, and immediately sought out an enlightened watercolor teacher. That teacher was Naomi Brotherton. Through Brotherton's friendship and tutelage, my relationship with Dorothy Barta, who later became my studiomate, my friendship with the late Leo Smith, and through the camaraderie with artists in the Southwestern Watercolor Society, my fate was engraved in stone. I painted like a fiend, and I began writing again for magazines and eventually began writing art books.

My life is kaleidoscopic, always changing, uncertain and colorful. And like a visual diary, my paintings mark this path in different ways. I articulate innermost thoughts through abstract painting—often emblematic of the Jungian idiom *Imago Ignato* (unknown image), referring to all those antecedents that are innate but can't be painted with recognizable symbolism. When I paint something representational, there is always an abstraction about it. More than twenty years ago, I began to carve my own images, painting and stamping them into my work, and now they are a leitmotif in most of my paintings. Teaching workshops all over the country forced me to think of various ways to approach different subjects so that I slip in and out of what I call realistic abstraction and pure abstraction. One day, I might paint flowers, the next a figure. And then I may find myself immersed in total abstraction for a week. But I am always looking for a new and innovative way to express myself, and with every subject, I tend to work in series.

Long ago I recognized that I am a process painter, totally involved with the immediacy of what is happening on paper or canvas. Beginning spontaneously and intuitively, I leave the left brain to refine and burnish the painting later. The finished product is important, but the "at one-ness" comes while I paint, and my art history background is invaluable in evaluating my own work. I advise my students not to be attached to outcomes, a tenet which frees the subconscious and stymies the critical mind. Painting is the ultimate meditation for me, and it is through the act of painting I express both the world within me and the world outside me.

MEDITATION ▶
30" × 22"
(76cm × 56cm)

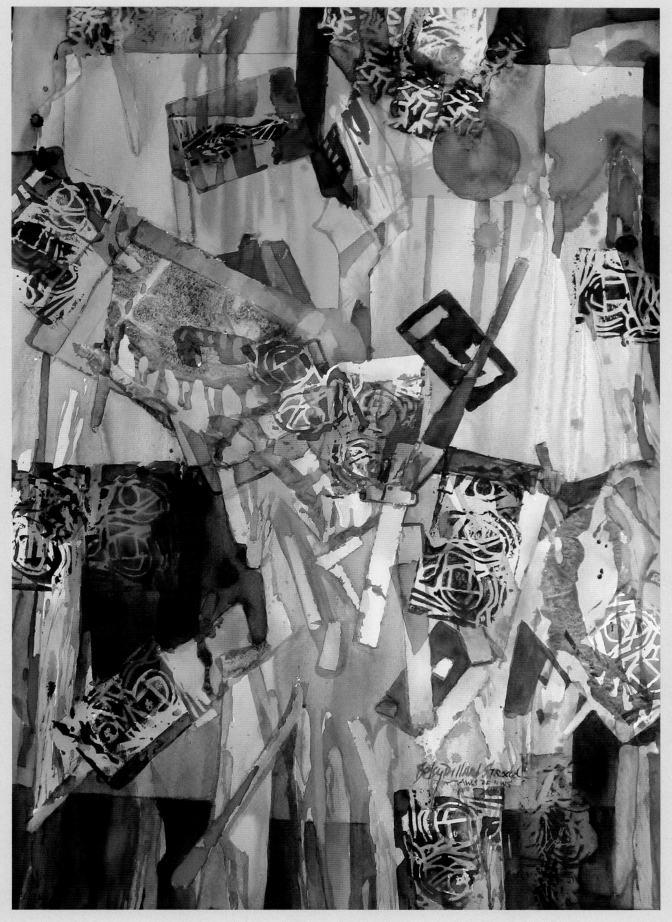

My House Has Many Mansions

When I begin painting, I have nothing planned. Unleashing the subconscious in pigment, making brushstrokes and texture my only goal. I do not attach myself to the outcome. Rather, like a child opening presents, I wait to see what will happen next as I put brush to paper, working rapidly.

1 I begin by squirting four pigments onto a few dollops of fluid matte medium, which I will smear together to make mud. Out of this mush, I will lift, stamp into the wet mixture and sometimes draw with the opposite end of my brush.

2 This is an image of the stamp I carved to go with this piece and the one I use (I use several) to begin the stamping after the first step.

3 Stamping into the smear, I then paint a yellow square near the stamping because I want to make verticals to offset the horizontal beginning.

4 I add calligraphy in a square shape with Napthol Red Deep and keep moving around the painting. I've begun to add some black gesso with a little red mixed into it. Notice the Bleached Titanium White I've added in places and a diagonal red line on the bottom left to say *hush* to the verticality on that side. It's all about the mystery of layering at this point.

5 As I painted, the phrase "My house has many mansions" kept running through my head, and my painting began to look architectural. Never planned, these paintings are part of a series that I mentioned earlier—the Jungian *Imago Ignota*. After staring at the painting for hours, I decided it needed black.

Adding black, I breathed a sigh of relief because I thought, "This is it!" It needed more drama and contrast. It also reflects Robert E. Wood's saying, "Let every painting be a surprise journey with an unexpected ending."

GAUGUIN DREAMING OF MATISSE
30" × 22" (76cm × 56cm)

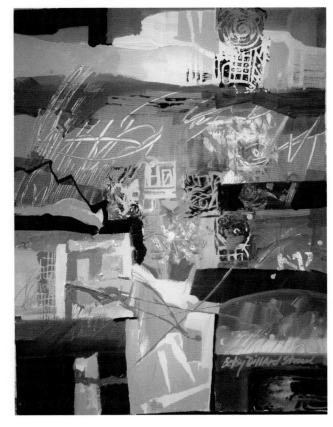

ONE PERFECT ROSE
22" × 30" (56cm × 76cm)

ARIZONA DREAMING
30" × 22" (76cm × 56cm)

Cathy M. Woo

Not having any art supplies as a child did not stop Cathy M. Woo from manifesting her creativity in other ways. This illustrious artist tells me, "Instead, I channeled my artistic inclinations into stamp collecting. I loved the colors, shapes and designs of postage stamps from all over the world and from different times of history. I was also an obsessive seamstress who taught myself to sew my own clothing. Sewing is the magical art of constructing a three-dimensional garment from a two-dimensional piece of cloth. And each piece of fabric, like a painting, has its own color, pattern and texture.

"Creativity, art making and painting were always underlying themes in my life, "she adds. "I took for granted that I was a visual person who processed and digested life in images. As a child, I also needed to spend a lot of time in solitude in nature, and nature has always been an inspiration for my artwork. But I didn't commit to truly being a full-time artist until I was in my late twenties."

Two locations gave Woo a cornucopia of ideas for paintings that would later develop. She was born in Oakland, California, but her family didn't settle there. They spent several years in the Bay Area when she was young and then moved to a small town on the East Coast. She describes this experience. "Each of these locations, so different from each other, offered me experiences of culture and spectacular natural beauty that I incorporate into my paintings to this day."

While living in Massachusetts, she was able to attend Saturday art classes at the Museum of Fine Arts, Boston. After the classes were finished, Woo would wander through the galleries and visited paintings by the Old Masters as well as the European Impressionists. She remarks, "These visits to the museum and its real-life painting masterpieces opened my eyes to a world of art I never could experience through books."

Discussing her process, Woo opines, "My art has been about change over time—both personally and artistically. My life informs my art, and my art informs my life. And I have consciously worked at developing both. Participating in a painting session, one has to be open to the unexpected, the untried, the previously discarded and rejected. One depends on past skills and experience as a foundation and a guide. One questions authority and is not obedient to a lockstep series of rules. This approach makes painting a rather frightening and daunting experience. It creates a lot of anxiety and frustration. Along my journey, I have always had a strong sense of curiosity and adventure. I am always asking myself, 'What would happen if I did this …' It's rather like jumping off a cliff into the unknown.

"When I first started painting, my goal was to develop successful paintings, but this kind of approach forces me to ask important questions such as 'What is a successful painting?' 'Is this painting unique?' 'Does it reflect my authentic self?' 'When is it finished and why?' My process has become more about addressing a series of questions rather than producing rote answers."

Describing her process, Woo admits, "During the painting process, I invite chance, impose relationships, invite trial and error, and cultivate connections and clashes. I aim for jarring, disastrous dissonance as well as soothing, mellow and subtle transitions. Much of my process is a crapshoot that I can edit later."

Woo is no stranger to painting out areas of her painting if a beautiful area doesn't work. A plethora of colors, shapes, lines and patterns decorates her surface. It's the yin/yang in her painting that is so compelling, with many organic, flowing shapes (feminine) juxtaposed with geometric (masculine) ones.

She uses ambiguity to tantalize the viewer. Bold colors and strong patterns vibrate against scumbled grays, coexisting with veiled passages, a palimpsest of the artist's thought process. Imprinting, collage and sometimes strong, sometimes subtle areas surround a focal point of impasto paint and geometric shapes painted in brilliant colors. These saturated geometric shapes may appear on the side of her painting or sometimes floating above it. Sometimes circles dominate. There is an element of the totemic in some of her images, reminding me of ancient walls decorated with ornate symbols. Woo has created a spatial world replete with her own language, a language that draws the viewer to contemplate, speculate and enter the lavish surface of her creative works.

UNTITLED ➤
24" × 24"
(61cm × 61cm)

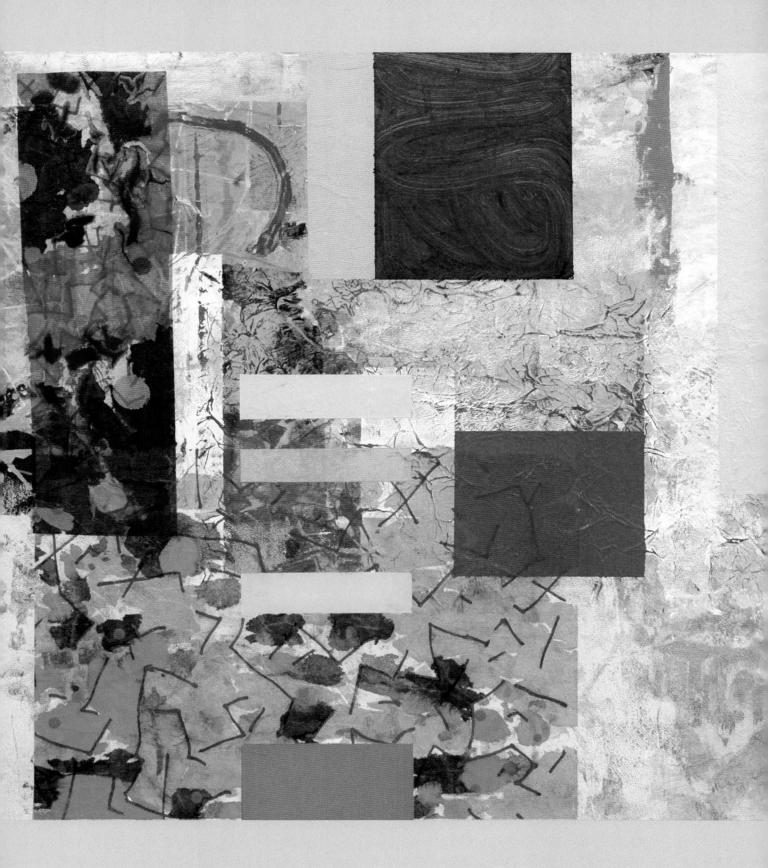

Untitled

Cathy M. Woo begins her paintings intuitively making brushstrokes. Her objective is to use layering in color and collage, marrying those elements for exciting surfaces rich with texture and complex pattern.

1 Woo begins to create a base layer of collage and random geometric painted shapes, and at this point is unconcerned with composition. She plays with color, pattern and shapes using homemade collage materials and a variety of acrylic paints.

2 Starting the process of creating multiple alternating layers, Woo applies a warm unifying color using plastic scrapers and silicone spreaders. She also paints out much of the collage, allowing notes of color to peek through the new layer of paint.

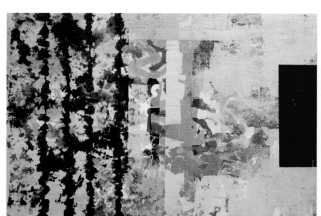

3 On the left side of the painting, Woo layers more collage and smacks the right side with a big block of Cobalt Blue paint, keeping in mind the concept of the juxtaposition of opposites: squares against curves, bright versus dull, light against dark and so on.

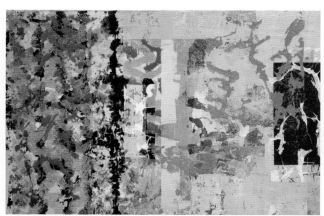

4 More collage is applied on top of both the left and right sides. Pattern and rhythm are among her favorite painting elements.

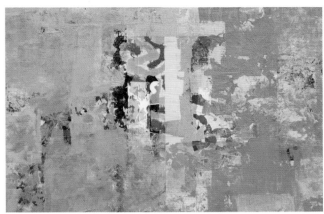

5 The final layer of warm tones allows contrasting cooler green paint and patterned layers of collage to both emerge and recede into the background.

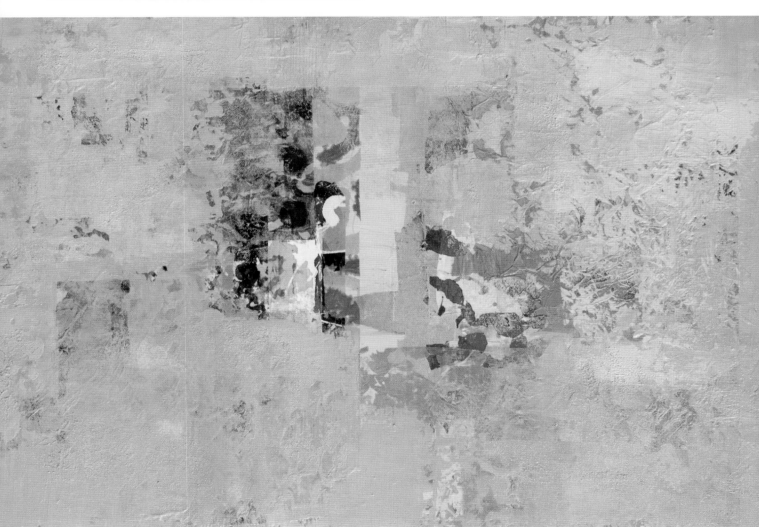

6 Woo plunges ahead and sacrifices much of the green layer to establish a contrasting underpainting of color that will be visible through the final layer of paint.

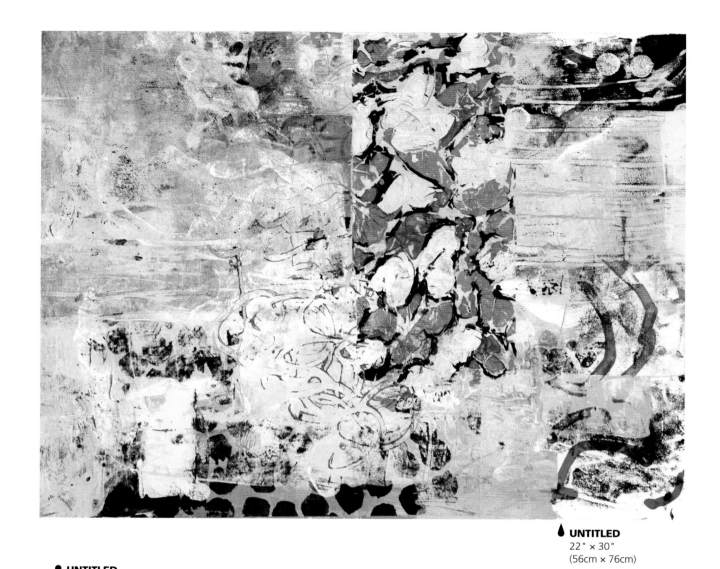

UNTITLED
22" × 30"
(56cm × 76cm)

UNTITLED
24" × 24" (61cm × 61cm)

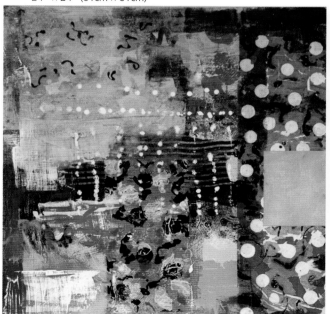

UNTITLED
22" × 30"
(56cm × 76cm)

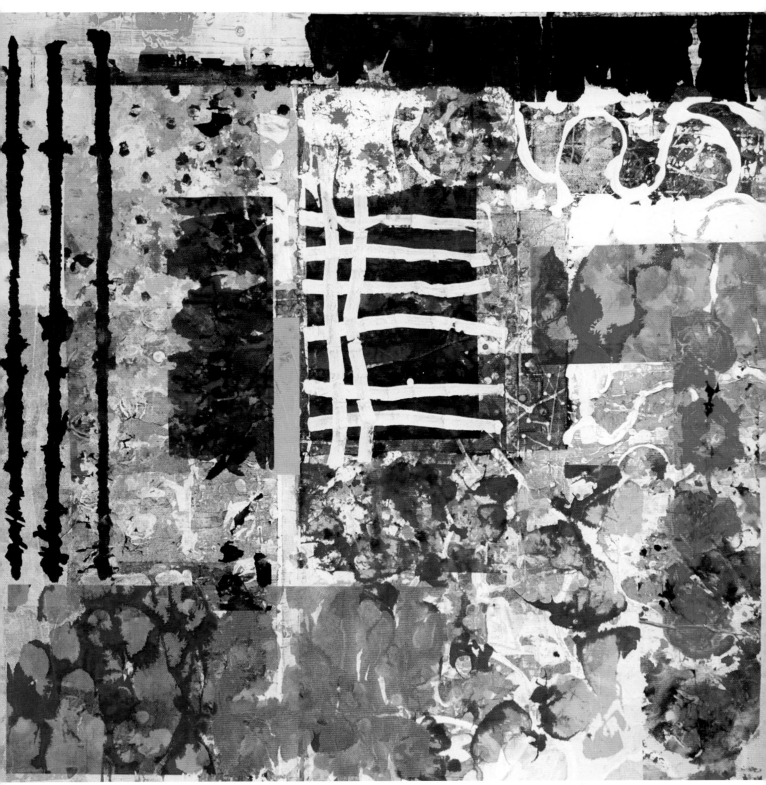

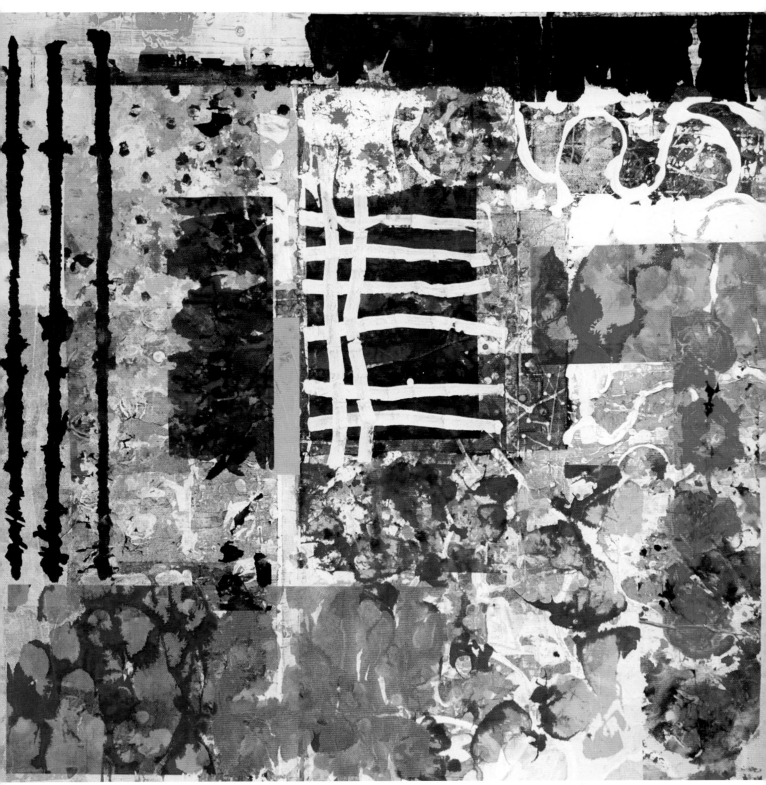

🟦 **UNTITLED**
24" × 24"
(61cm × 61cm)

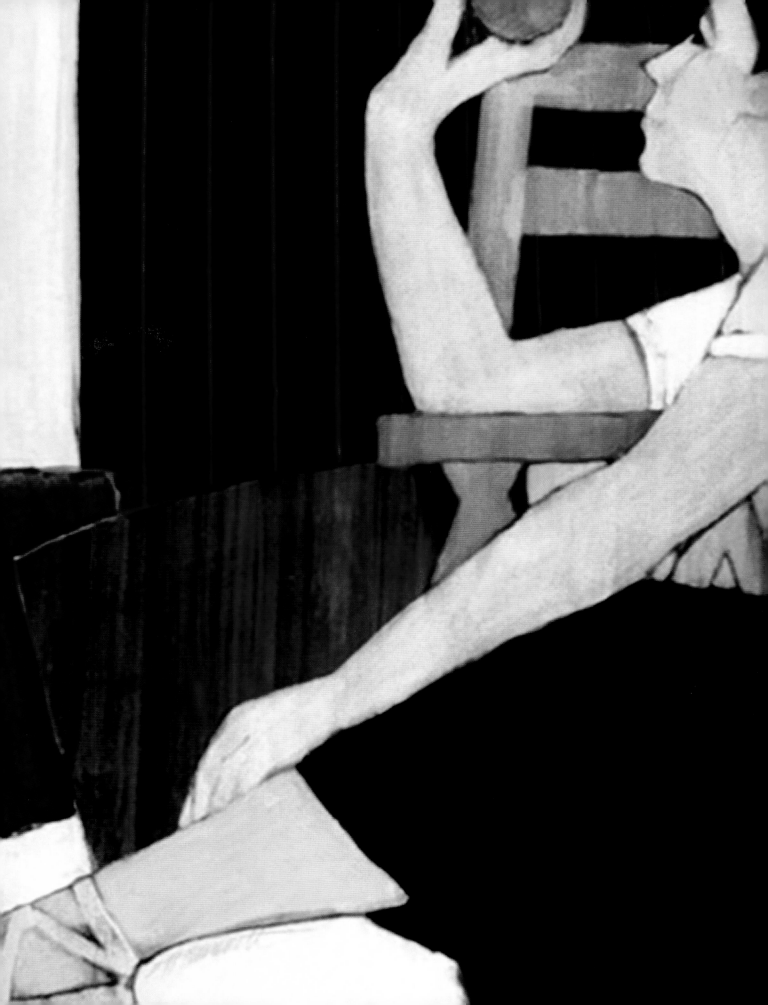

PART TWO
Legends

Many argue that the word *unique* is a cliché and should never be used.

Many argue that nothing can be original. And yet these artists, these legends, all created something so different that they refute all claims above. The diverse characteristics of their work, their discoveries and their approaches represent a lifetime of passionate exploration, painting and dedication. Their talents and abilities are only part of their legacy because they have shared their vision with thousands of students. In these pages, I present some of their images, images that exemplify their innovations and contributions to the world of watercolor. In addition, I add some of my own personal memories.

It is an honor to have known and benefitted from these superior artists. Their boundless wisdom and their insightful words and character made a lasting impact on me as on thousands of others. It is with humility and a sense of grace that I thank them for their contributions. Their legacy is a divine gift to be cherished by all.

◂ **BLUE EGGS
(CROPPED)**
Polly Hammett
20" × 22" (51cm × 56cm)

Mary Todd Beam

"I was born with a paintbrush in my hand," Mary Todd Beam says with a chuckle. Born at the end of the Depression, with little money for extras like art supplies, Beam's desire to paint would manifest in an innovative way. That innate desire led her to an alley where she painted on sidewalks with water. When the painting dried and her image disappeared, Beam would just sit there and cry. Her talent, she thinks, is genetic, as her father was a painter. She remembers the excitement of sitting on her father's lap, watching him draw cartoons.

Snuggly wrapped up in her blanket on Cricket Holler Road in Cosby, Tennessee, she reminisces about her painting and her life. Her astounding abilities showed themselves early; in the third grade, she won a contest called "Who can draw the teacher best." Beam reflects, "After that, I didn't have to do math. I got to leave class and go to the Dayton Art Institute."

After high school, she went into nursing, but that was a bust because, as she recalls, "All I did was cry with my patients."

Her charming personality and her instinctive and ingrained talent have entertained and educated students nationwide, and her paintings have won innumerable awards nationwide, including two gold medals from the American Watercolor Society.

Beam's surfaces are rich with texture, mysterious passages and allusions to her life. With her limited palette and a variety of tools, she explores her spiritual and physical milestones, both in reflection and in her daily existence. The hand is a favorite leitmotif of Beam's, and she uses it symbolically.

Early in spring 2015, a talented stone mason came to the Beam house to do some masonry work. After he finished his job, he asked Beam if he could look at the paintings housed in the gallery attached to her house. He said to her, "I'd like to look at them alone." Beam acquiesced but couldn't keep herself from looking in the window as he stopped at every painting, giving it his full attention. When he came out of the gallery, he said to her, "Mrs. Beam, this isn't a gallery. It's a chapel."

Iconic and archetypal images in her work suggest a strong spiritual essence. As a contrast, her playful nature loves textures, and the combination of the textural products she uses and her endless imaginative explorations always creates an adventurous surface and an artistic challenge. "Texture," Beam says, "gives the eye more clues as to what is going on in the painting. It can reference Earth, or it can suggest age and what went before." Now she is working on a painting about her husband, Don (who died two years ago), using red as the dominant color in the painting, symbolic for passion.

She advises artists to make their own symbols and encourages them to work with black gesso. "Don't be afraid of the dark," she advises. "Black recedes, and white comes forward. Black gesso serves as a good base for a painting. Put some textural things in the black, and draw into it while wet with a ballpoint pen. This makes a relief. You are mark making just as the ancients marked on the walls of caves and tombs." Beam exemplifies all the salient characteristics of the intuitive painter in her work. She allows images to emerge, and then she refines and works with those images until she achieves the specific expression she desires.

"My goal in art is to become a visual poet," Beam asserts. "To be a visual poet, there are four things to consider. First, you must speak in metaphors. Second, you should have a narrow focus. Third, use humble subject matter from everyday life experience. And fourth, recognize that you celebrate life by doing this." She laughs heartily. "You don't have to go to Venice to paint.

"When I first started painting, I was in a workshop with Ed Whitney. A lot of us sat on the floor around him. He looked down at me and said, 'Young lady, you think you're designing your painting. But you're really designing your life.' I didn't know it at the time, but he was absolutely right. And Ed Betts remarked, 'Look down at your feet. There's a whole world down there.' That's when I started watching how leaves mass together," she remembers. She recalls another specific, poignant event. "When Ed Betts died, my class on Spruce Mountain and I went to a lovely place, and we each painted a rock with Ed's name on it. Then we sang Amazing Grace. His wife, Ettis, said that was better than having a tombstone. The pile of rocks is still there, even though Ed's name is worn off of most of them."

Her solid advice to students is simple, yet profound. "Sometime, if you have the opportunity, take a walk in the mountains, and when the flowers are spread in front of you, if you listen, you can hear the mountain music, too."

Mary Todd Beam began painting with water and has continued to paint with water, now adding paint. Her enigmatic and expressive content, her luscious tactile surfaces and the emotions they evoke in the viewer make this lovely artist a true master who is legendary.

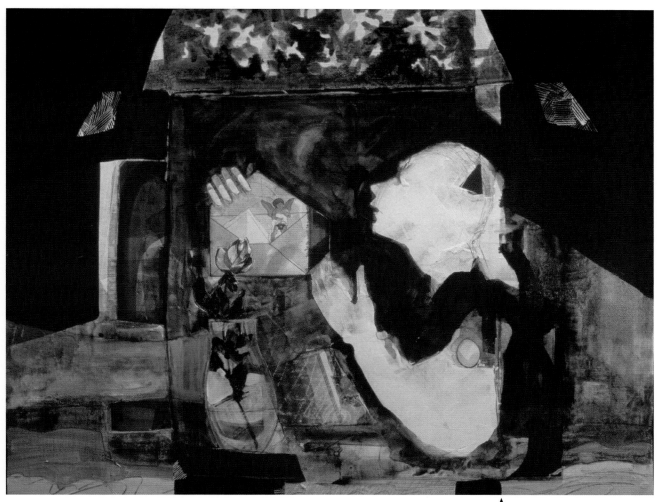

● **WAITING FOR THE MALE**
30" × 40" (76cm × 102cm)

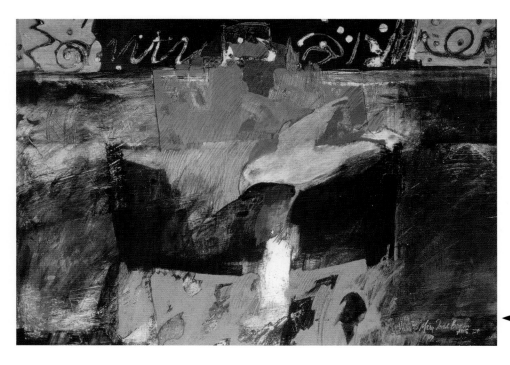

◀ **BEFORE ANGELS SANG**
30" × 40" (76cm × 102cm)

Ed Betts

Tall, elegant, intelligent Ed Betts (1920–2008) commanded a room. His charismatic and intuitive nature made him a great teacher, and his keen eye and his innate talent and learned insights made his paintings outstanding.

I met him in 1981 in Dallas. Betts was conducting a workshop, and students had to enter slides to get into his workshop. Miraculously, I got in, but I had few watercolors and a lot of drawings that I had done from the teachings of expressionist Morton Traylor, who studied with Rico Lebrun. My drawings on bristol board were expressive abstractions, sometimes with a hint of realism. One mandate Betts demanded was that all students bring in a portfolio of their work. The other members of the workshop weren't pleased to have me, the neophyte, in their talented midst, and I was so in awe of their paintings that I thought, "Just leave now before he gets to your portfolio."

When he sallied up to me, I told him that I had brought only drawings because I was new to watercolor. He opened my portfolio and began going through the drawings. I held my breath. All of a sudden, he stopped the class by saying, "I want everybody to look at this child's drawings." I almost fainted. He proceeded to take my portfolio and show all of my drawings. He said, "I want to see this child's watercolors fifteen years from now. She says she hasn't done many watercolors, but she draws like an angel." My heart soared like a hawk, but I gaped in disbelief.

Amazingly, fifteen years later to the month, I got into the American Watercolor Society in New York and won a High Winds Medal, and Betts was one of the award's jurors. When I received Signature Status four years later, he was also a juror.

In 2000 we met again in Houston and had a chance to talk. I lauded his book *Abstract Seascape Painting* as the best book I'd ever read about abstract art. The book was out of print, and I bemoaned that fact. A few months later, I had just left my mother's deathbed, and when I arrived home, there was a package on my front porch. I tore open the package, and in it was his book. He wrote on the title page, "To Betsy: I was cleaning out my studio, and I found this last book. I can't think of anybody I'd rather give it to than you. Ed Betts."

Betts insisted on the best from everybody, and that made him a spectacular teacher. A few years before he died, I had the opportunity to write about him for *Watercolor Artist* (then *Watercolor Magic*). Our interview was sprinkled with both his infectious sense of humor and insights from his towering intellect. We laughed uproariously, and I reminded him of the important part he played in my development as an artist. He laughed and said, "I just have good taste."

His representational paintings reflect his love of landscape, and his abstract paintings are emotional, dramatic and sometimes cryptic. His paintings hold the viewer spellbound. The realistic ones are characterized by strong drawing skills, and the abstracts teem with the energetic magnetism that comes from spontaneous beginnings. In all of Betts' paintings, we find the genius and the extraordinary vision of this giant in the art world. Always in his paintings, as he would say, there is a feeling of landscape because he believed that abstraction derived from astute observation. He leaves an invaluable legacy for the watercolor world.

BAIT WHARF (PERKINS COVE) ➤
(Collection of
Ogunquit Museum of American Art.
Gift of the Edward H. Betts Estate.)
27" × 21" (69cm × 53cm)

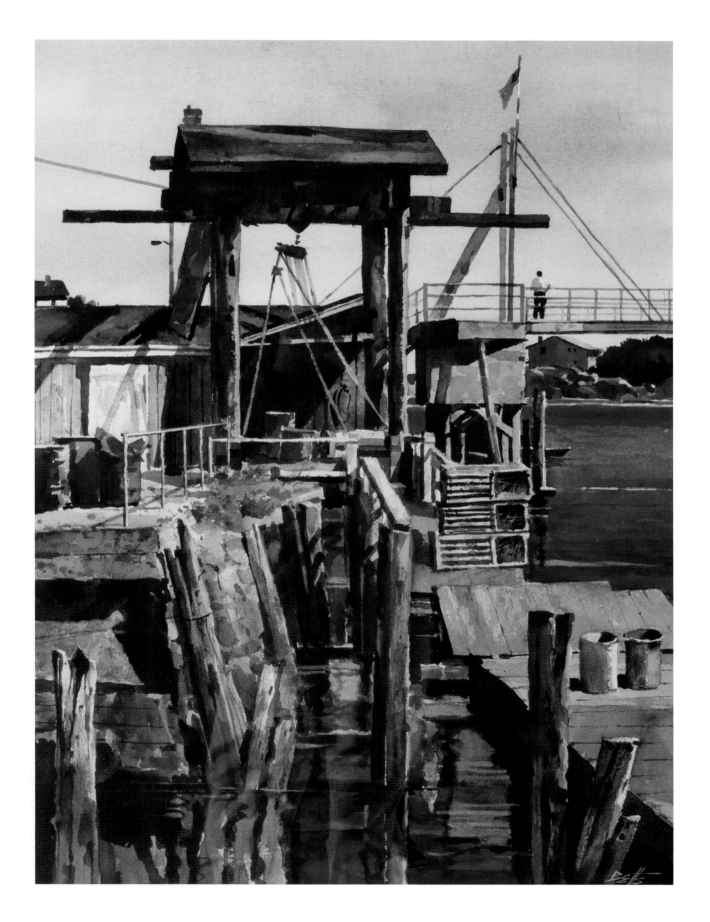

Gerald Brommer

When he was in the fourth grade, Gerald Brommer contracted measles and couldn't go to school for weeks. He kept up with reading, writing and arithmetic but not his assigned lessons for art. He went outside and decided to draw some irises in his backyard. When he went back to school, he apologized to his teacher that he didn't have the art assignments she had given, but he did have a drawing. The teacher held up his drawing and remarked, "Now this is real art." That did it. Brommer was hooked. "I want to be an artist," he said to himself.

And now, he asserts, "Somebody has to point you in the right direction or something has to happen to make you have this realization. I've never forgotten that in all my years of teaching. Always start with a word of encouragement. In college when I told my counselor that I wanted to be an artist, he looked at me and said, 'Now, you don't want to do that.' I took a different route and became a geographer. Then one Christmas, Georgia, my wife, gave me a set of oil paintings, and I began painting. I asked the principal at the elementary school that I taught in if I could also teach a painting class. He was fine with it. Then I was offered a job at UCLA to teach geography. Georgia and I had gone away for two weeks, and when I came back, I found out I had been offered a job at UCLA. I also found out that since they hadn't heard from me, they hired somebody else."

Fate stepped in again and pointed Brommer to his true path. He began teaching high school students art. Twenty-seven books and countless accolades and awards are the tip of the iceberg for this creative man, whose innovative approach to combining collage and painting cracked open the watercolor world to ensure his irreplaceable presence in and gift to its history.

How did he arrive at his destination—to make that break into the watercolor world with collage? After reading an article by Glenn Bradshaw on collage, he began to experiment with collage and watercolor. He entered a show and won best of show (as judged by Keith Crown).

As a humorous footnote, Brommer told me that at Yosemite National Park he painted one-and-a-half watercolors while Ansel Adams was shooting one picture in a tide pool.

Brommer personifies the archetype of the zen master. He is always on the mark with a pertinent and positive commentary. His critical eye in helping students to improve is unmatched. He has a priceless sense of humor about himself, life and art. And perhaps most importantly, he is a consummate teacher whose gifts have shaped the lives of so many grateful students, including mine.

A few years ago Brommer critiqued the Western Federation of Artists Exhibition, which he had just judged. He received a standing ovation from a sizable audience. Gerald Brommer, the artist, the man and the friend, deserves a standing ovation for the rest of his life.

"Collage is a medium that is continually transforming, subsiding, leaping into unexplored area and growing. Artists explore abstract, representational, semi-abstract and nonobjective imagery through a variety of collage techniques."

— Gerald Brommer from *Collage Techniques*

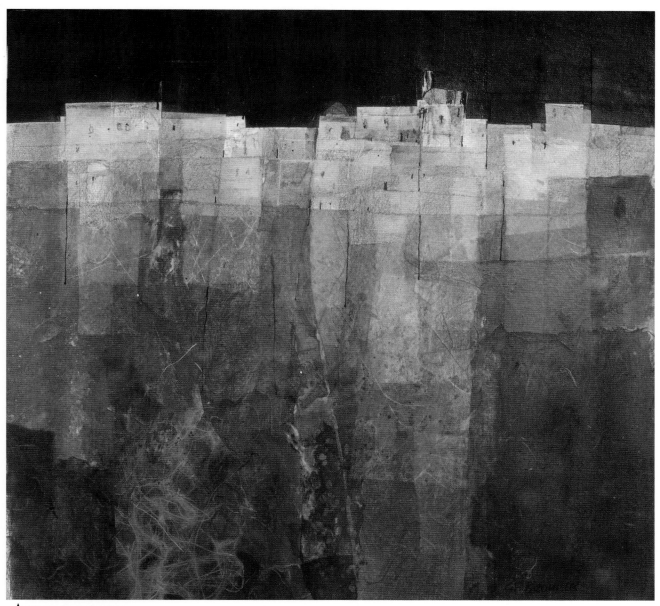

💧 **ITALIAN HILLTOWN**
11" × 11" (28cm × 28cm)

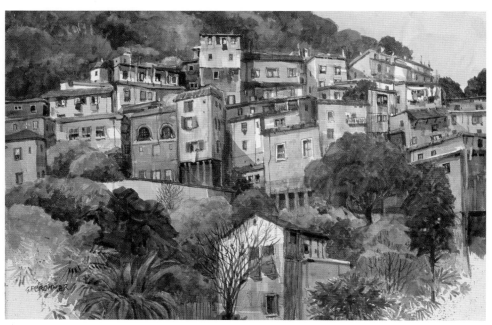

TAXCO HILLSIDE ◀
15" × 22" (31cm × 56cm)

Naomi Brotherton

It is a few days after her ninety-fourth birthday when I speak to Naomi Brotherton, and she is still painting and still teaching. Despite her macular degeneration, her creativity thrives along with her indomitable spirit.

"When I was little," Brotherton recalls, "my folks gave me pencil and paper at church because I wiggled so much. I began drawing people in the church. One day a woman sitting next to me taught me how to draw wavy hair. I was hooked at an early age. And when I went to Baylor College, I was introduced to watercolor. I wanted to become a fashion illustrator, and watercolor was used for that profession then."

Brotherton's influence as a teacher is legion. She teaches the basics and allows her students to go their own way when they feel they can leave the nest. Her method of teaching is gentle, and yet she firmly sticks to her guns concerning her feelings about watercolor and the way it handles best. "Go in and out of a sky in thirty seconds," she says. And she is always right.

Perhaps some of her best inventions are her night scenes. She credits Ed Whitney for her extraordinary sense of design.

Brotherton, Bud Biggs and Reese Kennedy started the Southwestern Watercolor Society, a regional watercolor society based in Dallas. Through that organization, many of the best painters in the history of watercolor in the last and present centuries taught workshops. I remember the day Brotherton said to me in her sweet manner, "I think you ought to join SWS." She said this as she poured coffee all over my arm instead of into my cup.

It was a totally hilarious moment. I was not hurt in the least, and I still tease her about that day.

From Brotherton I learned so much about the nature of watercolor, its eccentricities and its handling. She taught value and composition, and her charming way of depicting landscapes is always recognizable. With the patience of Job, she taught wet-into-wet flower painting and painting direct. She taught lost-and-found edges, gradation and all the things you need to know to become a good watercolor painter. She showed us how to get a "thirsty" brush. One unforgettable moment came when she lectured about the importance of palette "mud" in paintings, referring to paint left in the palette that becomes a good neutral. A woman in the class raised her hand and asked, "Where can I buy some of that palette mud?"

To this day, I credit Brotherton for giving me the confidence to go forward with my work. Her invaluable encouragement and our lifelong friendship are gifts that have pushed me and guided me for the past thirty-five years.

As we get ready to end our conversation, she remarks, "I love watercolor and being an artist. I have been fortunate all through my life." Brotherton's legacy is immeasurable because she infuses that enthusiasm into the many who love her and have been taught by her.

The Southwest Watercolor Society in 2015 awarded Brotherton its highest honor. In perpetuity the Naomi Brotherton Award is now Best of Show.

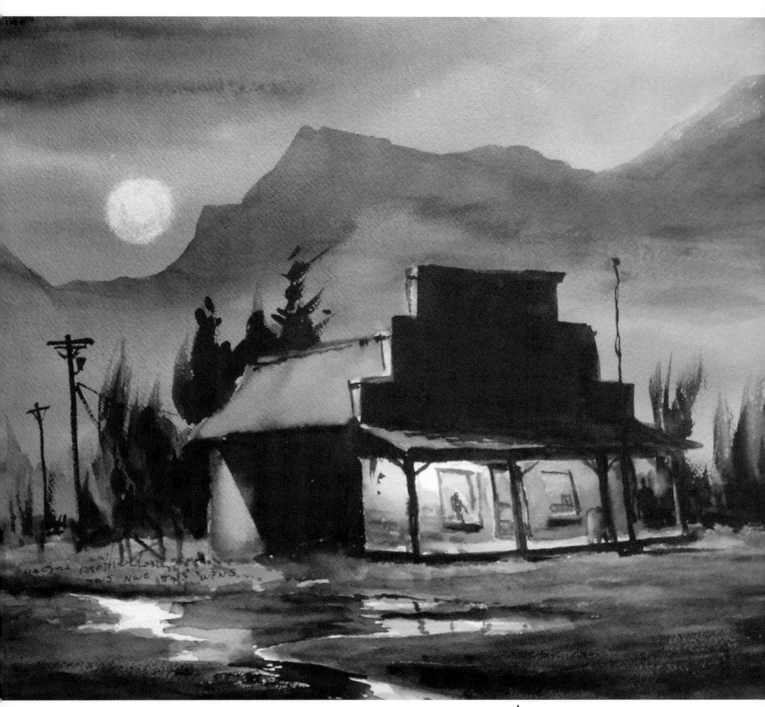

CORNER STORE CLOSING TIME
22" × 21" (56cm × 53cm)

Virginia Cobb

Virginia Cobb is a true legend. As a young woman, she was chosen as a member of the National Academy of Design. Here is her story.

"I am the daughter of an artist and the granddaughter of a poet who read Shakespeare to my sister and me when we were too young to understand the words. I learned early to listen and watch for nuance and subtext—a language of expression, gesture and symbol—rather than fact and data. In answer to a question I have since forgotten, my grandfather said, 'It is real if you believe it is real.' That statement did not stand me well in math and history classes or prepare me for a career in anything but art.

"When we were children, we were expected to amuse ourselves with paints and pencils and brushes while our mother was working in her studio, and we each developed individual methods of expression early. My paintings proceed much as my life has. I throw myself into each experience with great abandon, finding my way through to resolution by trial and experiment. As a result, my paintings never fail to surprise me, and I hope that will always be so."

Cobb's influence as an abstract artist is legion. Her work is configured with iconic images mixed with layers of paint and unexpected juxtapositions. As a member of the National Academy of Art, she has set the bar for all women artists. Her book *Discovering the Inner Eye* is a groundbreaking book on abstraction. In it, Cobb talks about her own artistic odyssey, taking the reader on an adventurous journey in paint.

Cobb is an artist whose work has many layers, as does her life. Her paintings present the viewer with a marvelous challenge as we enter her mysterious and labyrinthine compositions. Her gift as a teacher is to encourage the student to express him or herself in myriad ways.

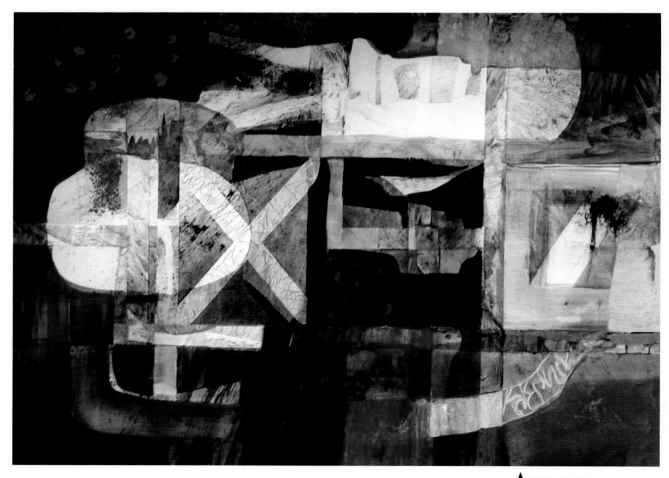

BIRD GAME
22" × 30" (56cm × 76cm)

● **SECRET SOCIETIES**
32" × 40" (81cm × 102cm)

● **THE SQUARE ROUTE OF RED**
46" × 92" (117cm × 234cm)

Polly Hammett

Polly Hammett and Virginia Cobb are sisters, yet their art couldn't be more different in subject matter. Both are masters of design, and both are acclaimed for their inventiveness.

Polly describes her art. "I've always painted women because I was surrounded by women—aunts, my grandmother, my mother—and I've always been an indoor painter. Growing up in Oklahoma, I did not find the landscape intriguing. We always had interesting art books around, like the illustrations by N.C. Wyeth in many of the children's books I read. I have never changed my subject matter, although I changed my medium and my technique."

Hammett's unique technique involves painting her subjects on hot-pressed paper using a lot of watercolor paint, as thick as oil paint. When this layer is dry, she covers it with a glaze of Manganese Blue and allows that layer to dry. Then her deft hand lifts her lights out with a wet brush, revealing the design beneath. Her paintings are always architecturally designed with an innate sense of spatial integrity. The intimacy in her paintings evokes emotional response and visual delight. There is no depth in her paintings, as she concentrates on flat, beautiful shapes and bold color, although with this technique, she often creates nuances of color by lifting out.

The most important thing about being an artist, she says, is acknowledging that "art is a question—never an answer." There is no question that Polly Hammett has earned her place in the stars, no doubt about it.

◗ **VIRGINIA'S QUILT**
20" × 22" (51cm × 76cm)

💧 **HE LOVES ME, HE LOVES ME NOT**
22" × 20" (56cm × 51cm)

George James

California painter George James is a nonpareil. His paintings of enigmatic figures enclosed in decorated geometric backgrounds of intriguing and complex patterns and motifs have won this artist a slew of medals, including the gold and silver medals at AWS. How did this creative artist find his way? What impulses led him to his life as an artist?

"I began with the violin," James says. "But I had a teacher with a sister who painted, and when the teacher invited us to her house, I saw her sister's paintings hanging on the wall. That was the beginning of my desire to paint."

In his hometown of Detroit, James also credits the yearly J.L. Hudson Exhibition as another stimulus that fostered his desire to paint. But a few years later, a move to Newport Beach, California, gave him opportunities he never dreamed of. The great painter Rex Brandt and his wife, Joan Irving, became close friends, and James began taking classes with Brandt. At one point Brandt offered James a scholarship to paint solely with him.

Laughing, James explains. "I was a gopher for Rex and Joan. I would babysit, but I would also paint with Rex every day. And his studio was always open to all the painters, so artists like Phil Dike, George Post and Millard Sheets dropped in. Art was always going on."

Brandt's analytical approach to painting influenced James. From Brandt and the other artists, James learned their point of view—the aesthetic geography of California: sky, light, water, boats. But then James began to shift away and do more conceptual art.

"Rex was a wide open fellow who could talk art with anyone," James says, and he credits Brandt with helping him understand the importance of building a solid foundation for his art. He laughs. "Call it mumbo jumbo, but it's a fact that often you learn things that you don't realize you'll need down the road."

Another powerful influence in James' development took place in Dong Kingman's studio, always open to artists and always with myriad paintings in progress.

As the art world changed, James remembers a young man came from New York sporting splashy abstract paintings, and Brandt gave him a stern critique. He called it "splash with no substance," which James asserts is a common problem with some abstract paintings today.

Encouraged by Dick Stephens, James entered Chouinard Art Institute and gleaned from the masters

there, a big stepping-stone for his work. At Chouinard, he joined a group called Exodus. The group always worked between traditional ideas and abstract and contemporary art. The ability to bounce ideas off each other made this group a godsend.

When asked how his work has changed him, he answered, "Teaching and working with young intellectual students, doing more reading about art, turned me into a more conceptual painter. We were lucky because Al Porter, who was my officemate, got watercolor put into the curriculum of California State University, a university where eventually I landed a job." At that point, he admits, "I had no clue which domino I was." Now James is a professor emeritus.

"I got involved in the watercolor world in a big way in 1992 when I discovered Yupo. It took me two years to really understand all the mysteries it can conjure as you paint," he explains. "When I won the gold medal in AWS with a Yupo painting and two bronzes right after that, I really had to blink. The biggest lesson I've learned from art is that I am truly a visual person. I am always looking at things—visual arrangements, pattern, shapes, and even when watching television, I am looking at the two-dimensional way of arranging things. I always start big and work down to minutiae. And I'm always working with graphic elements. When working with Yupo, a whoops (with a little manipulation) can become a beautiful place in a painting. And it is often the whoopses that provide the decorative aspect to my designs."

James' love of drawing led him to figure work. Painting directly from the model and working with graphic elements are the most important factors in developing his style. His work is characterized not only with intriguing narrative, but also by conceptualized descriptive figures enhanced by the interpretive space around them. His interiors display a mastery of provocative designs and unexpected motifs. He feels there has to be a sound relationship between the brush and the mind. James' paintings are narratives, and his inventiveness lies in the endless ways he narrates through paint the stories that enthrall us visually and are a lasting tribute to this masterful artist.

Trust Your Eye. Think of watercolors as shorthand, not longhand, and as suggesting, not rendering, a subject. But most importantly, think about watercolors as a visual haiku, a short insight into a moment or a feeling.

— GEORGE JAMES

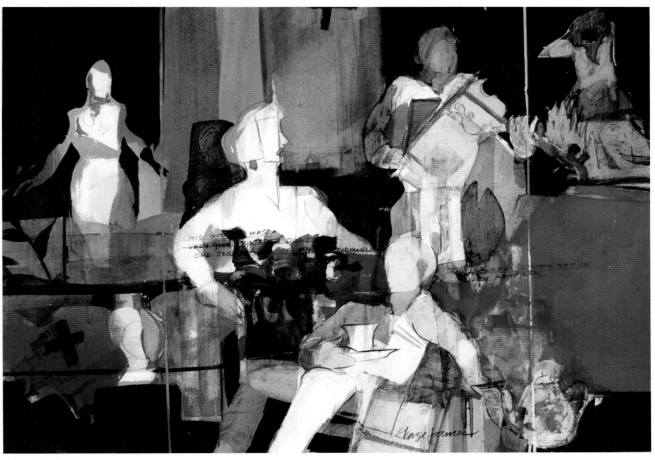

💧 **UNTITLED**
22" × 30" (56cm × 76cm)

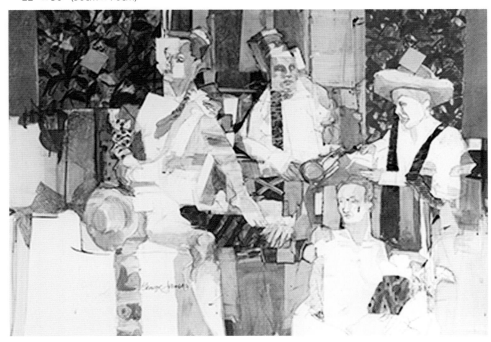

◀ **UNTITLED**
22" × 30" (56cm × 76cm)

Tom Lynch

At the age of twenty-two, Tom Lynch burst onto the workshop teaching scene with unbounded energy, an unmatched creative drive and youth (he was possibly the youngest workshop instructor ever at the time he began). Forty-three years later, he is still going strong with the same verve, joie de vivre and dynamic approach to teaching. In high school, Lynch found himself mesmerized by art, and that was that. Once he wet a brush, he never followed the conventional road again. He owes a big debt to his parents because even though they didn't understand what he wanted to do with his life, they provided him with a space to create, and they displayed his work with pride, which gave him a feeling of accomplishment. He says with a laugh, "Refrigerator magnets were my claim to fame."

Oils were too slow for this brush dynamo, but watercolor was a perfect match. After high school, Lynch won a gymnastic scholarship, and his father was all for it, but Lynch wanted to go to art school. He spent three years in art school and one year at university. After his years of study, he became an illustrator and did black-and-white illustrations for newspaper furniture store ads. As a result of that training, his art became more tonal and realistic. He had learned value.

Soon, however, Lynch got away from commercial art because, he says, "Your art is not your own." His first big

workshop was in Dallas, but his big break came with his television series, which aired on PBS for ten years.

One secret he shares and one of the most important things he learned was to work in a series with one theme. Unique themes like Chicago at night, Chicago at sunset, Chicago at dawn became his hallmark.

Athletic metaphors like "Practice makes perfect" morphed into his painting methodology. Lynch also credits many teachers with helping him perfect his special skills, including Nita Engle, John Pike, Bob Wood (for color), Zoltan Szabo (for edges), Irving Shapiro (for "the first wash") and Richard Earl Thompson (for translating the subject).

In the beginning, he admits, "I spent too much time on technique and not enough on creativity. I should have explored that earlier." His epiphany came from a client who asked him to paint a building in an exhibit that he had sold to someone else. Eureka. He realized that it was a description and a mood that he was after, not a specific place. His motto today is: "Get out of your comfort zone and don't ever stop studying."

Tom Lynch is an artist who looks to the future as he explores new avenues for self-expression and novel methods to teach students how to paint. With his great success as an artist, he gives the most valuable gift of all: He pays it forward.

◄ ANTHEM
14" × 19"
(36cm × 48cm)

Lavender Skies
30" × 50" (76cm × 127cm)

◄ **MONET'S LILY POND**
24" × 18" (61cm × 46cm)

Paul Melia

As a child of four-and-a-half, almost five, Paul Melia was hit by an automobile, and by the time he was eight, he had terrible breathing problems. He describes this devastating experience. "I couldn't go to school, and I couldn't sit up. So for me there was no playtime. That's when I began to draw. At this point, my weakness became my strength.

"My father used to carry me into the doctor's office, and I began drawing airplanes. I feel my angels are always with me because after the Depression, when World War II began, my uncle was in a classified position (in the army), and he used to send me lots of photographs of battles, tanks and people. These endless photographs he sent provided me not only with inspiration but an almost infinitesimal amount of drawing material."

Melia was lucky enough to go to an art high school in Dayton, Ohio, where he had great teachers. Because of his experience there and the experience he had drawing from classified photographs, he decided to pursue a career in commercial art. He says with a laugh, "I was always fascinated by the illustrations in magazines in the 1930s and 1940s. It's funny. Then I hated Picasso, and later I began to love Picasso and Matisse. By accident, I found my style. For me, watercolor was too bland, so I tried tempura, gouache and ink, which had guts and power to them. Of course, I used them transparently in conjunction with pastel and markers, because you could see through the transparency and explore your drawing. I'd always start with a drawing—make a small sketch of it—and when I got a gem of an idea, I'd then take that idea and blow it up on my board and complete it.

"I also began collaging and became inspired by the cemetery in Queens. Using scissors and X-Acto blades, I would cut out parts of my painting and glue down those parts until I had glued down the whole composition.

Paul Melia's superb drawing skills and his experimental paintings—a combination of pouring inks and then refining with gouache—show the amazing scope of this fantastic artist. In 2015 Melia was awarded a lifetime achievement award by the Ohio Watercolor Society.

As an artist, just be aware that change is constant.
— PAUL MELIA

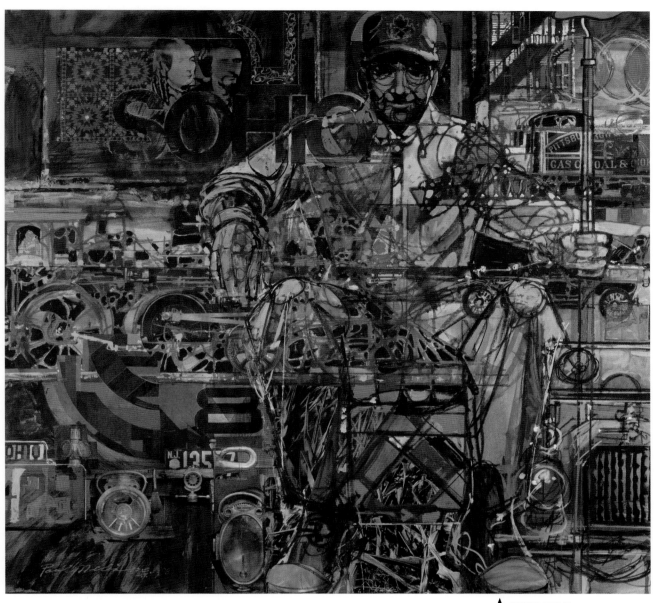

💧 **SOHIO MAN**
44" × 43" (112cm × 109cm)

Barbara Nechis

Barbara Nechis, known for her extraordinary ability in manipulating the brush and her spontaneous approach to painting, in an interview with Konstantin Sterkhov was asked, "The heroes of your paintings are shapes. Do they come to life out of your imagination, or are they based on life impressions when you create them?"

Her response: "They come from inventing shapes, many that reflect those I find in nature. I use fundamentally abstract patterns of nature both as a source of inspiration and as a compositional element sometimes in disorienting juxtapositions. Those resulting paintings allude to the physical landscape without imitating it. My intention is to form an illusion of landscape even though the shapes themselves may or may not be found in nature."

About her content, Nechis explains, "I respond to the entire experience of nature. By not being specific, I capture the essence of feeling about a place and an experience. I use source material, still derivative of subject, but introducing personal abstraction."

When I was a fledgling watercolorist, Nechis released me from limiting techniques by demonstrating her concept of putting down brushstrokes into a wet surface to allow that surface and that brushstroke to dictate another brushstroke and then another. Like holding a magic wand, she uses her brush to encourage imaginative ambiguity. With a wet surface, Nechis begins to paint, washing in color, allowing watercolor to wander its meandering way, and as it begins to dry, she stops. Only when the painting is dry does she execute her masterful layering technique and her unique way of painting negative shapes. Her intuitive and spontaneous approach to painting lends itself to suggestive subject matter and abstraction.

Nechis admits, "I'm wary about formulas of any kind. "Goals are for a football player."

Continuing, she remarks, "There are wonderful things to paint, but they are already there in my head. I take lots of photographs because I am interested in intriguing shapes and ideas, but I don't work from these images. When I start, I don't know what will happen, but within minutes, something happens based on shapes I've found in landscapes. I remember a quotation from Brahms because I've always finished every painting. He said, 'Work at it; work at it; until it is finished.'"

Her finished work is always the epitome of a lyrical poetic style, a haiku in painting terms of unexpected diffusions where form and subject matter coalesce in a subtle nuance of color and brushwork. Her magical technique epitomizes the expressive qualities that watercolor possesses—its fluidity, its transparency and its incalculable mystique. As an artist, my experience with her was lifechanging.

◀ **THE WELL**
22" × 30" (56cm × 76cm)

◊ PLEISTOCENE
22" × 30"
(56cm × 76cm)

GLEN ALPINE ►
22" × 30"
(56cm × 76cm)

Marilyn Hughey Phillis

As is true for many an artist, Marilyn Hughey Phillis' love of art goes back to childhood. Her mother, her ardent champion, signed her up with a teacher, Alma Gardner, and she took lessons all through high school. She began traditionally, with pastel and oil, switching to watercolor in her teens. Early influences were Blake and Turner, and she was especially interested in the mistiness of Turner's renditions.

In the sixth grade, Phillis got glasses, and that was really when she began to "see things." Before she got glasses, she saw objects as ethereal and imaginative, images she never forgot.

As she veered away from representational work, her background in science began to influence her. As she progressed with her painting, that background led her to abstraction. She feels that her artistic ability is genetic; her mother painted, and also had an uncle who painted and drew.

Phillis explains her spiritual and psychological approach to art this way: "I always felt there was a real beyondness in life, connected to more than the ground I lived on." She remembers looking at the horizon, gazing and thinking it was home. Her work is metaphysical, and she explains, "I always try to bring a feeling of light into my paintings that is greater than I."

Her work contains lovely infusions of brilliant light into backgrounds of mysterious diffusions and ambiguous shapes. Phillis has given much to the world of art as she formed and ran the Creative Challenge Watercolor Workshops in Ohio for many years.

In her artist's statement, she writes: "I firmly believe that we as humans are born with a capacity to create.

"An ever present energy to express individuality through whatever one does, but especially seen through the arts, whether they be music, dance, architecture, visual, the written word or mechanical skills, exists within the person. These are the jewels of the creative mind. To use and develop these gifts is to blossom.

"The enormity of creative expression has enriched mankind, has helped to give insight into the many complications of humanity and its problems. In this early twenty-first century with its challenges and complexities, each artist must discover how he or she can best give of his or her talents to mankind. We have much to share and sometimes have vision which is beyond our immediate circumstances.

"As a painter, I expressed the love for nature in my early years with childlike efforts. I wanted to paint every detail in intricate form, but discovered that simplification made a more profound statement. I found that the search for truth and beauty through the use of color, form and light as a response to nature demanded that I include the soul in order to make a complete statement. How to incorporate those four things was the challenge."

As the founder of the Ohio Watercolor Society's symposium Stretching Creative Boundaries, Marilyn Hughey Phillis is a living legend and has made a lasting and invaluable contribution to the world of watercolor.

GALACTIC CONNECTION ►
40" x 30" (102cm x 76cm)

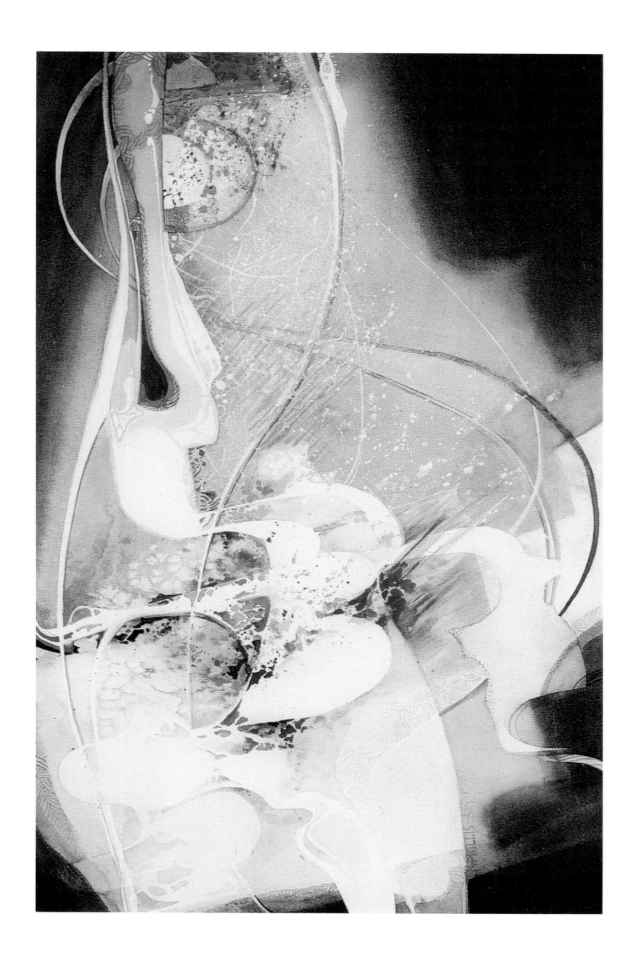

Millard Sheets

Millard Sheets has an iconic presence in the history of art as well as the history of watercolor, not only in America but also throughout the world. He was a man of great character, astutely aware of excellence as evidenced by the way he lived his life and dedicated himself to his art. His paintings and murals showcase an artist of boundless energy and power. I was fortunate to get to be with him on two occasions, and to be in his presence was electric. He and I had a private meeting in which he acknowledged me as an exciting artist who he felt would make important contributions to the art world. That conversation got me through many a dark time.

Once, in the depths of despair about my work, I wrote him and asked his advice. He wrote back, "Betsy, I want you to do twenty paintings about who you are.

Perhaps the paintings will change as you go along, but don't be unnerved. Allow the changes to take place."

This piece of advice I pass along because it is a "journey to Ithaka" for any artist to attempt. (If you aren't familiar with the poem "Ithaka" by C.P. Cavafy, I urge you to look it up.) It was not long after that last letter that I came up with my *Postcards from the Edge* series, which became my signature series and helped me achieve signature status in the American Watercolor Society, the National Watercolor Society and the Rocky Mountain National Honor Society.

Millard Sheets' paintings and murals attest to his marvelous contributions to the art world, and his personal and professional associations with friends and students will always make an indelible mark on our hearts.

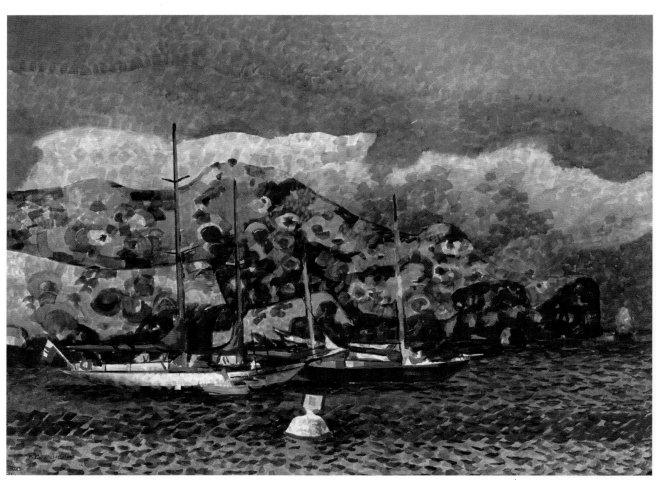

◗ ISTHMUS, ANCHORAGE
(Photo courtesy of
californiawatercolor.com.)
22" × 30" (56cm × 76cm)

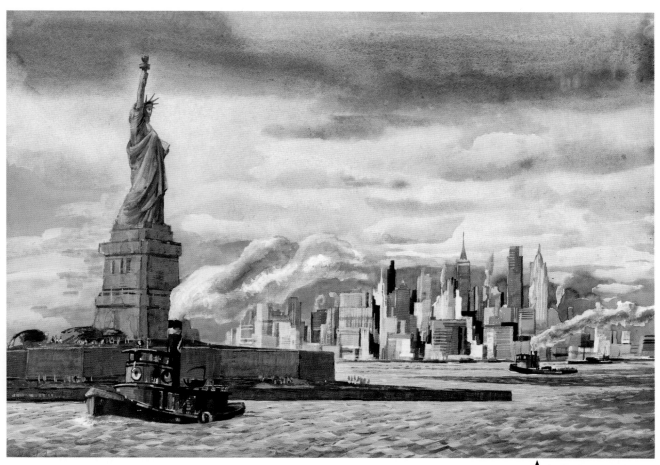

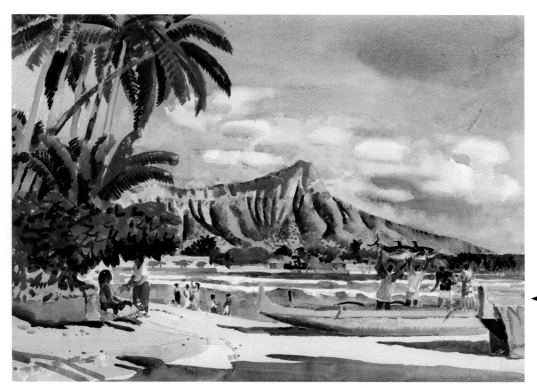

Morton P. Traylor

1976 was a life changing year for me. My uncle Herbert died, and I began the book on him that changed my life. That year I also met Jean Sampson and Morton Traylor. Jean had been his student at the Virginia Art Institute, and although she and I met in a fitness class outside of the University of Virginia, we connected immediately, and I found out that she, too, was an artist. Once a week, when weather permitted, Jean and I drove the twenty-some miles to Crozet, Virginia, where Traylor and his wife, Maxine, lived. Traylor's studio was a painter's paradise. There were bottles of every color, skulls, ropes, lanterns, shells of every description, size and shape, and even live chickens that wandered in and out. Traylor had studied with Rico Lebrun and was quite famous, but, like Milford Zornes, he was approachable and had an earthiness and gentleness that told he was the salt of the earth.

Our first assignment was to draw a rock, and there were various rocks scattered across long tables where students sat. I picked a place and began to draw the rock in front of me thinking, "Boy, is he going to be impressed with how well I draw this rock!" After I finished, Traylor came up and said to me, "Now,

Betsy, I want you to really draw that rock." Something inexplicable happened to me, and I began drawing again, totally unaware of my surroundings. Time stopped, and then I felt a gentle hand on my shoulder. It was Traylor, who held out his hand. We shook, and he said to me, "Welcome to the world of modern art." I looked at my drawing, and I was shocked. Perhaps there was a semblance of a rock, but inside was the nuance of a figure hermetically sealed within its silhouette.

In those days at Traylor's studio, I learned so much about the connectedness of all things, and it paved the way for my development as an artist. The atmosphere electrified me, surrounded by all those fragments of reality, bones and shells, and always the smell of Maxine's humongous peanut butter cookies wafting through the air, drifting outside the studio door where the climbing magenta clematis was a visual prelude for what was inside. For the first time, I felt the pressure and the excitement of becoming a true artist.

I am eternally grateful to Morton Traylor for evoking that essence residing within that makes me cherish the creative rock that I will carry for the rest of my life.

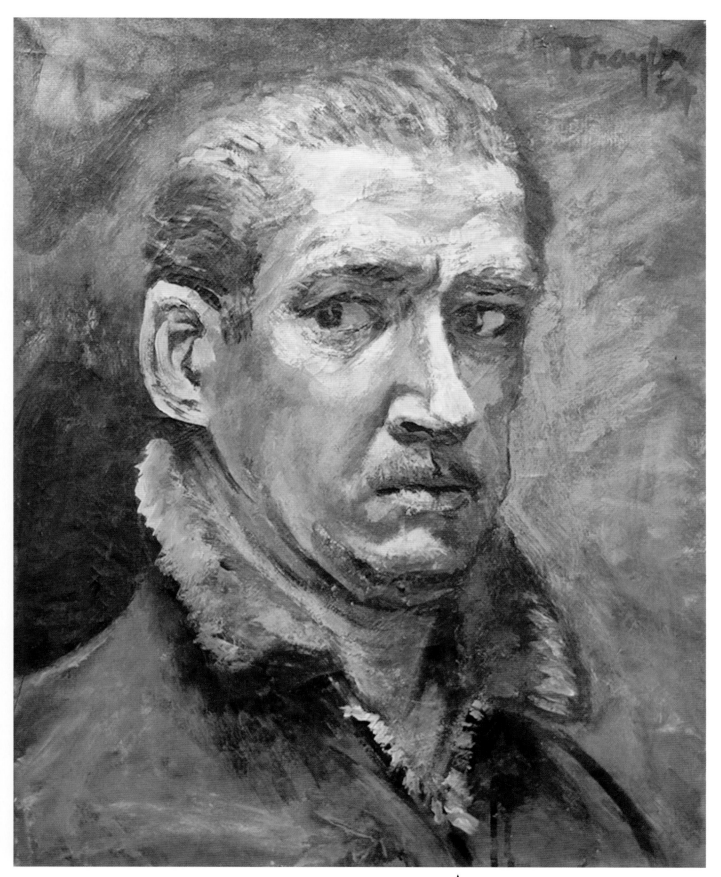

SELF PORTRAIT
(Photo courtesy of Randall Henniker.)
20" × 16" (51cm × 41cm)

Edgar A. Whitney

At the beginning of the book, I described my visceral, emotional and spiritual reaction to Ed Whitney and his wet and wild painting demonstration. After that encounter, my excitement never waned.

Edgar A. Whitney started it all, driving like a maniac across the country in his rickety van teaching watercolor workshops. Many said a Hail Mary, and some held their breath because they knew how he drove, especially as he approached ninety. What a man! What a teacher! What an artist!

I've also mentioned that he was responsible for helping Naomi Brotherton, Bud Biggs and Reese Kennedy begin the Southwestern Watercolor Society, and SWS is just one of many organizations that was born and established because of his help, influence and genius.

Ed Whitney changed the face of watercolor. The word was out. Other artists followed suit. Great teachers, like Ed, graced art workshops, museums and art centers with their knowledge, their skills and their personalities. What a time it was. In its own way, it was like a petite Renaissance, where students could study with artists they never would have known, where they were taught techniques and told stories and where they could experiment with watercolor and watermedia in new and exciting ways. These artists revealed their secrets and with the availability of workshops, a new chapter was added to the history of art in this country.

"The fatal futility of fact," Whitney would boom. Another one of his favorite sayings was "Don't be a reporter." His voice rang like a gong. Watching him paint was always a revelation. One of his favorite habits was saying, "Do I have a problem?" Then he'd cavalierly throw a big wet brush, often with black paint on it, right in the middle of his painting. Some people would gasp, and others who'd seen him do it before would also gasp but laugh like crazy. He was a charming charismatic.

Students will always remember his definition of a good shape. "A good shape is placed obliquely in the composition with different dimensions and size and interlocking edges." Disciples will always leave whites in their painting.

He had a wonderfully emotional side that was contagious. Once, I brought a poem to class that I thought he would like. As I read it to him, tears rolled down his cheeks. Always the consummate teacher, one day he screamed at me so loudly that heads jerked up in the workshop: "What you have here is *hamburger*!" (I'd left too many whites in my painting.) Who could help but love him?

One last pearl of Edgardian wisdom: "Paint something twenty times to get to know it, and change it a little each time you paint it."

He had a lovable and roving eye. As I walked into the first workshop I took with him, I noticed him in the corner with his arm around a lovely woman. I turned to the person next to me and said, "Isn't that sweet? He's got his arm around his wife." My friend nearly died laughing. "That isn't his wife, Betsy."

What an explosive movement he generated, one that still flourishes and whose character is mutable, just like the pigments we paint with. Hail to you, Ed Whitney, and thank you for your unparalleled contribution to the history of watercolor.

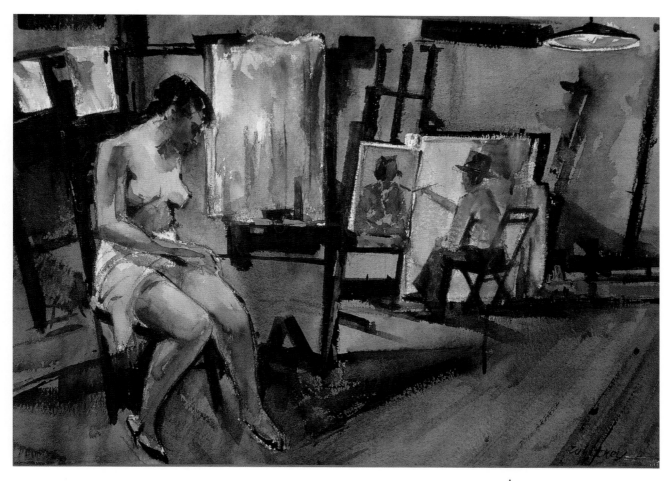

💧 **NUDE MODEL**
(Photo courtesy of
Naomi Brotherton.)
15" × 22" (38cm × 56cm)

◀ **THE 2 INCH BRUSH
PAINTING**
(Photo courtesy of
Naomi Brotherton.)
15" × 22" (38cm × 56cm)

Robert E. Wood

"Every painting should be a surprise journey with an unexpected ending," Robert E. Wood used to say. What an excellent teacher. Typical of Wood, he would often walk into a class and say, "What symphony will you paint today?" His effect was staggering, as was his ability to paint the most gorgeous landscapes and figures effortlessly. People would sign up years in advance for his workshops. And no one was ever disappointed. His inspirational approach to painting was infectious. Once,

when I had done an abstract underpainting and painted the negative space to allow the figure to emerge, he came up behind me. I was about to criticize the painting when he said, "You have no idea how good that is." I'll never forget his encouragement or the graceful way he critiqued and treated all his students. His legend will live on in the thousands of works he executed during his life and in the memories of all the students who had the privilege to study with him.

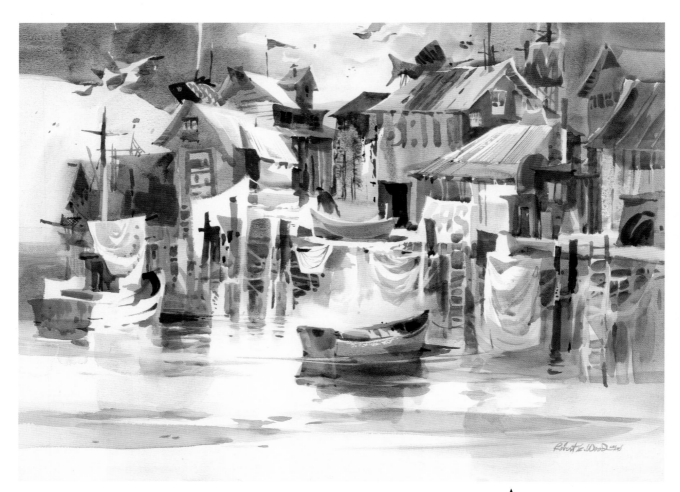

MONTEREY REFLECTIONS
(Photo courtesy of
californiawatercolor.com.)
21½" × 29¾" (55cm × 76cm)

♦ **WOODLAND ADVENTURES**
(Photo courtesy of
californiawatercolor.com.)
21¾" × 29½" (55cm × 76cm)

Milford Zornes

Milford Zornes looked like a legend. Tall, lanky and indefatigable, Zornes was a nonpareil. In his workshop in the late '80s, I quickly became mesmerized by the swift, bold and simple way he depicted everything. Looking over his shoulder on Swiss Avenue in Dallas, I watched as with one deft movement, he painted the most beautiful purple shadow I had ever seen and with a bristle brush. Later I got to know him better through our mutual friendship with Guy and Julia Kirkpatrick and then through teaching with him at Yosemite National Park at the wonderful workshops sponsored by Jane Burnham and Patty Allen.

At Yosemite, Zornes put artist Carl Dalio and me to shame, as we staggered out of our rooms a little after 6:30 a.m. to find that Zornes, along with Bill Andrews, had been up for hours searching for just the right place for teachers and students to paint in the absolute freezing weather. The fourth day of the workshop, Zornes and I were alone in the teaching area. In the afternoon, the students went back to their rooms to do their paintings. Zornes and I sat at the window looking at the torrential rain, talking about art, and I took notes as he told me story after story, reminiscing about his painter's life and throwing in all sorts of insightful thoughts about painting. One of his main caveats was do not paint from a photograph. That was the subject of his lecture at the National Watercolor Society Luncheon the last time I saw him, and that day I was lucky to sit with him for lunch. By then, he was almost blind.

The greatest illustration of Zornes' energetic zest for teaching and painting is a memory of our critique group in Phoenix and Scottsdale when we flew him out for a two-day workshop to paint in the desert. This was about three years before he died. There we were in the desert in a ghost town near Apache Junction, and it was as hot as Hades. Zornes began with a painting demonstration—dressed all in black—as his eyesight was really failing. After his demonstration and talk, we artists went our separate ways and painted. He walked from artist to artist, making comments and offering suggestions. He never stopped. By noon, some of us were exhausted, but we took a break and Zornes did another painting demo. It started all over again, with each of us wandering to our spot to paint, and tall, lanky Milford Zornes continuing to walk through the heat and the sun and the dust to each of us. If he sat down, it was only for a moment to talk to an artist about his or her painting. At the end of the day, he gave another talk, and then most of us dragged ourselves back home and flopped in bed. The next day was just as hot, just as dusty, with Zornes loping around the group giving insights and doing another demo. That night Zornes gave a lecture and painting demonstration at the Scottsdale Artists School. We all went, and he was completely fresh, totally present (of course), and he captivated the whole audience with his painting demo and his lecture.

One will never forget a Milford Zornes tree or a Milford Zornes mountain or Milford Zornes himself. His extraordinary creativity, his striking symbolic style and his amazing teaching ability make him a legend who is an inspiration to all. He was diligent, kind and 100 percent artist. He died only days after his one-hundredth birthday and a few days after his last demonstration for the National Watercolor Society.

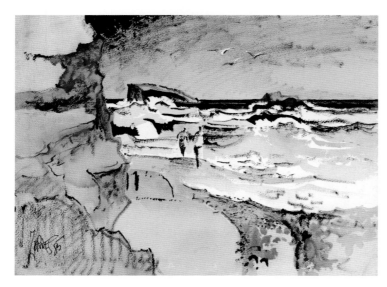

◀ **FROM THE COVE, LAGUNA**
(Photo courtesy of
californiawatercolor.com.)
22" × 30" (56cm × 76cm)

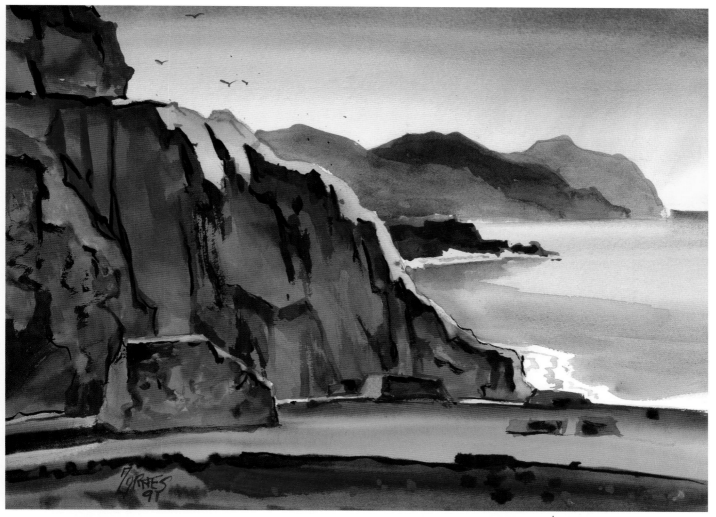

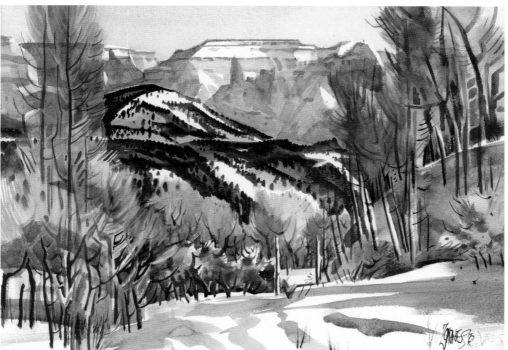

POINT DANA
(Photo courtesy of
californiawatercolor.com.)
22" × 30" (56cm × 76cm)

**WINTER AT MOUNT
CARMEL, UTAH**
(Photo courtesy of
californiawatercolor.com.)
22" × 30" (56cm × 76cm)

Conclusion

We have come to the end of this book, but there is no conclusion to the burgeoning growth in the field of watercolor and watermedia. There will always be new masters and new legends surging onward with innovative approaches and unbridled creativity. Thinking of this path as a complex mosaic, the accomplishments, the experimentations and the fortitude of all those artists on this path will shape and determine its character and its future. This brave excursion will be characterized by small and large, well-defined and sometimes ambiguous steps that with our limited vision we cannot foresee. But we can rest assured that on this journey our artistic mosaic will accumulate more tesserae, and together they will sparkle with the brilliance of diamonds.

BONGO BOB ➤
Betsy Dillard Stroud
30" × 22" (76cm × 56cm)

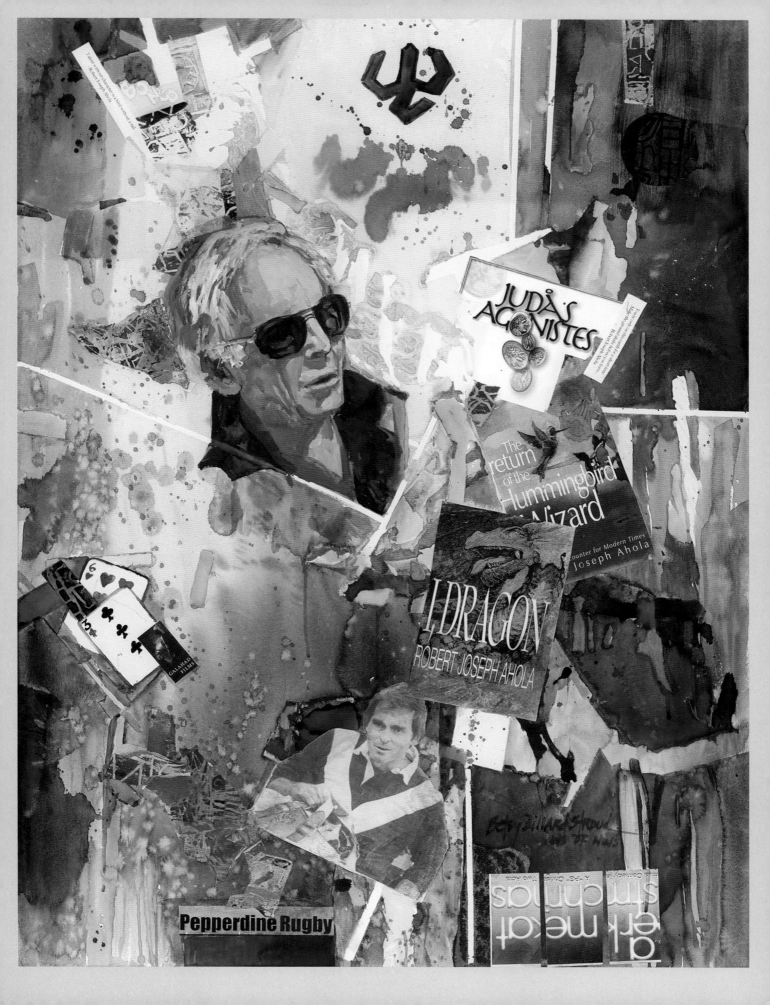

About Betsy Dillard Stroud

Betsy Dillard Stroud rides the twin, turbulent steeds of painting and writing.

Stroud is a signature member and Dolphin Fellow of the American Watercolor Society, a signature member of the National Watercolor Society, the Rocky Mountain Watermedia Honor Society, the Western Federation of Watercolor Society, a Royal Scorpion and life member of the Arizona Watercolor Society and a former president of the Southwestern Watercolor Society.

An internationally acclaimed and award-winning artist, Stroud is also a former art historian who received her BA in art from Radford University and her MA in art history from the University of Virginia.

Stroud completed all her course work for the doctorate and passed the orals before she wrote her first book, titled *Coming Hither—Going Hence*, a memoir of her uncle, Colonel Herbert Nash Dillard, Jr., who was a beloved professor at the Virginia Military Institute. Through circumstances associated with the publication of that book, she met and married her husband and moved to Dallas. Though the marriage did not survive, her painting career thrived. Stroud currently resides in Phoenix, Arizona, and her paintings continue to reflect her East Coast upbringing, her love of the West and Southwest, and her passion for certain subject matter and symbolism.

Betsy Dillard Stroud was one of only 28 American artists from the United States invited to exhibit in the Xiangsu Museum in Nanjing, China, in the first Invitational Exhibition of Contemporary International Watermedia Masters in November, 2007. Her paintings are in hundreds of collections across the United States and are in international collections in Japan, England, Canada, Australia and the Bahamas. She is the author of *Painting from the Inside Out* (North Light, 2002) and a Dutch edition of her book was published in Holland in 2005. *The Artist's Muse: Unlock the Door for Your*

Creativity (also published by North Light) was released in December, 2006. Stroud is also a professional magazine writer and has written for major art magazines since 1987. Stroud served as an associate editor of *International Artist Magazine* from 1998-2003. *Moving Toward the Light: Joseph Raffael* was published in September 2015, and was written by biographer Lanie Goodman; David Pagel, art historian and critic for the LA Times; and Stroud (Artist to Artist—Betsy and Joseph).

Since 1987, she has judged more than sixty-five international, national, regional and state shows, including for the American Watercolor Society in New York, the National Watercolor Society in California, and the abstract/experimental category for the international competitions of *The Artist Magazine*.

Betsy Dillard Stroud is an accomplished lecturer and has achieved the International Toastmasters Silver and Competent Leader statuses. She is a member and former president of Park Central Toastmasters in Phoenix.

CELESTIA ➤
Betsy Dillard Stroud
30" × 22" (76cm × 56cm)

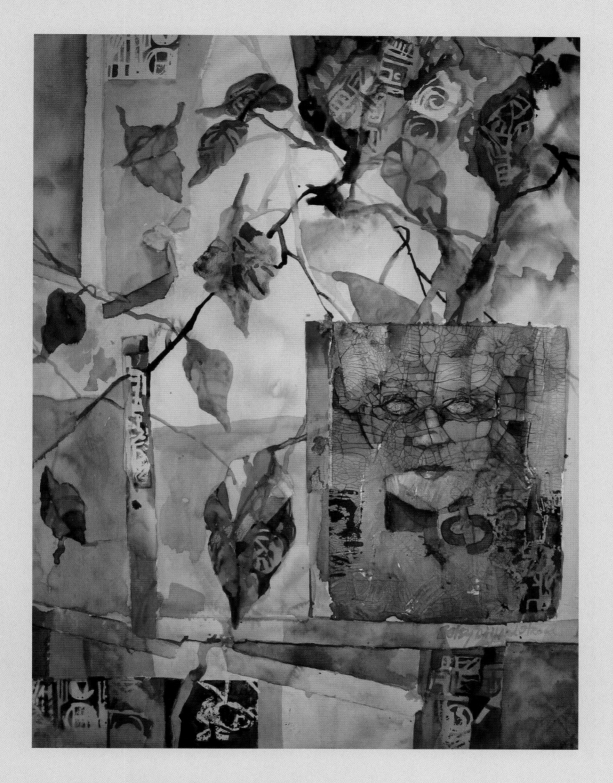

Dedication

With love for my lovely sister Caroline Dillard Tucker and my lovely niece,
Cabell Taliaferro Eames.

And to the memory of my beloved sister, Celestia Taliaferro Dillard, and
my cherished friends, Jeremy Leggatt, Bill Reed, Jason Williamson, Ginnie
Lee and Bob Williams.

Index

158

a content + ecommerce company

20 19 18 17 16 5 4 3 2 1

DISTRIBUTED IN CANADA BY FRASER DIRECT
100 Armstrong Avenue
Georgetown, ON, Canada L7G 5S4
Tel: (905) 877-4411

DISTRIBUTED IN THE U.K. AND EUROPE
BY F&W MEDIA INTERNATIONAL LTD
Brunel House, Forde Close, Newton Abbot, TQ12 4PU, UK
Tel: (+44) 1626 323200, Fax: (+44) 1626 323319
Email: enquiries@fwmedia.com

DISTRIBUTED IN AUSTRALIA BY CAPRICORN LINK
P.O. Box 704, S. Windsor NSW, 2756 Australia
Tel: (02) 4560-1600; Fax: (02) 4577 5288
Email: books@capricornlink.com.au

ISBN 13: 978-1-4403-3526-6

Edited by Kristy Conlin
Designed by Geoff Raker
Production coordinated by Jennifer Bass

Metric Conversion Chart

To convert	to	multiply by
Inches	Centimeters	2.54
Centimeters	Inches	0.4
Feet	Centimeters	30.5
Centimeters	Feet	0.03
Yards	Meters	0.9
Meters	Yards	1.1

Acknowledgements

"No one ever makes it by talent alone. They are molded by forces other than themselves."
— Gary Cooper, Actor 1901-1961

Gary Cooper's statement expresses my own sentiments and boundless gratitude for the following people: James Markle for making the publication of this book possible; Kristy Conlin, my "very" favorite editor, for her help and our great rapport; Maureen Bloomfield, my forever friend whose endless encouragement and engaging humor sustains me; all the fantastic artists in the book and those amazing artists who are no longer with us; Marion Roberts Sargent, for the invaluable gift of her lasting friendship and for giving me another friend, Bob, her wonderful husband; John J. Yiannias, who listened endlessly (also my life-long friend.) and who always tells me the truth; William Kloss, my former advisor, who always said, "You should write, Betsy, write!"; remembering with affection the late Frederick Hartt, who encouraged me as a painter and as a scholar; Theresa Meeker for her loving friendship and support; the talented Richard Gehrke, architect and photographer who photographed most of my paintings; my good friends and talented colleagues Sebastian Pereira and Jo Toye for their skillful photography and friendship; Jefferson Heath; Nikki and Sheldon Silkey for their friendship and Nikki for photographing me for this book and Shel for his unbelievable computer skills; Michael and Nick Johnson of californiawatercolor.com for providing art by Milford Sheets, Robert E. Wood and Milford Zornes; Randall Henniker providing art by Morton Traylor; Ronald Crusan and the Ogunquit Museum of American Art for providing art by Ed Betts; and Jean Sampson, poet and artist for her friendship and her integral part in my life's scenario. And, wherever she is, Nancy Jo Ferguson, my art teacher at Stuart Hall. Thank you to the incredible painter Joseph Raffael, whose inspirational paintings are indelibly engraved in my heart and for his trust in me as a writer. To my heroines, Naomi Brotherton and Mary Todd Beam for their endless support, and to Tabby T and Hamlet for their affectionate meows and their reassuring purrs.

Ideas. Instruction. Inspiration.

Receive FREE downloadable bonus materials when you sign up for our free newsletter at artistsnetwork.com/Newsletter_Thanks.

Find the latest issues of **Watercolor Artist** on newsstands, or visit artistsnetwork.com.

These and other fine North Light products are available at your favorite art & craft retailer, bookstore or online supplier. Visit our websites at artistsnetwork.com and artistsnetwork.tv.

Follow North Light Books for the latest news, free wallpapers, free demos and chances to win FREE BOOKS!

Get your art in print!

Visit **artistsnetwork.com/splashwatercolor** for up-to-date information on *Splash* and other North Light competitions.

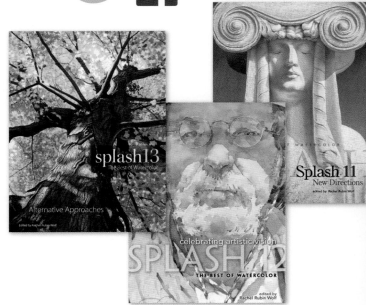